SKETCHING TECHNIQUES

SKETCHING TECHNIQUES

EDITED BY MARY SUFFUDY

WATSON-GUPTILL PUBLICATIONS/NEW YORK

Copyright © 1985 by Watson-Guptill Publications

First published 1985 in New York by Watson-Guptill Publications,
a division of Billboard Publications, Inc.,
1515 Broadway, New York, N.Y. 10036

Library of Congress Cataloging-in-Publication Data
Main entry under title:

Sketching techniques.

 Includes index.
 1. Drawing—Technique. I. Suffudy, Mary.
NC730.S47 1985 741.2 85-17960
ISBN 0-8230-4855-1

Distributed in the United Kingdom by Phaidon Press Ltd., Littlegate
House, St. Ebbe's St., Oxford

Manufactured in U.S.A.

First Printing, 1985
1 2 3 4 5 6 7 8 9 10/90 89 88 87 86 85

The artists whose work and teaching are included in this book deserve particular recognition and thanks. Because of their generosity and willingness to be involved in this project, *Sketching Techniques* contains the finest instruction Watson-Guptill has to offer. I would also like to offer special thanks to Susan Davis and Jay Anning for their invaluable contributions to this book.

Mary Suffudy

Contents

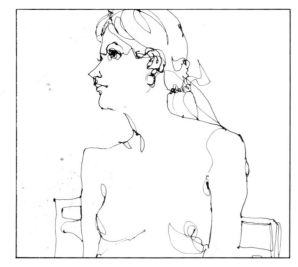

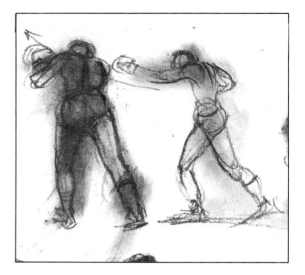

Introduction 8

Materials and Basic Techniques 9
Choosing a Sketchbook 10
Selecting Pencils, Pens, Markers, Brushes 12
Working With Watercolor 14
Exploring the Personality of Line 16
Creating Illusions by Repeating Lines 18
Using Sepia Ink 20
Experimenting with Charcoal 22
Working with the Scribble Approach 24
Using a Gestural Approach 25
Capturing Motion with the Mannikin Approach 26
Using Tonal Mass Approach 27
Sketching Outlines 28
Making a Contour Drawing 30
Adding Shading Gradually 32
Adding Simple Tonal Washes 34
Emotional Speed Sketching 36
Designing the Sketchbook Page 38

Studying Your Subject 40
Studying Plants and Trees 42
Sketching Clouds, Landforms, and Water 44
Working with Charcoal Outdoors 46
Analyzing Your Subject 48
Sketching Your Subject from a Different Perspective 50
Studying Animals Close at Hand 52
Sketching at the Zoo 54
Drawing at the Natural History Museum 56
Developing Form Sketches of Deer 58
Developing Sketches of Monkeys 60
Developing Sketches of Elephants 62
Conveying Movement with Watercolor 64
Practicing Movement Variations 66
Outlining the Figure in Motion 68
Capturing the Feeling of Dance 70
Drawing People: A Moving Target 72
Learning to Draw Body Language 74

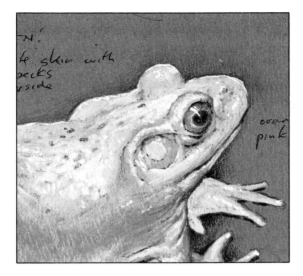

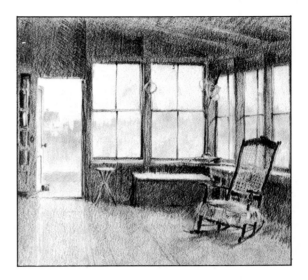

Determining Shapes and Patterns, Compositions, Value and Color 76

Learning to Control Large Forms 78

Seeing Shapes Accurately 80

Creating Figures in Three Values 82

Seeing Positive and Negative Shapes 84

Emphasizing Dark, Negative Shapes 86

Establishing the Composition 88

Sketching Still Lifes to Learn Composition 90

Drawing Like a Painter Thinks 92

Determining Local Value versus Light and Shade 94

Controlling Values 95

Planning a Basic Value Scheme 96

From Sketch to Finished Painting 98

Building an Illusion of Space from Intricate Detail 100

Painting a Figure in Light 102

Creating a Mysterious Night Light 104

Refining a Painting 106

Exploring Light and Color in the Landscape 108

Learning Innovative Landscape Techniques 110

Discovering a New Way to Express Light 112

Thinking About Design 114

Using Thumbnail Sketches as a Guide 116

Thinking Through Ideas with Small Studies 118

Different Ways of Approaching the Same Subject 120

Working Out Details Through Sketches 122

Painting Flowers After In-Depth Study 124

Working in Series 126

Many Moods from One Subject 128

Interpreting Light 130

Composing with Color 132

Correcting Finished Paintings 134

Correcting Washed-Out Lights and Muddy Darks 136

Saving a Weak Painting with Darks 138

Resolving a Divided Center of Interest 140

Establishing a Center of Interest 142

Index 144

Introduction

In continuing response to requests from our readers for books that show how a variety of successful artists work, the editors of Watson-Guptill are pleased to introduce *Sketching Techniques*. In keeping with earlier books in the Watson-Guptill techniques series, *Sketching Techniques* is actually several art courses rolled into one; here are carefully selected lessons from many of the best and most popular artist/instructors working today.

There are of course many different reasons for sketching. For some people, sketching is relaxing, a meditation. Many artists insist that sketching is essential to developing accomplished finished paintings. Sketching can provide a good record of people, places, and events. And sketching can help artists work out problems of composition, color, and value. In *Sketching Techniques*, all the possibilities of sketching are explored, and the result is a book that is useful as well as great fun.

Now here is some information about the artists and books on which *Sketching Techniques* is based.

James Gurney and Thomas Kinkade are authors of *The Artist's Guide to Sketching*. Excerpts from this book provide basic information on materials and techniques, as well as invaluable lessons in recording vital details of such subjects as plants, animals, skies, and water.

David Lyle Millard is one of Watson-Guptill's most celebrated authors. His first book, *Joy of Watercolor*, is actually a complete course in watercolor using the sketchbook as a workbook. And *More Joy of Watercolor* provides continuing lessons in color and design, based on sketching, for the intermediate and advanced artist.

Charles Reid, also an extraordinarily popular artist, does everything well—flowers, still lifes, landscapes, portraits, and figures. Included in *Sketching Techniques* is selected material from *Painting What You Want to See* and *Figure Painting in Watercolor*. Mr. Reid's other books are *Flower Painting in Watercolor*, *Flower Painting in Oil*, *Portrait Painting in Watercolor*, and his latest, *Pulling Your Paintings Together*.

Philip Jamison is a master watercolorist whose work has been exhibited in such prestigious museums as the Metropolitan Museum of Art, the Boston Museum of Art, and the Philadelphia Museum of Art. In his book *Making Your Paintings Work*, Mr. Jamison shows how sketching plays a vital role in the process of making successful paintings. Mr. Jamison is also author of *Capturing Nature in Watercolor*.

Jane Corsellis is an award-winning British artist. Passages from her book *Painting Figures in Light* show how sketching can help you manipulate light angle and quality to create figure paintings.

Rudy de Renya's *How To Draw What You See* was published in 1972. Since publication it has been a highly regarded text for serious artists of every level of ability. Mr. de Reyna is also author of *Realist Techniques in Water Media*, and his paintings appear in Wendon Blake's *Landscapes in Acrylic*, *Acrylic Painting*, and *The Acrylic Painting Book*.

Harry Borgman, a successful artist and illustrator, is another of Watson-Guptill's prolific author/instructors. We have included material from *Art & Illustration Techniques*. Mr. Borgman's other books are *Drawing in Pencil*, *Advertising Layout Techniques*, *Drawing in Ink*, and *The Pen and Pencil Technique Book*.

Norman Adams is a masterful wildlife artist and co-author with Joe Singer of *Drawing Animals*. We have excerpted form sketches that enable you to study animals in various characteristic poses and engaged in various familiar activities.

From *Figure Drawing Workshop* by Carole Katchen we have selected the work of three fine artists. Mel Carter shows you how to master line; Shawn Dulaney shows how to capture the figure in motion; and Kim English teaches you how to draw body language.

From *Painting the Landscape* by Elizabeth Leonard we have taken the work of four superb artists who show how sketches lead to polished finished paintings. Gerald Brommer demonstrates his innovative watercolor and collage techniques. John Koser is also an extremely inventive painter who demonstrates his technique for combining thousands of speckles of paint to form new color sensations. Alex Martin shows how to create color, light, and mood in landscape paintings using sketches as a guide. William McNamara, an accomplished realist watercolorist, demonstrates how to build an illusion of space from intricate detail.

Through this book you will discover how much fun and how truly invaluable sketching can be to the artist. We at Watson-Guptill hope that you will explore the work of the artists featured here in greater detail, and that by doing so you will continue to develop a style and philosophy all your own.

MATERIALS AND BASIC TECHNIQUES

The materials used for sketching are as simple or as diverse as are the reasons for sketching. In this section, you'll become acquainted with the essential materials of sketching—the pencils, pens, markers, and brushes—and with techniques that are traditional to sketching as well as some that are unique. James Gurney and Thomas Kinkade show you four different approaches to the art of sketching: the scribble, gestural, mannikin, and tonal mass approaches. From Charles Reid, you'll learn about contour drawing—a sketching technique that helps you discover new ways of seeing form. David Lyle Millard and Mel Carter stress the importance of style in your sketching; both artists demonstrate that the "personality" of line is determined in part by your choice of medium and technique. Jane Corsellis teaches you ways that charcoal and sepia ink can be most effectively used for exploring the subtleties of figure sketching. And Harry Borgman demonstrates that the loose, colorful medium of watercolor is particularly apt for sketching the outdoors.

Choosing a Sketchbook

Your choice of sketching materials is as individual as you are. Anything you enjoy working with can be used for sketching. For this reason, don't bother to buy expensive materials at the beginning. Even a ballpoint pen and some scratch paper are enough to sketch any subject in any of the approaches described in this book.

As your interest and skill in sketching develop, you will want to purchase more materials to expand your range of effects, while always keeping simplicity and economy in mind. Through experience you will find, as James Gurney and Thomas Kinkade have, that the simplest materials usually produce the best results. Working with such elaborate materials as paints, which require on-the-spot preparation, can sometimes dampen your enthusiasm for a subject. Simple drawing materials are often the most satisfactory.

Portability is another important concern. If your materials can't fit in a small (11″ × 14″) knapsack, then Gurney and Kinkade recommend you leave them home. Consider ahead of time not only what you expect to sketch, but also how long you plan to be on the spot and how much walking you expect to do. The most common mistake you can make is to carry too much. Sometimes being limited to just one sketchbook and one drawing tool can inspire you to concentrate deeply on your subject and not get distracted by elaborate techniques.

You will eventually want to own several different sketchbooks for different kinds of sketching. There are dozens to choose from at most art supply stores, and they vary in size, binding, and paper quality.

Size. The smallest sketchbook that is convenient enough to be carried all the time for very quick notations in pencil or ballpoint pen is a 4″ × 6″ hardbound blank book. Also at that size you can find pads with good quality paper that allows you to work extensively on each drawing without wearing through the page. Miniature sketchbooks are ideal for sketching when you wish to remain unobtrusive, as in a theater or on a bus.

If you carry a backpack, purse, or briefcase with you daily, you can comfortably manage the 5½″ × 8½″ or 9″ × 12″ format. This scale will probably fit most of your sketching needs. This size has the advantage of being easy to hold and carry as well as fitting on a bookshelf.

By the time you move up to the 11″ × 14″ format, you will want to spend more effort on each sketch. This is the perfect size to take when you leave home on a Saturday morning to go nature sketching.

Remember that you don't have to do just one drawing per page—you can also do small studies. This size has only one limitation: It's more conspicuous.

The largest sketchbook that is practical is 14″ × 17″; beyond that a specific project may call for individual sheets of paper clipped to a drawing board. Some artists like to use extremely large pads—up to 18″ × 24″—for bold charcoal or crayon sketches, because they allow free arm movement from the shoulder. If you feel your work is getting too cramped, try this size for a change. When you return to the smaller sizes, you'll notice more boldness in your technique.

Binding. The three most common types of binding available for sketchbooks are hardcover, spiral, and adhesive. The binding that you choose depends on the amount of abuse you expect to give the sketchbook and whether you wish to remove pages from it. Hardcover sketchbooks are the sturdiest and most permanent, but also the most expensive. However, for a sketchbook that serves as a journal of your vacation or personal inspirations, the investment is well worth it.

A spiral binding holds pages fairly secure, yet allows the book to be folded back so that you have a single, flat surface to work on. This feature allows you to draw easily on the entire page of your sketchbook as well as making it easier to hold. The spiral binding allows pages to be easily removed, which is handy when a sketch fails and you want to discard it or when a sketch goes so well that you wish to frame it. But beware: Rough use can also cause the pages to fall out or become damaged.

Adhesive-bound sketchbooks are bound in a manner similar to scratchpads. They are often the least expensive type of sketchbook and unfortunately the least durable. Folding the front pages back usually causes the book to fall apart, so it is advisable to remove each sketch after you do it and file it in a safe place. In general, these sketchbooks are most useful for quicker sketches. When you intend to spend a great deal of time and effort on a sketch, you'll need a more durable book.

Another option, especially if you prefer working with special paper, is custom binding. It's easier than it sounds, and you can have a book bound for much less than you will pay for a commercial sketchbook. Most print shops can bind any stack of paper in a plastic clasp in just a few minutes. You can buy special papers at low cost at a paper supply warehouse or office supply shop, cut

them down to 9″ × 12″ or 11″ × 14″ bundles, and have several of them bound at a time. You can also make a sketchbook containing several different kinds of paper so that you can use various techniques while taking only one sketchbook on an outing.

Sometimes you may want to use a special size or type of paper that is not available in commercial sketchbooks. Instead of custom binding, another option is to work with loose sheets held to a drawing board with big metal clips on two or more edges. Many art supply stores carry large boards with the clips built in and a handle cut into one side for portability. Gurney and Kinkade use a variety of Masonite panels in sizes up to 22″ × 28″ for sketching in drybrush or wash techniques. The clips work well to hold the illustration board, but they are equally useful for other sketching media.

Paper. The type of paper you choose makes a big difference in how a sketch turns out. A wash drawing destroys cheap paper, and markers bleed right through it. On the other hand, the expensive papers should be saved for techniques that call for them.

There are a variety of inexpensive, lightweight bond paper pads that often bear the name "sketch" paper. These are really the bread and butter of sketching. Gurney and Kinkade use them for what they call the "15-minute, waiting-for-the-bus" kind of sketch. The "tooth," or texture, of the surface is smooth enough to allow for fairly delicate shading and cross-hatching as well as the broader kind of stroke. This is the paper to use for motion studies and fairly quick sketches of nature, people, or objects. But be aware of its limitations. Bond paper does not hold up to the wet media—brush and ink, wash drawing, watercolor—nor to the blending media such as charcoal or pastel. The best materials to use with bond paper are pencil, ballpoint pen, and fine line markers.

A good, versatile paper can be found in the so-called drawing pads. The paper generally has a slightly coarser tooth than sketch paper and is of a heavy enough weight that it adapts well to techniques involving extensive working. Its surface is favorable to pencil, charcoal, pen and ink, and drybrush. However, wash should be used sparingly as the surface buckles with excessive moisture.

Watercolor paper and charcoal paper are both high-quality, specialized papers with very coarse tooth available in pads as well as individual sheets. In addition to use with watercolor and charcoal, they also work very compatibly with such

techniques as brush and ink because of their interesting texture.

Markers have a temperamental personality that demands particular surfaces. The fibers in most papers are loosely bound together into a porous structure that absorbs the marker solvent, causing the dye to bleed through to the next page as well as creating a fuzzy effect. The commercial marker papers are nonporous; yet they're often too lightweight for most sketching uses. In addition, some are so nonabsorbent that the marker ink never really settles into the paper, and as a result every layer of color that you add to the original tone creates a smear. Certainly all these effects can be used to advantage, but because of these variables, it's difficult to find a good marker paper for general sketching use.

Strathmore Series 300 charcoal paper pads come the closest of all sketchpad papers to providing a good surface for marker techniques. But Gurney and Kinkade's favorite paper for markers is a white, satin finish, printer's bristol stock. They buy it from a paper warehouse in stacks of 100 sheets, 23″ × 29″, which they then cut up and bind into their own sketchbooks. The surface handles pencil very well and tolerates much cross-hatching in pen-and-ink techniques. If you can find some in your area, they recommend you try it.

Another one of Gurney and Kinkade's favorite papers is ordinary brown wrapping paper also available at printing paper warehouses. This usually comes in the form of large rolls that can be trimmed and bound into convenient sketchbook sizes. Not only does this paper have a smoother tooth than charcoal paper, but it's also much cheaper. The color is grocery-bag brown, providing a pleasant middle tone on which to work light and dark, such as with pencil and white gouache. Ballpoint pen works well, too.

If you want to sketch on something sturdy, and don't mind a bit of extra expense, Gurney and Kinkade recommend illustration or bristol board. Both of these are available at most art supply stores and come in two different surfaces—hot and cold pressed. Hot pressed is a smooth surface, while cold pressed is a bit rougher. Both surfaces can be used with any medium, though hot pressed favors pen and ink while cold pressed favors wash and charcoal. The durability of these papers makes them appropriate for sketches that you plan to spend some time on and that you know you'll want to keep.

Sketchboxes and Carrying Cases. A sketchbox is anything used to transport sketching tools. It is not necessary to purchase an "artist's" sketchbox. Instead, be creative and fashion one from another container. You can use tool, fishing tackle, or lunch boxes, or even an old violin case. There are times when you may not be sure what type of sketch you will be doing and you'll want to bring along enough materials for any technique you might want to try. At such times, a medium-sized container such as a fishing tackle box can carry everything you might need.

At other times you'll have a specific technique you're interested in using and you'll want to carry only those materials. For these occasions you'll want to organize your tools into a few separate containers—one for each technique. The disadvantage of this is that it doesn't allow you to experiment by combining media.

For the most part, you may find that the sketching set-up you reach for most is simply a pencil and a fountain pen or marker in your shirt pocket and a 9″ × 12″ spiral-bound sketchbook under your arm. Or you may want to keep a knapsack always loaded with a few sketchbooks and drawing tools, so when you want to go sketching, you can simply grab your knapsack and you're off.

Selecting Pencils, Pens, Markers, Brushes

A wide variety of media are available for sketching: from pencils and pens to markers and brushes. It's up to you to determine which ones best serve your needs. Often that depends on the type of work you wish to do.

Pencils. The ordinary graphite pencil is a versatile, reliable tool for sketching because it can deliver both a smooth line and a controllable tone, at the same time that it can be erased. The three pencils shown at the bottom of the illustration are standard yellow office pencils of varying degrees of hardness. They can be used for a wide array of effects in line and tone. James Gurney and Thomas Kinkade use these, instead of expensive artist's pencils, for the underdrawing stage of most sketches.

Continuing on up, the Eagle Draughting, Berol Prismacolor, and Koh-i-Noor black have thicker leads and give rich blacks. The Prismacolor also has a waxy base that makes smudging or erasing difficult. A drafter's lead-holder pencil takes individual leads that can be bought from the hard 6H to the soft 6B. Mechanical pencils feature ultrathin leads for delicate lines. Chalky white Carb-Othello works well on tone paper. Finally, charcoal is available in both compressed sticks and pencils, but Gurney and Kinkade find pencils are most practical for everyday sketching. But remember to bring along a fixative.

Not shown, but also essential, are erasers. You'll need them to fix errors and lift out light accents from toned areas. Buy two: a kneaded eraser for correcting lines and a Red Ruby for creating crisp highlights.

Pens. Pen and ink has long been a favored medium among sketchers because of the spontaneity it provides. The rapid flow of ink and the smooth gliding of the pen over paper allow for immediate expression.

The old-fashioned dip pen with flexible nibs shown at the bottom of the illustration has given way to a family of specialized modern pens that require that no ink bottle be carried—or spilled—on location. Artist's fountain pens, such as the Pelikan 120 and the less expensive Schaeffer cartridge pen, have a refillable

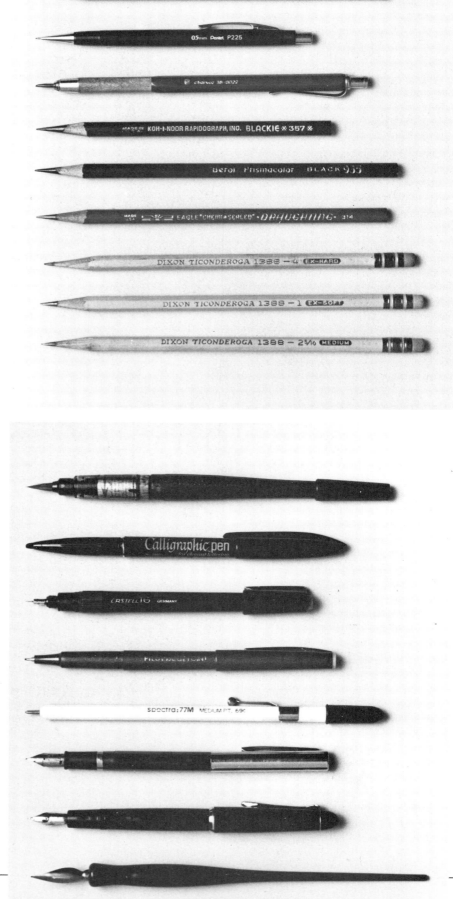

ink supply and a rounded nib. Ordinary ballpoint pens have the same feel as a pencil and are useful for quick sketching.

The fine-tip felt pen and its more precise cousin, the technical pen, yield a black line of uniform thickness. Gurney and Kinkade use the chisel-tip calligraphy pen for any kind of sketching that combines line and black areas. It's hard to beat for quick, painterly indications of complex subjects. The brush pen, which is most versatile and easy to handle, has replaceable ink cartridges and a sturdy nylon-brush tip.

Markers. Gray markers are best suited to spontaneous tonal techniques in combination with a pen line. A typical procedure would be to make a brief pencil underdrawing, then do a line drawing with a fine tip felt pen, and finally add a few touches of marker to suggest tones.

Gurney and Kinkade use the cool gray, chisel-tip AD markers, which come in a controlled range of values from light to dark. They use #2, #4, #6, and #8. Markers also come in a vast assortment of colors.

They also use a standard Marks-A-Lot for average-sized sketches and a broad-tip Pilot marker for large black areas. You can also buy black markers in other inexpensive brands.

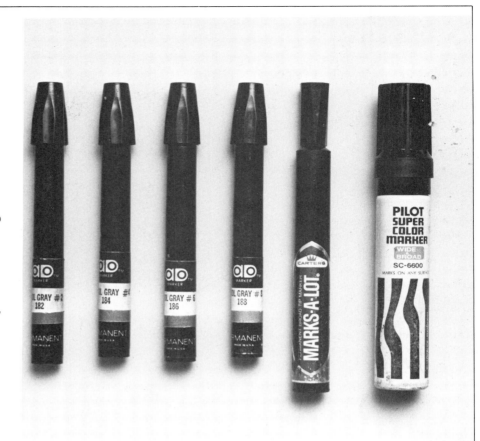

Brush Materials. Both wash and drybrush are somewhat cumbersome sketching techniques because you must carry a bottle of water and a bottle of ink beside a brush and a pad. However, the effects you can get make both wash and drybrush among the better techniques for realistic rendering.

A simple assortment of pure red-sable watercolor brushes—Nos. 2, 8, and ½″ flat—are worth the investment because they can produce many different sketching techniques, including wash, drybrush, brush-and-ink line drawing, and white gouache on tone paper. The clip-on covered palette cups can be filled with white gouache or ink on one side and water on the other, and the caps can be used as miniature palettes for diluting the paint. Two small baby food jars or empty 35mm film containers also work, though not as well as the cups. Pelikan Fount ink is Gurney and Kinkade's favorite because it can be used with brushes as well as with refillable pens.

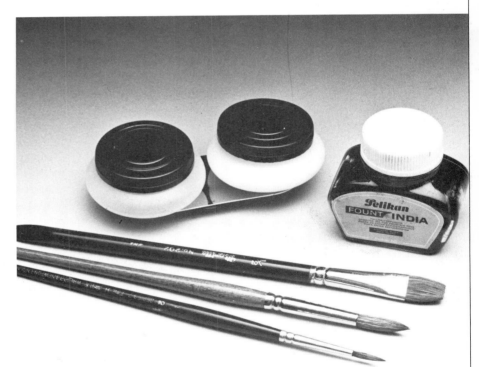

Working with Watercolor

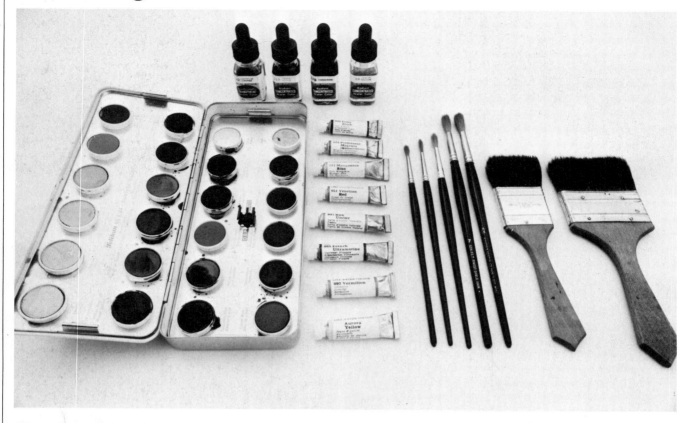

Watercolor holds a fascination for many people because it is such a challenging medium. But it can, as you have probably guessed, be difficult to work with. Actually, to work properly with watercolor you must carefully plan your sketching in advance. Unlike some other mediums, you cannot just remove your mistakes. You must be able to put down the right colors and values the first time. Changing colors or overworking this medium can be a disaster. Watercolor should be very fresh and spontaneous.

A thorough knowledge of the tools will help you become at ease with the medium. The key, of course, is to practice a great deal. Sketching outdoors on the spot is a great way to become facile with watercolor. A good background in using designer colors will also help.

Many brands of watercolor are available, and one of the finest is Winsor & Newton. However, these colors are quite expensive, so you may prefer to begin by using a cheaper watercolor set. Pelikan makes a nice 12 or 24 color set in a rustproof box that is very handy for outdoor work. As you gain confidence and skill in this medium, you will then want to graduate to the more expensive lines of paint.

Dr. Martin's watercolors are very vibrant and are available in bottles, although they are really dyes and subject to fading. Inconvenient for outdoor work, this line, however, is very popular and useful in the commercial art field where permanence is not a problem. You might choose to apply these watercolors once you're back home.

You should have a good selection of watercolor brushes, starting with Nos. 4, 5, and 7, but only use the finest red sables. Cheaper brushes will not work well or last very long. The only cheaper brushes to use are the inexpensive, wide sign-painter's brushes that you may need for wetting large areas or painting large, flat washes.

Watercolor paper is available in rough, medium, or smooth surfaces and can be purchased in individual sheets or in the more convenient blocks made up of many sheets. The Arches watercolor blocks from France are very fine papers to use. Here again, you will have to experiment with the different papers and surfaces to find out your preferences. Before you begin sketching, practice the exercises on the opposite page.

Wet your paper with clear water, drop dabs of color onto the wet area, and study how the color spreads.

Follow the last exercise, but brush a little clear water over part of the area while the tones are drying and observe the effect you can create.

Paint a wash with a tone of color. As the tone dries, add dabs of color with your brush and study the reactions during the various drying stages.

Brush a wash of color over the watercolor paper without wetting the paper surface first. An interesting texture will result. Try this with different kinds of paper.

In this example, first wet the paper with clear water, and then paint a tone, leaving a white area in the center. When the tone is almost dry, add some darker color tones. Note how they will only blend in the damp areas.

On dry paper, paint some wash strokes. While these are still wet, paint over some of the strokes with another color. Watch how the colors blend throughout the strokes.

Exploring the Personality of Line

Every line has its own personality. Depending on the medium and the technique with which a line is drawn, a line can be bold or tentative, aggressive or sensitive, rigid or fluid. Mel Carter maintains that the emotional statement made by a line is what's important. For example, a straight line seems hard, direct, absolute, strong, fast, while a curved line feels, organic, delicate, sensual, relaxed. Carter believes that direction, weight, and speed of lines are other important considerations in determining personality.

In these drawings Mel Carter uses the same figure in the same pose. The only variations are different mediums and the character of the line. Notice how these changes dramatically affect each drawing.

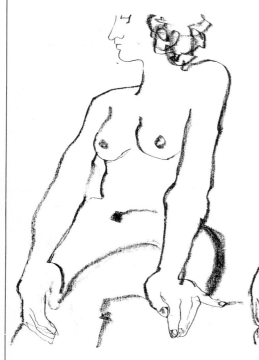

1. Graphite. Graphite is available as lead in pencils and in solid sticks. Here Carter works with a stick. Notice how he achieves a thick line by drawing with it turned on its side. The fine lines in the face and hands are produced by working with the pointed end.

Note the fluid quality of the line in the face. Carter could have chosen to create a delicate, graceful drawing by rendering the entire figure with that type of line. Instead, he used bolder, more angular lines to give greater vitality to the drawing.

2. Crayon. Crayon has many of the same properties as graphite, such as the ability to go from thick to thin and from dark to light. But crayon is not quite so delicate as graphite (compare this face with that in the previous drawing), but it does create a much more dramatic black.

Other media that are similar to graphite and wax crayon are Conté crayon and charcoal. The biggest difference is that Conté and charcoal are unstable substances that smear easily. Try using all four so that you can get a sense of each medium's advantages and limitations.

3. Technical Pen. With the technical or Rapidograph pen, Carter creates a line that is precise and controlled. The drawing has a delicate quality because the line is so fine. And because the medium used is ink, it is also a very firm line.

Notice the playful quality of the curved lines in the hair. These whimsical circles and curves keep the drawing from looking too somber.

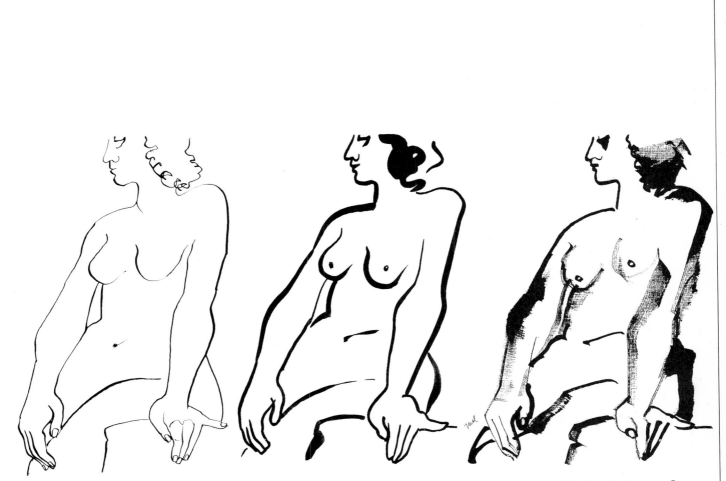

4. Pen and Ink. With traditional pen and ink, Carter achieves much greater line variation than is possible with the technical pen. Notice how the line varies from the very thin line delineating the nose to the thick lines in the torso and limbs.

The lines here are also less fluid than those drawn with the technical pen, thus making the figure appear less graceful. However, because of their greater variety, the lines themselves have greater visual interest.

5. Brush and Ink. This brush and ink drawing has a lovely flowing line that is reminiscent of Oriental calligraphy. To create this graceful line, Carter used a pointed brush and drew in long, continuous strokes. This is only one of the many types of lines that can be produced with this medium.

Carter says that the only way to know what you can accomplish with any tool is to do lots of drawings with that particular medium. Your only limitation is your own imagination.

6. Stick and Ink. For this drawing Carter used a twig that he found on the ground. By dipping the stick in ink and drawing with it, he achieved the greatest line variation possible in an ink drawing. Compare the fine lines in the face with the broad, textured lines in the arms and the heavy black lines along the back of the figure. He controls the line by using more or less ink and by drawing with the tip or side of the stick.

Another drawing tool that gives a richly varied line, but that offers more control than a twig, is the Oriental bamboo pen.

Creating Illusions by Repeating Lines

One line alone has an individual character; different kinds of repeated lines create a variety of effects. Repeated lines can give emphasis to a section of a drawing. They can convey a feeling of movement or rhythm, and they can create areas of lighter or darker value. Since drawing is a matter of creating illusions, crosshatching or overlaying lines can enhance those illusions.

1. Crosshatching. This drawing was executed with fine, light pen lines. By themselves the lines are delicate, but together in the form of crosshatching they create a strong impact of light and dark areas within the figure. Mel Carter placed his lights and darks in the drawing according to pure design considerations. However, it is also possible to use the values—the dark and light areas—to create a sense of solidity. Imagine using crosshatched lines to indicate where light and shadow fall on the figure.

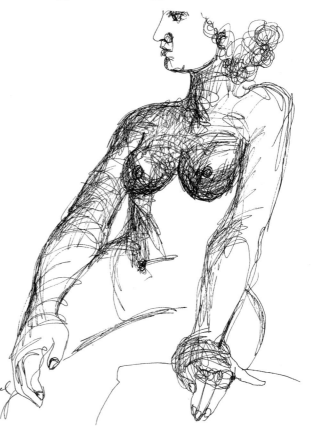

2. Directed Lines. This drawing is an example of directed lines—that is, lines that are all traveling in the same direction. In this case they are curved lines moving all over the surface of the body. These repeated lines give an interesting rhythm to the drawing and add a sense of volume to the figure.

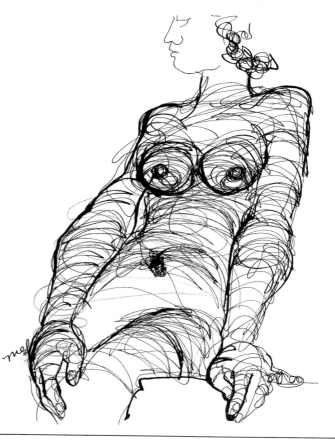

3. Repeated Lines. This drawing is a wonderful example of repeated lines and the various effects they can create. Notice the lines that make up the figure's right shoulder. There are so many lines in this area that are repeated so closely that they give the sense of being one heavy line. Thus, the weight of these lines draws attention to that part of the drawing.

In the other shoulder, one line closely parallels another. This repetition defines the contour of the shoulder, but with more vitality than one solid line. Throughout the breast and torso area there are many arbitrary lines that intersect one another, creating interesting shapes within the lines.

Notice the center line that starts at the neck, makes a jump at the collarbone, flows down the breast, and then cuts back sharply into a curve across the contours of the breast. This line illustrates how Carter's eye jumps around the figure in a fluid, rhythmic way. That particular line has a spontaneity that adds vitality to the whole drawing.

Using Sepia Ink

Sepia ink is a marvelous medium with which to explore tonal ranges and subtleties of the figure. Sometimes Jane Corsellis uses a pen for brief contour lines, but usually she prefers to use just a brush.

Starting with a pale wash, she leaves the lightest areas white and paints progressively darker, ending in an almost black. By working up to the darks in this controlled, disciplined way, she finds she can achieve a greater sensitivity and more delicate effects.

Observe that she pays careful attention to the shapes that the shadows make as they fall across the figure. While individual lines of anatomy are interesting in themselves, she never lets them interfere with seeing the figure and the background as a whole. If they break up the overall lines of the drawing, she leaves them out.

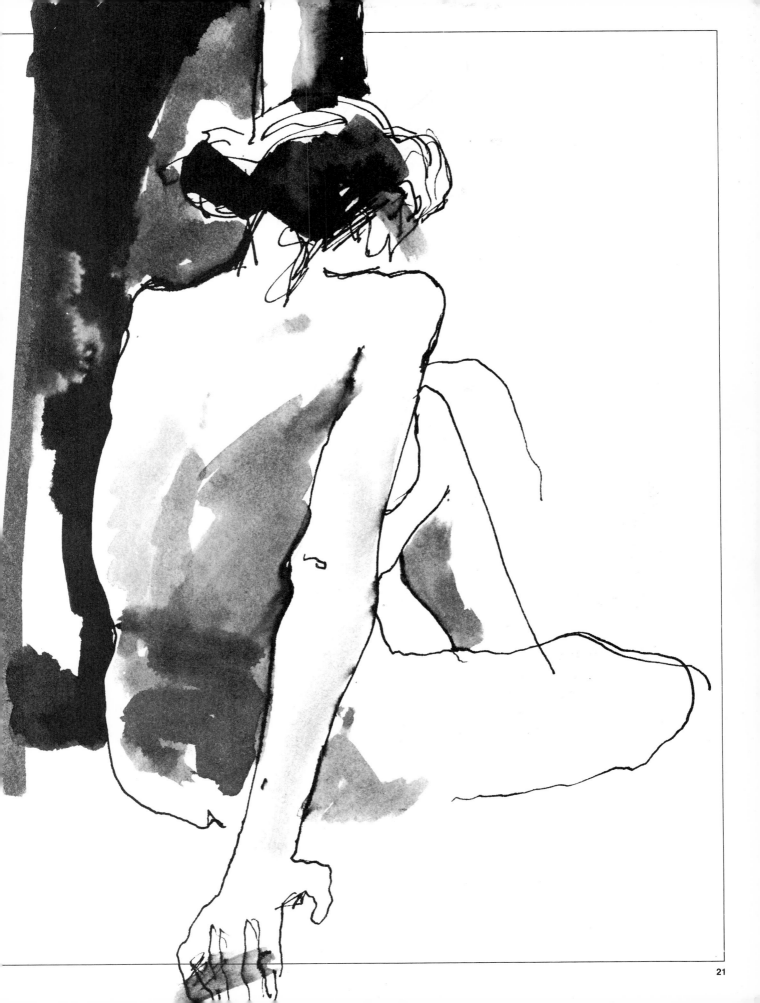

Experimenting with Charcoal

Jane Corsellis regards charcoal as the drafter's equivalent of the brush. She finds this medium very sympathetic for quick figure drawings. You can draw fine lines with one movement and block in a tonal mass just as quickly with another. If the drawing becomes too black, you can do as Corsellis does: Lift out areas using either a piece of soft bread or a kneaded eraser. White chalk can also be used in the dark sections. The drawing can progress layer upon layer and can still retain a freshness.

Corsellis often poses a model against a window. Drawing a dark, shadowed figure against a bright light forces you to concentrate on hard to see subtle changes of color and tone on the skin. She also likes the way the hard lines and angles of the windows and doors counteract the curves and lines of the body.

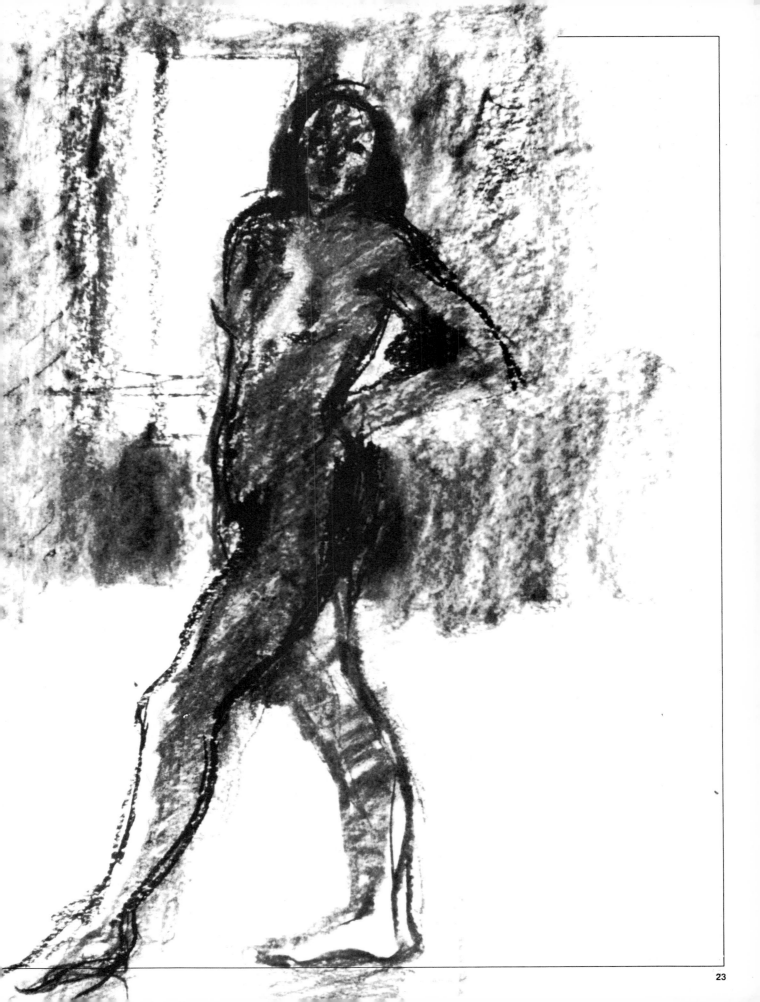

Working with the Scribble Approach

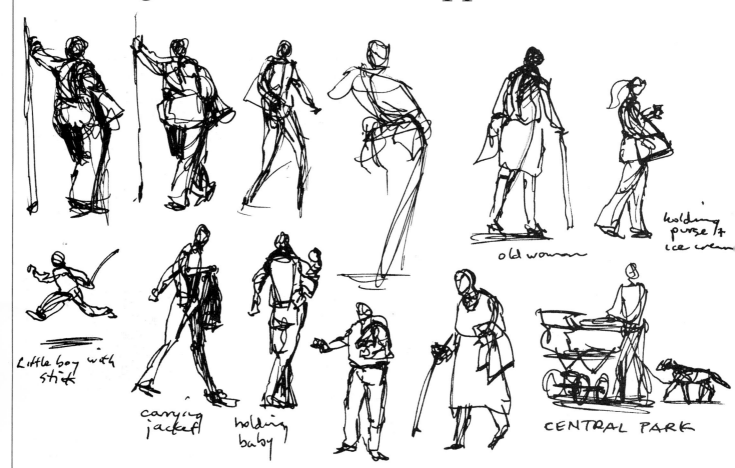

Little boy with stick

carrying jacket

holding baby

old woman

holding purse /+ ice cream

CENTRAL PARK

Use an ordinary black ballpoint pen on inexpensive paper for this kind of sketching. The ballpoint tip delivers a fluid line in all directions without needing to be refilled. Since it cannot be erased, it forces you to be more bold. Don't be afraid to make mistakes.

These sketches should be small—about 2" high. They should also be very fast. Spend only about 10 seconds on each, and then move on to the next one. You should have an entire page covered in five minutes.

Hold the pen in your hand as if you were about to write your signature. When you sketch, use only wrist and finger motions that are fast and fluid. A good way to proceed is to draw a small circle for the head, drop down through the body

to the foot, establishing the ground plane right away. Then move your line in and out of forms, letting your hand move freely.

There are only two rules. Keep the pen in constant motion, and never lift the pen from the paper. Your instincts may rebel against these rules at first, but you will discover that these restrictions will liberate your pen line.

Your goal is to achieve rhythm. Rhythm is the graceful, pleasing flow of one contour into another. Since the movement of the hand is graceful, so too is the movement of the viewer's eye. A few preliminary exercises will help get you warmed up. Start out with repeated circles in both directions; then make spirals and continuous figure-eights.

Your hand should be alert and well

trained, ready to follow the command of your memory. If you feel as though you are doodling aimlessly, then your hand is out of control. If it stops every second or so and moves in a jerky manner, you need to *relax* control. Somewhere between those extremes is an ideal balance that yields rhythmic sketches.

Once you observe a pose, the next step is to get it down fast. Allow the line itself to wander in and out of forms; it does not always have to follow the contour. Lines that would normally overlap can be shown as if they were transparent. The lady with the coat over her arm (shown second from the right on the bottom row), for example, has been sketched with the back edge of her dress visible through the coat she is carrying.

Using a Gestural Approach

Instead of using the small-scale action of your wrist and fingers, you can use the action of your shoulder and upper arm to record the fleeting impression of motion. These sketches require a much larger scale. Some people like to do gestural sketches on 18″ × 24″ pads, with just one or two individual sketches per page. Gurney and Kinkade find this size too cumbersome and conspicuous for most typical motion sketching opportunities. Instead they recommend you use an 11″ × 14″ or 14″ × 17″ pad with paper that's cheap enough so you can use up 10 or 20 pages at one sitting. Use either a brush held normally or a 6B charcoal pencil held in the fingertips of your hand in an overhand grip, with your palm facing down.

Using your shoulder makes you draw much more slowly than you would using the scribble approach. Just as if you were throwing a baseball or conducting a symphony, the motions of your hand are simpler and more flowing because they are weighted down by the lower arm. The result will be a feeling of more smoothness without the immediacy of the scribble.

In the first lines you draw, look for the long C-shape or S-shape lines running through the center of the forms of the person or animal you are drawing, especially the line running along the spine. Draw these with simple, graceful strokes, lifting the pencil between each one. Nothing but the tip of the pencil should touch the paper; your hand should move freely.

Try this method at home first, sketching other members of your family or recording the action on TV. Note the accompanying studies were sketched as a cooperative friend put a coat on dozens of times.

Whenever you practice, consider the first three or four pages to be simply warm-up. Don't expect every gesture sketch to be a winner. Just try to reach the same balance between freedom and control that was discussed under the scribble approach.

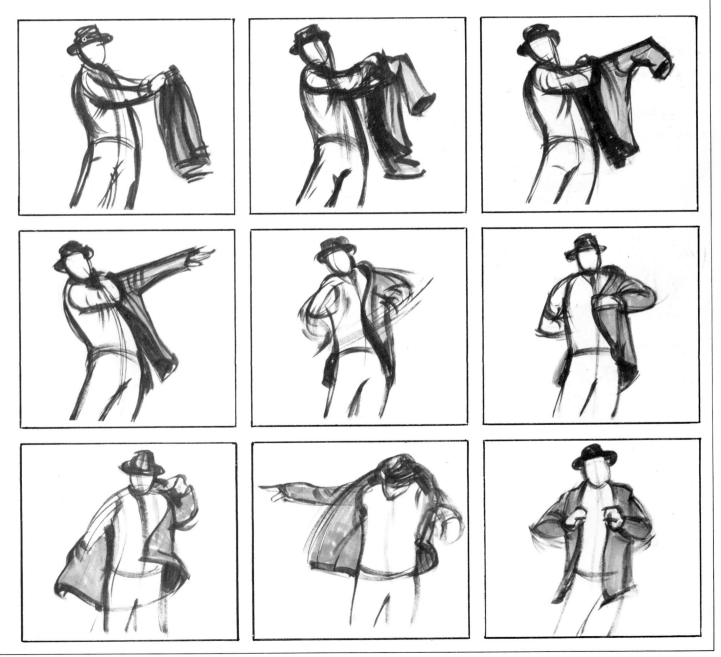

Capturing Motion with the Mannikin Approach

The human form is so complex and features so many movable parts that drawing it in motion inevitably requires some intelligent simplification. Artists throughout history have devised endless systems for indicating the human form with a minimum of lines. Most of these systems boil down to variations of the stick figures that most of us drew as children.

The mannikin formula that James Gurney and Thomas Kinkade use most often consists of a stick figure with three basic body blocks: an egg shape for the head, a large rectangular block for the ribs and shoulders, and a smaller block for the pelvis. These simplified forms correspond to the basic immovable units of the actual human body. When connected by a single, flexible line representing the spine, they can be made to bend or twist into practically any imaginable position. The arms and legs are represented by nothing more than line segments, indicating only general direction and proportion. Simplifying the forms in this way helps you concentrate on the degree of tilt and twist of the body. This sense of twisting, bending dynamics is what makes the figure seem to be alive and moving.

To use a mannikin to capture the gesture of a moving figure, simply catch a single impression in the manner Gurney and Kinkade described under the scribble approach and then look at your paper and translate it into the shorthand terms of a mannikin. With the legs and arms represented only by line segments, all you have to remember is the *direction* they took in the original pose. You can ignore the outer contours, the muscles, and the folds of clothes.

After capturing a gesture in this manner, you can elaborate on the sketch to any degree you like. Gurney and Kinkade generally use tapered cylinder forms to indicate the full volume of arms and legs, as they did with the jogging figure in the lower left of the drawing. Any additional drawing you do over your initial mannikin should be based on your knowledge of form combined with whatever observation relates to that pose. In other words, after you sketch a simple mannikin, you can construct the basic forms of the body using what you know about how arms, legs, and torsos look. Adding clothes comes last, after you've established the

underlying forms. The clothes you draw can be a pure invention or borrowed from other figures. You can adapt one person's pants, another's jacket, and still another's hair.

The mannikin approach can be modified for use with animals. Like humans, animals can be simplified into three basic rigid body forms—the head, rib cage, and pelvis, which are constructed around the spinal cord. The limbs and tail can be indicated simply as line segments.

Using Tonal Mass Approach

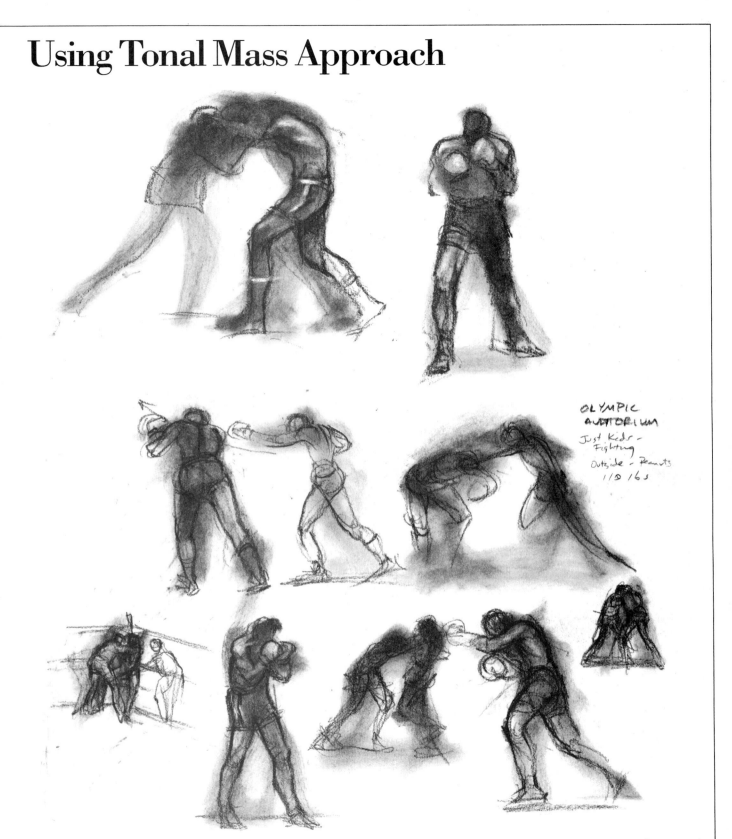

OLYMPIC
AUDITORIUM
Just Kids -
Fighting
Outside - Peanuts
1/10/65

The tonal mass approach involves scrubbing in a general silhouette of your subject using either a cotton ball rubbed with charcoal or a broadtip gray marker. First, capture a quick impression by closing your eyes and retaining the after-image. Now look immediately at your paper and begin stroking with your scrubbing tool. Make sure your shapes represent the cores of the forms, building from the inside out. Continue until you have captured a crude suggestion of the pose. Then using a pencil or pen, begin outlining a more accurate version on top of your tonal lay-in. You may even discover the tonal underlay actually *suggests* forms to you!

You may want to make several tonal mass lay-ins before overdrawing. The secret is to be as loose as possible and not think too much. This moody approach can also be used with trees, landscapes, and manufactured forms.

Sketching Outlines

Plan your outline drawing carefully. Think about and study your subject before starting to sketch.

The 5-Minute Sketch. Begin with the curve of the street. Then, as you draw the rooftops, start from the left and shape and design them so you create an exciting, abstract "sky piece."

Next, draw each house in relation to the neighboring shapes. Each part of each house is different from any other part. Note how the bases of the buildings become the tops of the sidewalks, roughly, but not exactly repeating the curve of the street. Note how these curves complement the angularity of the houses.

Place the figures carefully. A shadow on a shoulder and a darker figure become the center of interest.

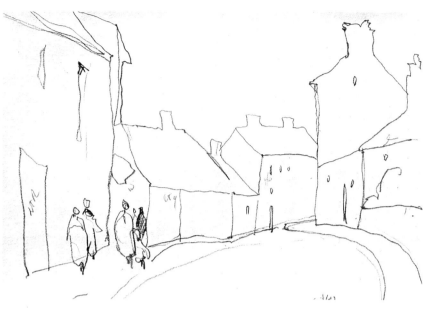

Block out the figures with your fingertips and see how the mood of the scene changes. The figures create a needed center of interest.

The 15-Minute Contour Sketch. This is an "earth piece," because the compact grouping of buildings has a good feeling of solidity. There is also a good sky shape, but the emphasis is on the earth piece.

Start by drawing the main house on the center left and complete it with windows and the lone large figure. Then draw toward you, in contour lines, the sidewalk and the two houses to complete the bottom left-hand corner. Now move over to the top right-hand corner and in contour lines draw the building down to the street. Continue working up the street, all the while designing each portion of each house in relation to its neighboring parts.

Place the figures across and up the street from the first figure. Note how this leads the eye back into the sketch, creating a concentrated area of interest.

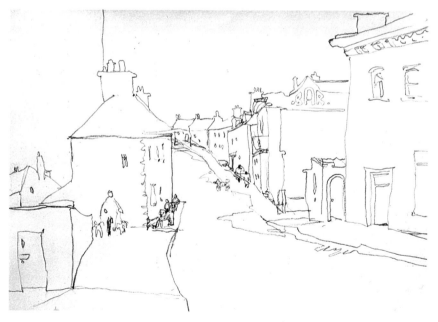

Make sure as you work up the hill to design each piece of each house differently. Also take into account the contours of the adjoining buildings.

Build up Your Memory. In this sketch work on developing your memory. Draw this as though you were spotting in the darks after leaving the site.

First, you should work for 5 minutes in simple, single-weight lines. This is to help you see the basic design of the composition in two dimensions while on the site. Imagine you're in a restaurant, watching the people moving around you.

Get a nice flow in the movement of your figures just by changing size relationships. This carries the eye up the left and across the street into the open doorway.

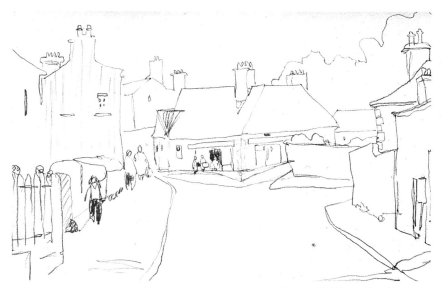

Note how the eye is led here by the placement of two dark pairs of pants. The figures then become the center of interest.

5-Minute Contour Lines. Working from the center out, sketching outlines and shapes only, pick a spot for the dark window, and draw the front of the square house around it. Draw the right side moving back in perspective. Don't fuss with vanishing points; just make an educated guess.

Next, draw in the little figure with the bucket alongside the bottom of the house. Then contour your way down into the grouping of the three figures on the lower left. Concentrate on how best to design them.

Now step back and look at what you have drawn. See how the lower figures and the one at the house are in line with each other. Can you see the beginning of an X form? You are now leading the eye of the viewer into the sketch.

With the X composition in mind, carefully design your way up to the right and then down toward the "earth line," which is the line at the base of the buildings where they meet the sidewalk. The second axis is completed by aligning the right edge of the roof with the sidewalk line. Do you see that the figures are aligned along one axis of the X?

The second axis is completed by aligning the right edge of the roof with the sidewalk earth line. The spot where the X crosses is where the last figure should be placed. This drawing is called a "vignette" because its edges are not square.

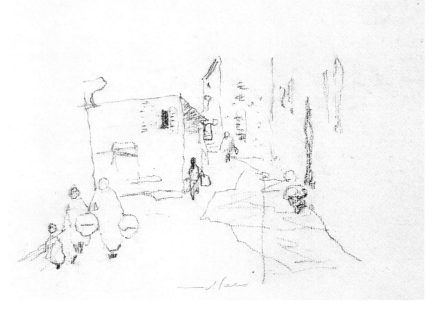

The largest figure in the foreground is placed in a classic location, a comfortable spot near the "golden section"—about two-thirds of the distance from one side or the other in a horizontal format, and similarly from top to bottom in a vertical format.

Making a Contour Drawing

Contour drawing is a valuable tool for several reasons. First of all, it can help you if you decide to paint a drawing later because it forces you to think in terms of shapes. Thus, even though you are using line when you draw, in the end you are more aware of the shape of your subject as a whole—its contour—than you are of the actual line you used.

Contour drawing also forces you to see connections between the subject and its surroundings because you are constantly working from the subject to the background and back to the subject, without lifting the pencil from the paper.

Finally, contour drawing helps you discover new ways of seeing. As a result, a student with no previous figure drawing experience may be able to create an exciting image through contour drawing. And even if the drawing is "incorrect" in its proportions, it will probably say a lot more about the model than another person's labored effort to get the drawing just right.

In fact, that's why Charles Reid likes his students to forget about getting proportions accurate, even though he does permit them to measure the overall proportions in a general way. It's impossible to get absolutely perfect proportions, and overemphasizing them, he thinks, defeats the purpose of doing a contour drawing.

So just relax as you draw and don't try to be exact. You're not a camera. You're an artist trying to express what you see. And self-expression and correctness don't necessarily go hand in hand. Here's a general idea of how to proceed.

Step 1. You can start the drawing anywhere you wish. In this case, Reid starts with the eye and completes it before he goes on, but sometimes people start with a hand or foot. Experiment with different starting places. The results may be strange, but the experience may force you to break old habits!

Now, working with a fine pen (a No. 2 office pencil, Pentel-type pen, or ballpoint pen will work well too), Reid draws the shape of the model very slowly. Wherever there is a change in direction, he stops—without lifting his pen from the paper—and decides where he's going next.

Drawing a contour does not only mean recording "outside" shapes. You can also record the outlines of form within the model too. In fact, notice that Reid draws "into" the boundaries of the figure whenever he can—the mouth, collarbone, shadow or cast shadow, and toes. He also avoids staying within the outline of the figure by bringing his line "out" into the background wherever the figure touches a picture or chair. For instance, when he gets to the chair, without lifting the pencil, he draws its shape and then returns to the model's form and continues to draw, working down to the feet.

Note also that he makes a mistake. He makes a new line without changing the first one. And when he reaches a dead-end—on the inside of the model's right leg, for instance—he repeats the form, backtracking while still keeping his pen on the paper.

Step 2. As Reid continues to draw the figure, he tries to let his line "escape" from the figure wherever possible, tying the model together with the surroundings. For example, he draws the model's left leg into the chair and joins her left elbow with the background picture behind her. Most students keep their line too contained within preconceived boundaries. This is probably the hardest habit of all to break.

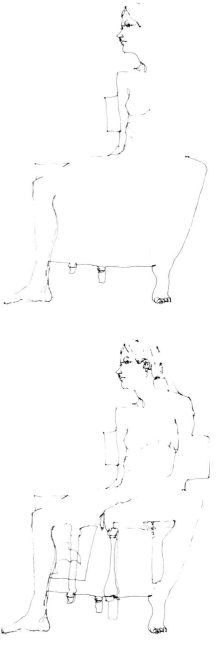

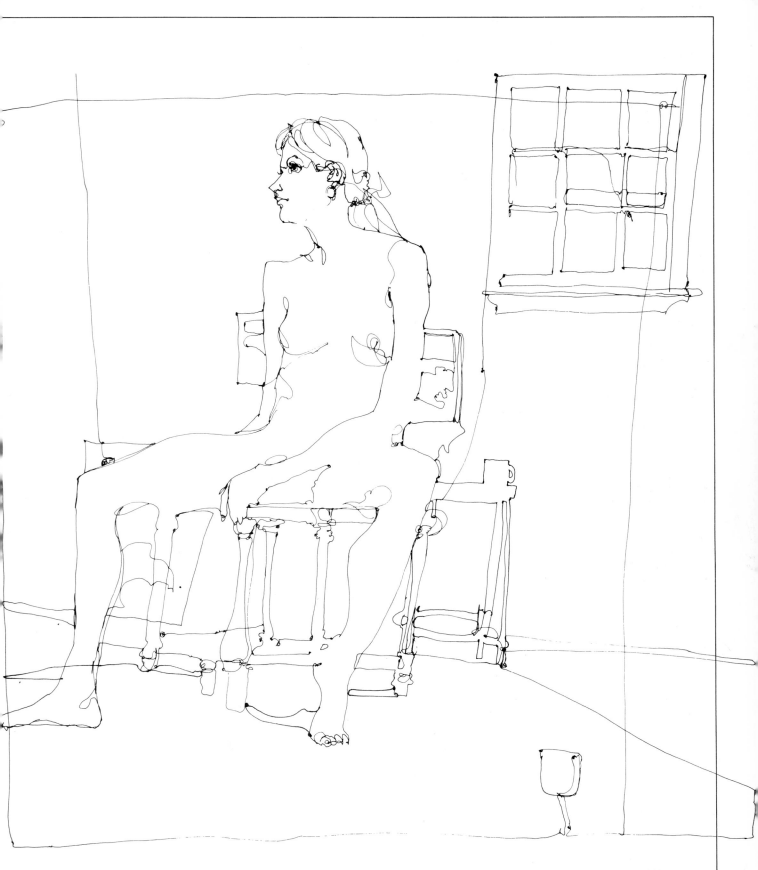

Step 3. Just as Reid ties the figure to the background in some places, he is also careful to separate it from the background in others. He does this by deliberately omitting the boundaries in various places. (Can you see where?) He also combines negative and positive drawing for additional information and variety. (Again, see if you can find where he does this.) Then, beginning with the cup on the right-hand table and gradually working from inside the drawing to the outer boundaries, he creates a border. Finally, he connects the figure to both sides of the drawing and the top.

Adding Shading Gradually

Now you can add subtlety and heighten dimension in your sketches with shading. It will bring new excitement to your work.

Add Tone to a Contour Drawing. You want to capture the radiant light of these pastel houses by the sea. This happens to be St. Tropez, but it could be anywhere!

Begin with a 5-minute contour drawing. Keep your linework light, and throw away your eraser so you won't be tempted to correct errors. Now apply tone. Make a pale, soft smudge over all the shadowed areas, saving your lights by leaving the paper white. Then rub in some deeper tones and add a few dark accents to the doorways and on parts of the three figures to attract the eye.

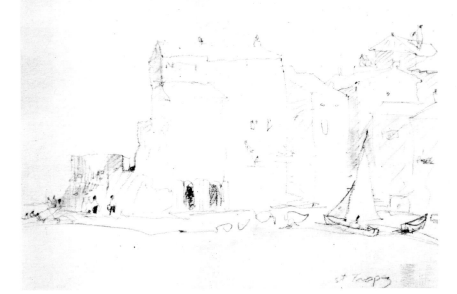

Add Tone with a Carbon Pencil. You are looking down from the cathedral grounds into the warm and cool mixture of earth tones in the old city of Cannes. You only have time for a 5-minute freehand drawing, and you choose a carbon pencil because it provides a range of tones from soft velvety grays to jet black.

There are many tones here, and each building and roof texture is handled separately. Some tones are made by rubbing and then hatching lines over the smudged tone. Others are indicated with vertical lines only. The deepest accents are solid blocks of carbon tones—first smudged and then restated.

Note the way the dark vertical pattern splits the paper. The left foreground is kept white to balance the white side of the building on the right. The uneven quality of the edges makes this drawing another vignette.

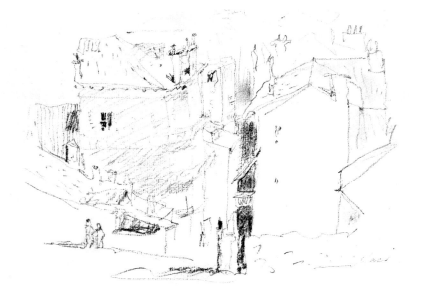

Smudge to Make Edges Soft. With a mixture of contour drawing and freehand sketching, make a 30-minute drawing of these buildings. Carefully position your figures, and hatch lines in some shadow areas for mid-dark tones.

On a separate piece of scrap paper, rub some carbon from your pencil (hold the pencil sideways as though you were sharpening it) to create a dry "smudgepot." Rub your finger into this carbon supply.

Apply soft, pale smudges to the foreground figures. Work right over the first figure. Rub alongside the second figure to soften the edge toward the shadow of the doorway. Smudge a tone over the roofs and sides of the houses, and then over the third figure from the left to move it back into the interior. Leave the next group white so they appear to be standing in the sunshine.

Washing your hands is a must after smudging!

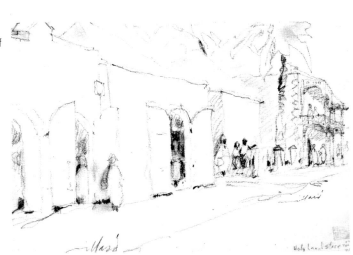

Smudge to Suggest Lighting on Figures. This is another 30-minute contour and freehand sketch. First prepare your stage set. Draw the buildings, and place some figures on the street and some on the balconies. Now you are ready to suggest the lighting.

Begin by smudging the shadows. First, put in the roof shadow, working around the figures on the balcony on the left. Then work on the second balcony, but this time bring the roof shadow down over the heads of the figures there. The result? The first group of figures are frontlit, while the second group is in the sun from the waist down. They seem to recede into the distance.

Now work on the figures in the street. The figures on the left are mostly frontlit, though a few are in the shadow of the doorway. The woman with the basket on her head is partly in the shadow of the overhead sign. This is the center of interest. The figures on the right should be backlit. Throw shadows over their bodies to show this.

Create Tone with Directional Lines. Study this 30-minute freehand sketch. Notice the variety of directions the lines take in different segments of the sketch. For example, the edge of the rooftop on the left is created by lines that come from the branches of the tree *behind* the roof. An eave is formed where a series of horizontal lines end.

Note that a middle tone connects all these buildings, creating a unity of pattern. Each building or part of it is treated with care and affection. Learn to love your sketches!

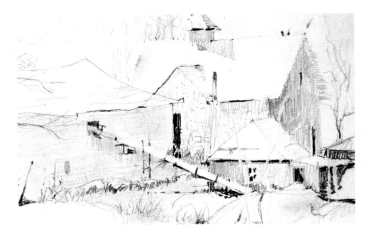

Adding Simple Tonal Washes

Before you start working with washes you should know that David Millard swears by the Winsor & Newton Series 7 sable brushes sizes 1 to 14. The size you need depends on the size of your watercolor sheet. For full sheets (22″ × 30″/56 × 76 cm), you'll need Nos. 9, 10, 12, and 14 brushes, as well as Nos. 3 and 8.

Millard also uses very inexpensive Japanese bamboo brushes. They come in a variety of sizes and hair such as fox, squirrel, bear, or wolf. Try painting with them and see how they suit you. Start with a set of ⅛″, ¼″, ½″ diameter, and if you like them, then get a more expensive 1″ diameter "horse." It seems as though it can hold a cup of water in its hairs and is marvelous on a full-sheet floral. Millard also recommends a No. 8 Delta Finest Selected "natural" curved French bristle oil brush for special edges.

Hold your work at a 5-degree angle; you should always do this when laying a wash. Starting at the upper left (if you're right-handed), paint the face of the backlit houses. Then, on the right-hand side, paint the area facing you. Leave the space between these houses blank, saving the whites. Remember to design as you paint.

Complete your washes, carefully checking the illustration each step of the way.

Determine the Light Direction. Select a composition for your first color wash. Rather than choosing round forms, pick a *cube*, where the light direction is more obvious. By adding a wash to the shadows, you can show form, change your sketch from flat to three-dimensions, and practice laying washes. Always study your drawing to see which way the light should come before you add shadows. Perhaps you may find a better design of light than the one you see here.

Add Shadow Washes. Mix up a puddle of shadow color—more than you think you'll need. Use a combination of cobalt blue and raw umber.

The sun is coming from the left in a morning side light. Paint a red dot in the upper left-hand margin of this sketch as a constant reminder of the direction of the light. It may look strange, but this little red dot is David Millard's secret of success. It has helped him prevent many a spoiled watercolor.

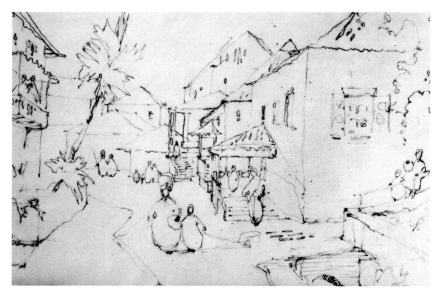

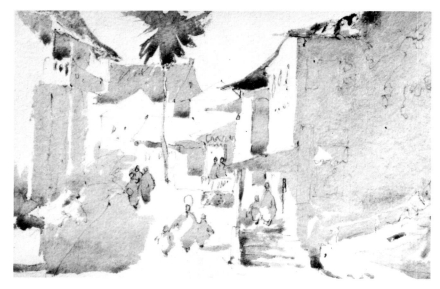

Prepare a Drawing for Front Lighting. You can suggest shadow on the sketch itself to help you place your washes. For example, the shadow between the two left-hand houses is noted with continuous lines. Another shadow farther down the street is indicated with darker lines, while spaces are left open in between. And there are dark accents—like the ones under the balcony and behind the figures—to describe the deepest values.

Add a Darker Wash. Here's a similar scene with the shadows painted in over a 20-minute contour sketch. Again, begin with a big puddle of shadow wash (the same colors as before) and paint left to right across the sky, around the rooftops, down to the upper windows and balconies. Then work at street level, cutting around the posts. Remember that you're designing every inch of the way. Then let everything dry.

Now put in the dark wash. To your first puddle, add a bit of ultramarine blue with a touch of ivory black to give you a darker, richer tone. Apply this second wash to the mountain top and a few selected dark spots around some balconies, an awning, and the heads of the two figures.

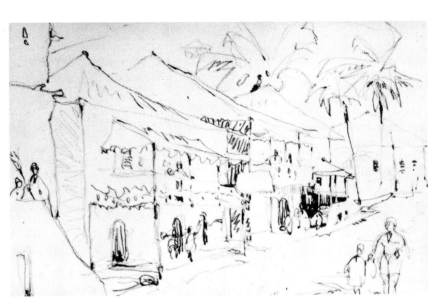

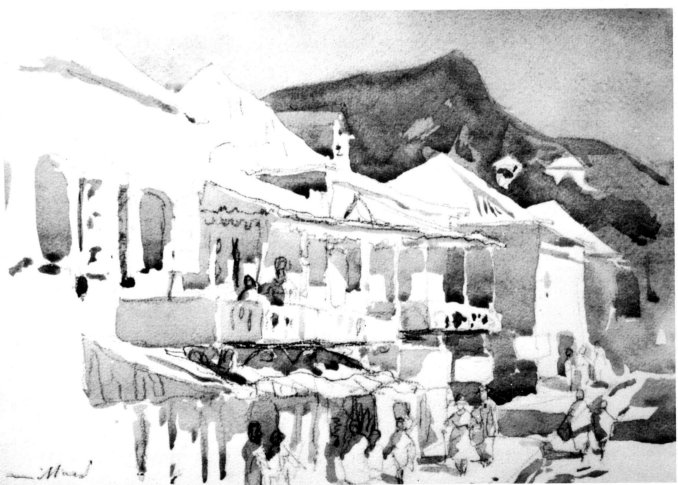

Emotional Speed Sketching

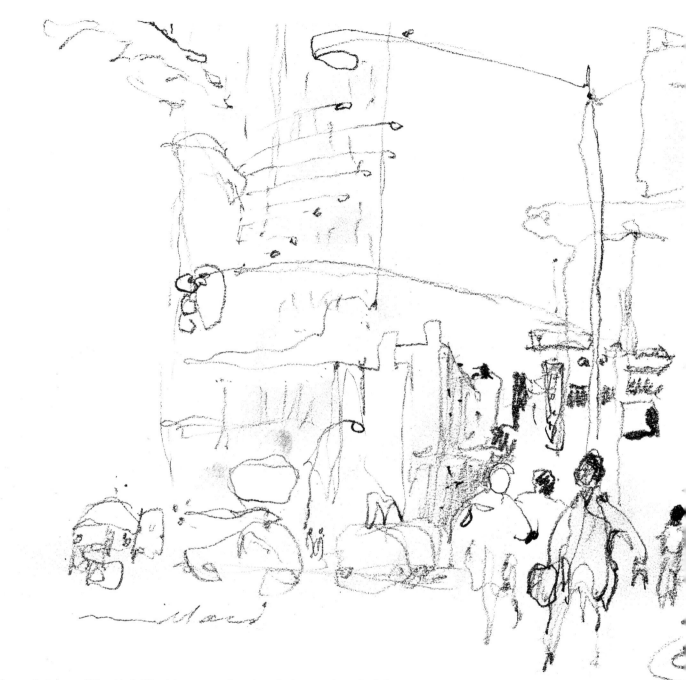

In these sketches of New York City, let your emotion show in the style of your line. Your goal is to capture the essence of the subject. Don't let yourself get bogged down in details. Hold yourself to five-minute sketches.

Five-Minute Sketching. Your first impression is of the enormous volumes rising vertically, creating various angles of perspective. Your second thoughts are of the monochromatic warm and cool grays in the city's great backdrop of buildings. Treat this like a stage setting.

Start this sketch in the left-hand corner following the curve of the marquee lights as they sweep your eye into the street scene. Build your way from left to right as you move across the array of

signs, buildings, and taxis. Be aware of creating a "canyon" effect as you build this set and prepare to put in your characters. Figures are scattered everywhere, but you decide to make one group your center of interest. Put this group in front of a simplified area to create a spotlighted effect.

Place your darks in a very carefully thought-out design pattern, making deep carbon accents on selected heads and a piece of the curb. That's all it takes. Note that the dark angled cornice on the right leads the eye into the strong vertical and down to the figure group. If you follow what your eyes see and place dark streaks and smudges at random, you'll produce a drawing that has been done to death. Remember when placing darks, less is more.

Emotional Sketching with a Pen. Now try speed sketching with a pen. David Millard recommends a Papermate black ink, fine-point, felt-tip. In this scene he finds the multilayered effect of fan-shaped negatives and that odd-shaped piece of white, rising six stories, a real challenge.

Do the two cranes first and then move down the right side of "Calcutta" and "Live Girls XXX" to the varied signage and on to the bus, car, and two pedestrians. Next, locate the top floor and verticals, fanning out from there with the negatives and other darks around the several white segments. Finish the sketch as the light changes to "walk," with a little flood of vaguely suggested people and car shapes.

Millard particularly likes the angles of the cranes, which counter the flow of the white shape and repeat the flow of the signage, traffic, and people. His title for this sketch is *Broadway Angles* (not *Angels*) or *New Hotel . . . Going Up?* He recommends that in addition to making color notes in the margins to help you remember some of the colors for your paintings, you get in the habit of naming your paintings at the sketch stage. He believes it helps paintings incubate in your mind.

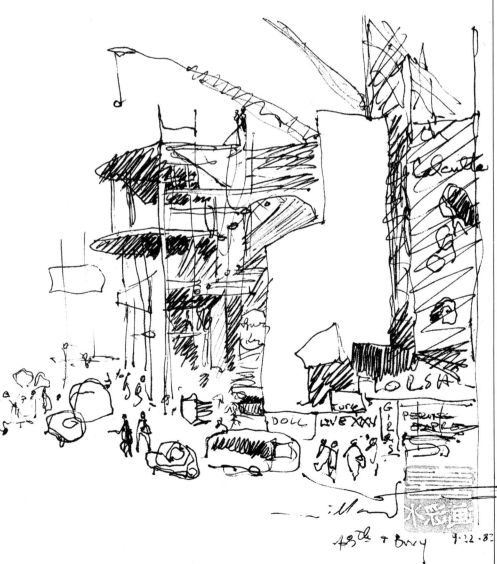

Designing the Sketchbook Page

You see a market coming into view that looks interesting. You want to sketch it quickly, so you should plan to leave room on your sketchbook page for a number of sketches.

Working Out Ideas. Squint your eyes (always keep squinting your eyes before you sketch). See how a pattern of light is made of the roofs as well as the sky. Now see how all the dark mass is pulled into one major tonal shape where all the street figures and the various buildings fall into a single unit. To be able to paint this means you have to sketch like a painter thinks!

As you move in on your subject, make a note of that odd and interesting "gull wing" roof and catch those figures quickly. You've got just a few seconds or they'll notice you and disappear. Don't try to sketch at close range. It's an invasion of privacy and will likely be resented. Instead, train your mind and draw from memory.

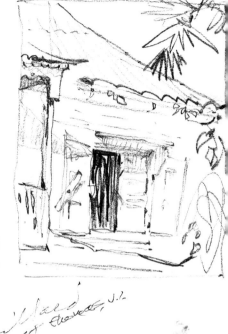

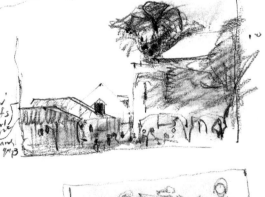

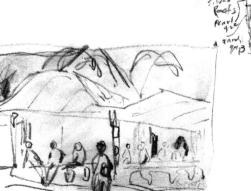

94.78

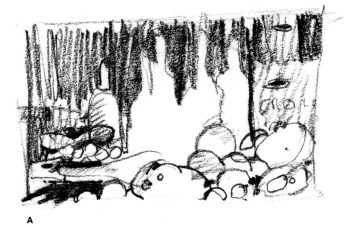

A

B

C

D

E

F

Working in Your Sketchbook.
You want to gather material for an hour or two, so start at the top left, leaving room around each sketch, and work down the left side of the page. (A) There are bottles of native juices and local vegetables with their unusual beauty. Commit the colors to memory or make a few notes. (B) Some attractive hand-woven hats make an intriguing design. (C) Catch that detail on some balconies as you meander. It might come in handy someday.

Now draw down from the top right: (D) There's an interesting couple in a doorway; be sure to catch them. (E and F) Fill out your page with odds and ends. Select material that you think might be useful to have for a future painting.

STUDYING YOUR SUBJECT

Sketching is a quick and economical way for the artist to observe the ever changing aspects of nature. Over the course of time, sketching can sharpen the artist's eye, hand, and mind.

In this section of the book, peripatetic artists James Gurney and Thomas Kinkade demonstrate specific techniques for effectively capturing plants, clouds, landforms, and water. Rudy de Reyna finds the outdoors an ideal subject for sketching and shows you how charcoal's ease of application makes it an excellent tool for working outdoors. David Lyle Millard teaches you how to sketch people who are moving about by combining a rapid contour line with a freehand sketching technique. Norman Adams shows you an easy, effective way to draw animals by first reducing their bodies into simple geometric shapes. Charles Reid, Shawn Dulaney, and Kim English bring to you their combined expertise at drawing the human figure; they illustrate ways to capture action poses—from simple walking figures to the exuberant gestures of the dancer.

Studying Plants and Trees

Plants probably attracted you early in your development as an artist. Can you remember your first careful drawing of a flower or a tree branch? That's why plants are a good place for the nature sketcher to begin. Of all the forms of nature, plants are the most forgiving when it comes to inaccuracy. They are also static, allowing you to concentrate on form without being distracted by motion. Most of all, plants are accessible no matter where you live.

Choosing your subject matter is an important factor in sketching plants. Most students try to tackle something large and complex like a tree and then proceed to detail leaf after leaf. Before long the sketcher feels frustrated with the confusion of detail and often resorts to technical gimmickry to finish the sketch.

The way to avoid this problem is to begin with simple subjects. An acorn, a leaf, a branch with a few leaves on it, even a carrot from the supermarket are all ideal. James Gurney and Thomas Kinkade recommend you begin with a pencil on smooth paper. Use the pencil directly on the paper, following the contours of your subject as carefully and patiently as possible. When you draw branching or leafy forms, it helps to think in terms of construction. Draw the central stem first, and then add the adjoining twigs and leaves. If you do this you will be sensitive to the way the plant actually grows and develops. A sensitivity to structure gives you confidence as you draw by helping you understand what you are drawing. It seems obvious, but you would be surprised at how few artists remember to do it.

This plant, found in a vacant suburban lot, provides a fascinating example of the structure of roots and the arrangement of leaves on a stalk. Kinkade begins with a simple pencil underdrawing, making sure to work large enough so he can capture details, but not so large that he loses a sense of intimacy with the sketch. Then he works slowly in ballpoint so as not to loose accuracy. Delicate tones are added with a 2H pencil.

BROKEN UPPER STALK

color modulation greenish
because of above tan
ground shoot

DIRT CLOD
details on lower
root structure

ROOT FORMATION
found in lower Arroyo
DCTS: MARCH 1981

An excellent approach for sketching a tree is to render it in silhouette only. This means that all the forms are drawn in black, as if they were cut out of paper. This is one of the easiest ways to sketch a tree, because you don't have to worry about overlapping, outline, or light and shade. All the large masses of leaves fall right into place, and the overall shape of the tree—the primary and secondary branches—comes across very clearly in the drawing.

Here's how you go about it. You can select any tree, as long as it stands clearly against the light of the sky. In a grove or a forest, you may have a difficult time seeing where one tree ends and another begins. But at dusk or early morning, in a park or a field, the conditions are ideal for seeing the silhouette.

Be sure to sit far enough back from the tree so that you can comfortably see the entire form without turning your head. Gurney and Kinkade find the best medium to use is brush and ink because it allows you to vary the thickness of your line quite easily, which is a real advantage when you are drawing tapering branches or palm fronds. The brush can also be used as a stippling tool to suggest masses of leaves. Be aware not only of leaf masses, but also of "skyholes," the areas in which you can see the sky behind the tree. In nature there is a judicious balance between the sparse skeleton and the opaque lollipop. Pay attention to balancing these two tendencies and your trees will look convincing.

Save these silhouette studies of trees. They will be valuable to you when you do landscape paintings in the studio. As a result of your tree studies, you will have engraved in your mind some of the basic rules that nature has established. For example, you'll intuitively remember next time you draw or paint a tree that a branch tapers gradually along its course, thinning at each point where another branch splits off from it. At the same time, you will be acquiring a sense of the enormous variety of tree shapes. You don't have to know the Latin names of the trees or get involved in any extensive botanical theory for this study to be meaningful. In practice this new knowledge will help you evaluate your work and enable you to see what "looks right" or "looks wrong." If your interest carries beyond that into the area of research, by all means pursue it.

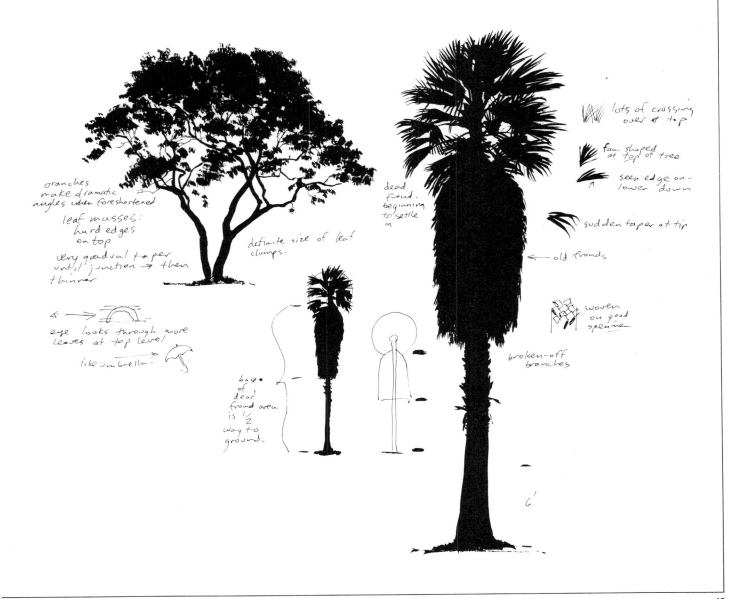

branches make dramatic angles when foreshortened

leaf masses: hard edges on top

very gradual taper until junction → then thinner

eye looks through more leaves at top level like umbrella

definite size of leaf clumps.

base of dead frond area is ½ way to ground.

dead frond, beginning to settle in

lots of crossing over at top

fan-shaped at top of tree

seen edge on— lower down

sudden taper at tip

old fronds

woven on good specimen

broken-off branches

Sketching Clouds, Landforms, and Water

What is required for sketching things in constant motion is that your eyes must learn to work like a camera. After following the motion closely, you choose a "snapshot" or "frame from a movie," record it in memory, and transfer it to paper.

Clouds. A good technique for cloud sketching is pencil and white gouache on gray or brown paper. The middle tone of the paper corresponds to the value of the blue sky, allowing you to develop the lighter tones of the cloud with the white gouache. Otherwise, using white paper, you would have to draw around all the light values and laboriously establish the middle tone of the sky. Using tone paper also lends itself to very fast rendering, since most clouds change drastically in as little as 10 or 15 minutes.

Study the clouds you have chosen to sketch. What direction is the light coming from? Where is the separation between the light side and the shadow side of the clouds? How close is the value of the shadow side to the middle value of the sky? How are the major masses arranged? Now you can begin by lightly indicating these forms with your pencil; this should provide only a reference for applying paint. Gurney and Kinkade

favor a fairly hard (2H or 3H) pencil to avoid making dark lines on the paper.

Begin applying gouache with a No. 4 red sable or sabeline watercolor brush. Experiment with different ways of working with the paint. It helps to apply the paint fairly dryly to avoid going too opaque too quickly. You'll want to save your pure whites for the brightest accents of sunlight on the clouds. If you have difficulty achieving enough softness with the gouaches alone, use a white pencil like a Carb-Othello or Conté white.

Be aware of unusual cloud sketching opportunities. If you can, pick a window seat on a daytime airplane flight for a magnificent view of the clouds. You can observe the variations in altitude of different cloud types, the boiling masses of a thunderstorm, or the rippled texture of an ordinary overcast cloud layer seen from above. Here, you may want to rely on white chalk or Conté crayon on toned paper or else simply use a ballpoint pen or pencil on white paper. Since you are moving so fast, you will have to limit your observations to very quick two- or three-minute mini-studies.

Rocks and Landforms. While you may not consider geological forms as being in

motion, once you begin to sketch them, you will become sensitive to the variety of cracks, structures shaped by weathering, and contrasting textures, such as the jutting angular forms of rocky outcroppings next to the rounded shapes of stream boulders. Sketching actual rock forms will also guide you in any landscape work you do in the studio and allow you to rearrange and compose rock forms while keeping them convincing looking.

The technique you decide to use depends on what aspects of the rocks you want to concentrate on. A patient line drawing will reveal the cracks and contours of your subject. If there is a clear source of sunlight, you might want to concentrate more on form and texture. With larger rock forms, like the face of a cliff or a pile of broken rubble, it helps to conceive of your subject in simple geometric planes. This will lend an overall solidity and authority to a sketch. To do this, look for the basic blocklike forms in your subject and sketch it in these simplified terms. Cubes and pyramids are the forms most often found in all kinds of geological structures. After establishing this basis you can concentrate on textures and subforms.

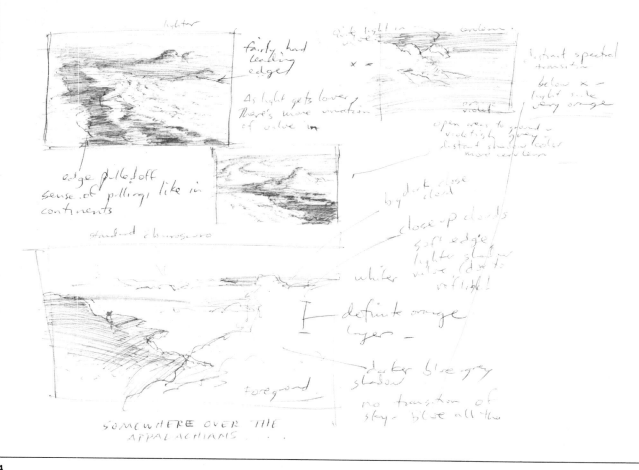

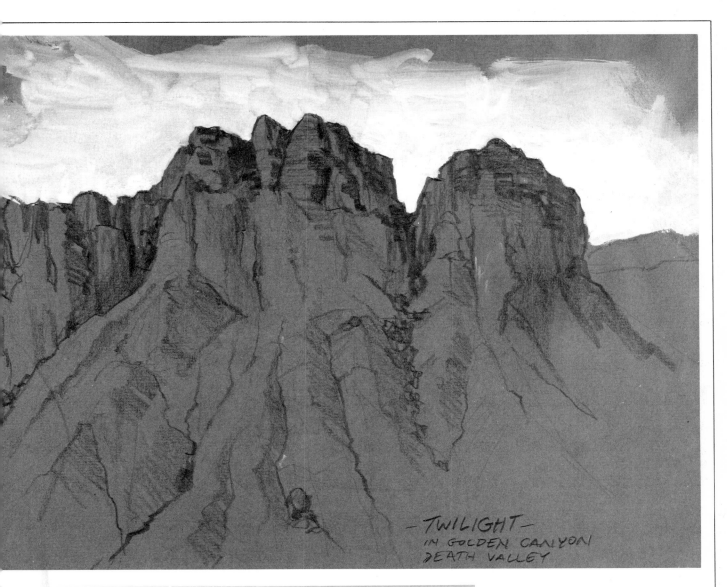

—TWILIGHT—
IN GOLDEN CANYON
DEATH VALLEY

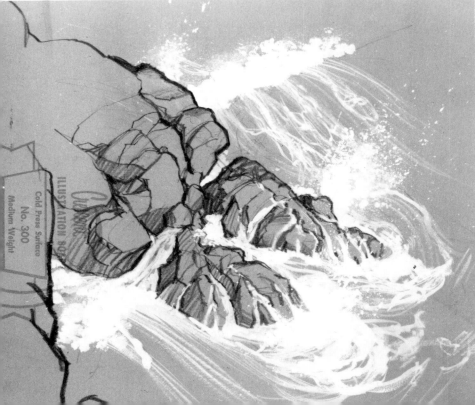

Breaking Waves. Waves have incredibly dynamic and variable motion, with distinct phases, occurring in a cycle as the wave forms a crest, breaks, and washes back out. The first step is to watch the wave cycle for at least five minutes to choose the action that best conveys the entire feeling. James Gurney decides on the moment after the wave breaks and passes the leading edge of the rocks, with the spray flying into the air and the remaining water rushing back down into the crevices. He treats the rocks in a planar shorthand to show their structure simply. He applies gouache with a No. 8 round sable watercolor brush, using dry gestural strokes along the back of the waves and a generous stippled texture along the foamy leading edge. He applied the spray by loading the brush with paint and snapping it downward.

Working with Charcoal Outdoors

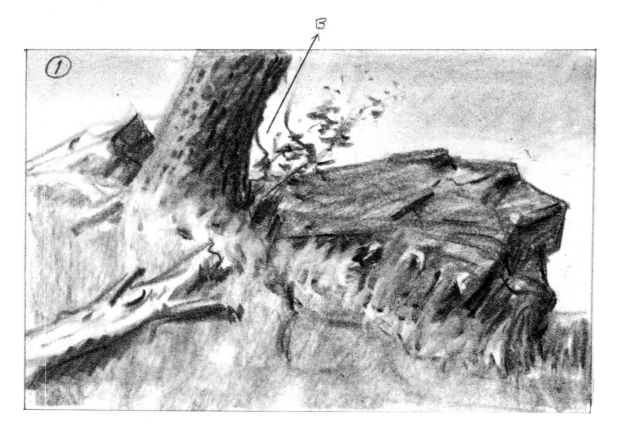

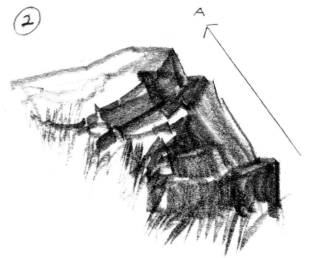

Charcoal is well suited to drawing outdoors. It's pliable and versatile, producing a wide range of tones and effects from delicate to bold. Charcoal also facilitates the speed necessary for rendering endlessly changing forms. You can quickly spread charcoal over a large area to produce a tone. Or you can lighten it by rubbing the tone with your fingers or a chamois cloth, or you can eliminate it altogether. Just remember that because a charcoal sketch can be so easily affected, you must spray it with fixative the moment it's finished.

As you begin, search out the simple, underlying geometric shapes. Charcoal's ease of manipulation lets you indicate these large shapes quickly. Then judge the proportions and interrelationships of these shapes with the other, smaller ones. Once you've captured a tree or rock in the broadest terms, you can work on the lesser shapes and intricate details.

There's one danger to guard against when rendering the large shapes of a particular subject, such as a rock. Because you're so engrossed with establishing correct proportions, you may forget about placement or composition. That's exactly what happened to Rudy de Reyna in this study. When he returned to his studio, he noticed the monotony of the rock's contour in view 1. However, the compositional problem could be easily solved in view 2. De Reyna simply slipped view 1 under another sheet on his Ad Art pad and traced parts of it, substituting the more expressive form in view 2. Note that slant A of the new rock provides the needed counterthrust to diagonal B of the tree trunk.

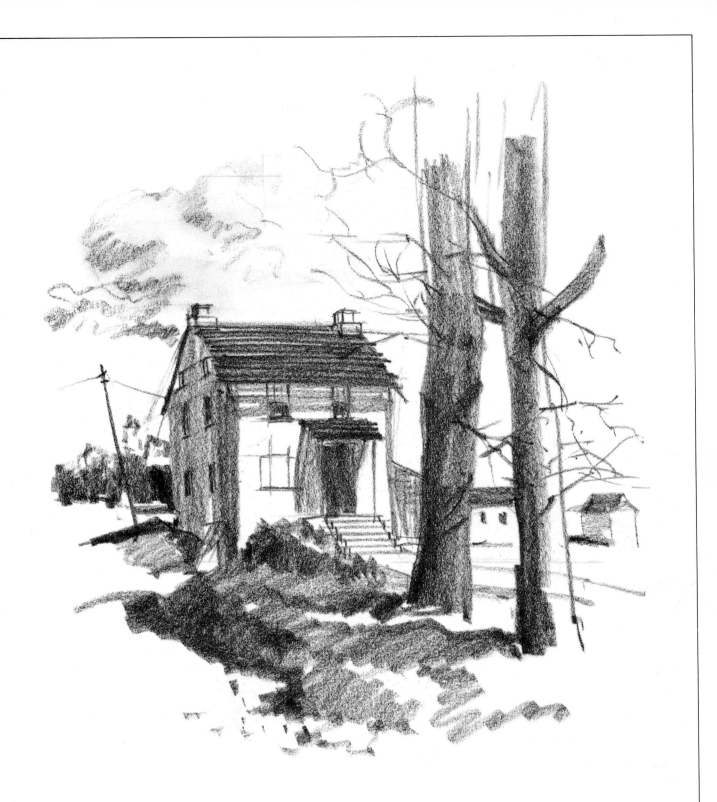

Most drawings on the spot produce what Rudy De Reyna calls "roughs," or sketches, rather than finished studies. In the latter you *study* the character and detail of a subject. In the rough, you capture only the fleeting impression of the moment, while you establish the basic proportions and relationships of the elements in your landscape. The rough should be executed quickly in a simple, flat outline of the basic forms. Only minor attention should be given to rendering particular tones or textures. They should merely be hinted at.

When you're happy with this first impression, you can then

concentrate on the edges of shadows, gradations of tonal values, and specific textures. As you work on your finished study, you may want to erase your sketch's first broad contour lines. Or you may choose to work as De Reyna does: He slips his charcoal rough under another sheet of paper on his Ad Art pad and uses that as the basis for the final rendering.

In analyzing the rough on this page before doing a final study, De Reyna thinks that he should make the trees less prominent, so they don't compete with the center of interest—the house. Making them more slender will help.

Analyzing Your Subject

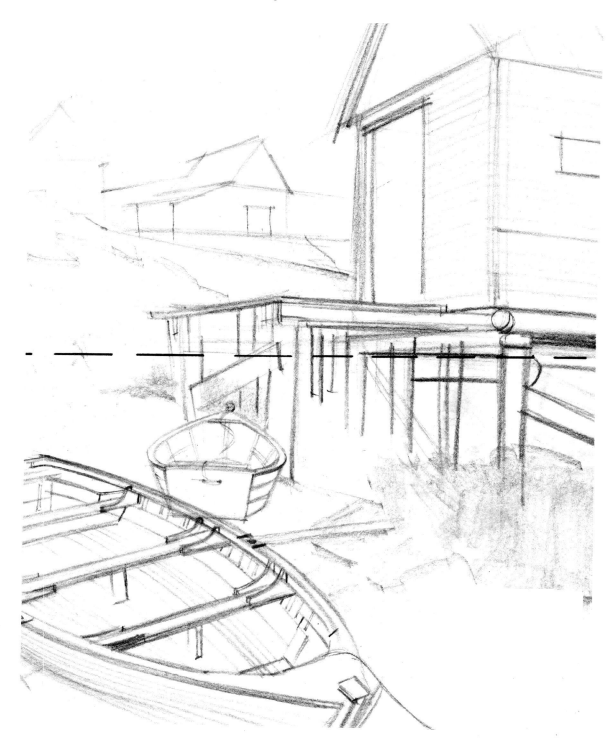

Rudy de Reyna doesn't believe in hiding his sketches that don't work. Here he starts with great enthusiasm because the shapes and textures of the seaside scene excite him. After quickly blocking in the line arrangement you see here, he notices that there are too many things going on: the background and the boats are competing for attention. He can save this by concentrating on the boats or just showing the distant horizon with the dock up front, as indicated by the broken line. How he chooses to correct the sketch is shown on the facing page.

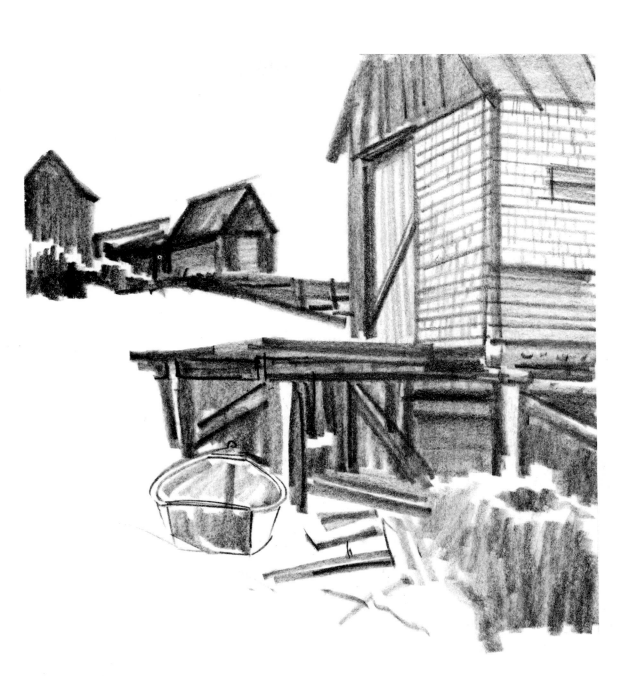

Reluctant to give up on this drawing, Rudy de Reyna slips the line sketch under another sheet of paper and starts applying tone. He only gets as far as what you see here when he realizes that his tones are coming out flat. Still, the color and textures of the scene are so beautiful—everything is pearly, iridescent, and crying out to be painted! That explains it to de Reyna: *this scene should be painted*, not drawn.

De Reyna recommends that the first thing you ask yourself is: What is it about the spot that attracts you in the first place? If it's color and you've only got charcoal, forget it. Make a note to come back later with your paints.

Sketching Your Subject from a Different Perspective

You find an excellent subject—a house on a hill. The shape of the house is good, plus it's sitting among a thousand yellow irises. Think out your color changes as you draw, and make note of them in the margin. Then sketch in the corner house in the foreground for scale, and shade it in. Place the curb and telephone poles to show the curve of the hill. Finally, locate the figures as accents.

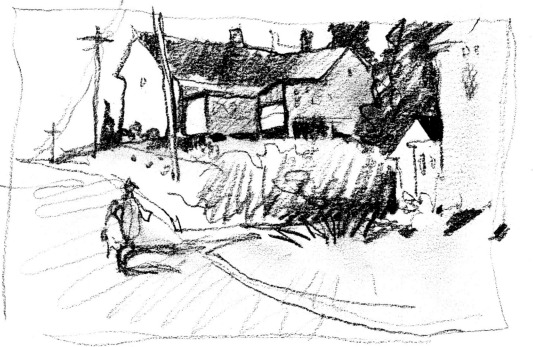

Try Another Point of View. Keep the feeling of the hilltop, even though you're now up on the ridge. Keep the sweep of the descending curbside, driveway, and staggered stepdown of the building complex. Keep the emphasis on those radically changed shapes of white.

Now change your viewpoint: Diminish the importance of the barn. Lose it in the trees. Smudge clear gray tone into the shadow sides of the house and then right across the trees and barn in a single swipe. Don't overwork your drawing. Those building shapes are so exciting, you don't need figures!

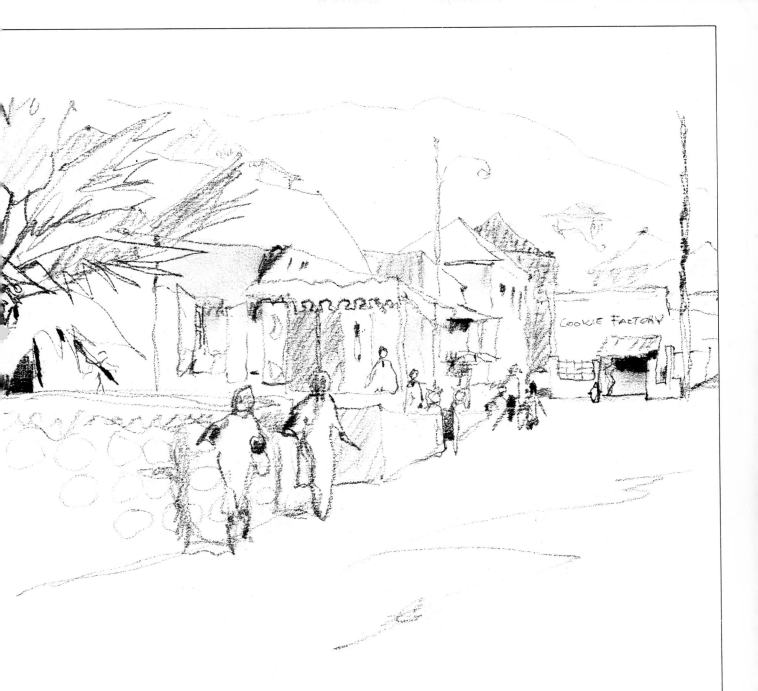

David Millard likes to work with a carbon pencil because of the range of blacks it offers—from the gentle to the robust. Hardt-muth, Rowney, and Conté are three brands he recommends.

How to select a subject and capture its feeling and mood with the mind's eye are what's most important to Millard in a sketch. Achieving a poetic or musical stance in your interpretations from reality is what Millard feels is most important.

Here are three things he suggests you remember as you draw:
1. There is a design pattern in everything you sketch. Look for it, and be sure it's in your work.
2. Every sketch should be thought out as a plan or structure for a future painting.

3. Your sketches reveal your initial responses to a subject. This emotion and each of your interpretations of it will inspire future paintings.

Lead the Eye Down the Street. In this sketch the decreasing size of the figures and buildings follows the laws of perspective. But don't worry about being too precise. Guess at the vanishing points. Notice the three-dimensional effect you get from alternating shapes and well-designed patches of clean gray tones. Millard uses that line in the street as a deliberate device. Block it out and see how you lose the magic in the scene.

Studying Animals Close at Hand

Sketching animals is a lot like fishing: you never know what you're going to catch. You have to learn to be a sly, alert, resourceful observer. You should cultivate a kind of confidence that will keep you undaunted by any failure that you might experience. Every bad sketch provides a dozen good ones with the lessons that it gives. So if you are like most people, you like animals but have never really taken the chance to draw them from life. Take the opportunity now. In no time, your drawing ability will surpass that of those who rely on the snapshot or who resign themselves to drawing only subjects that never move.

Your pet dog or cat has as much to teach you about the animal kingdom as anything else. All mammals share the same basic structural plan, which assumes a variety of manifestations from one family to another. For a fully detailed examination of animal anatomy, you can turn to any of several excellent books currently available, but for now at least be aware that the experience you gain sketching a dog or cat is transferable to other animals.

James Gurney and Thomas Kinkade recommend that you keep a small sketchbook on the coffeetable to record any of your pet's poses that strike you as interesting. Whenever it bites a flea, or curls up by someone's feet, or stands with its nose in the dinner bowl, be ready. On this page Gurney finds the overall structure of the dog's head interesting from a variety of angles. A lot of quick two-minute impressions such as these can be as valuable as a single long, involved study, because they solidify your understanding of the simple shapes. In any case, if you or your children have any pet, be it a bird or a frog or a fish, you've got a handy model for animal sketching.

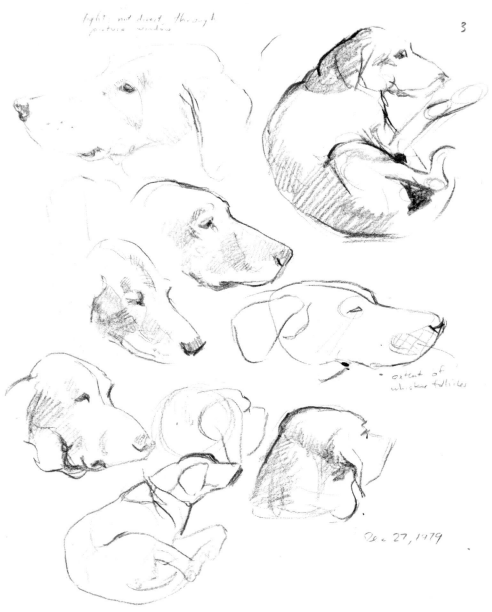

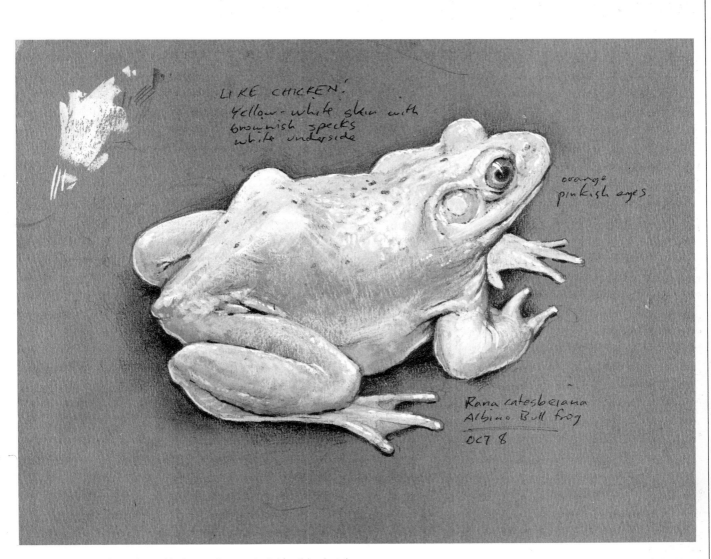

A spare piece of mat board is the perfect material for this sketch of a pale yellowish albino bullfrog that James Gurney discovers at a friend's home. Using the white gouache very thinly at first, he builds up the planes that face the light so they re lighter than those facing downward.

Gurney saves his pure white for highlights on the pelvis and the eye. After modeling the whites, he uses a soft graphite pencil very sparingly to add darks inside the eye and underneath the belly, as well as occasional accents throughout the form to suggest creases and spots.

Sketching at the Zoo

The zoo is a paradise for animal sketching because it offers you a chance to see, close up, a variety of animals not usually seen elsewhere. You can observe not just the *forms* of the animals, but also their behavior. During a good day at the zoo you can expect to bring home about eight or nine pages of sketches of varying quality. Students frequently report that at the zoo they are able to have a breakthrough with something that has been frustrating them. In exchange they are intrigued by a new challenge that had not interested them before.

Most people make the best early progress with elephants, camels, and rhinoceroses. There is no question that these are among the most fun to draw, perhaps because of their clearly defined forms or their rather comical appearances. These animals are also rather slow moving and seem to have a kind of patient understanding of the sketcher, obligingly holding very awkward poses, while eyeing you curiously as you draw.

This crocodile provides such a model for James Gurney. One of his favorite tools for careful studies of line and texture is the ordinary ballpoint pen. In this sketch it proves just as useful for the quick sweeping lines on the crocodile's tail as it is for the scaley skin texture on the close-up studies. In addition, the ballpoint is perfect for adding written notes that Gurney always makes during his nature studies. The closest equivalent to the ballpoint pen is the #2 office pencil; but unlike the pencil, ballpoint pens never need sharpening!

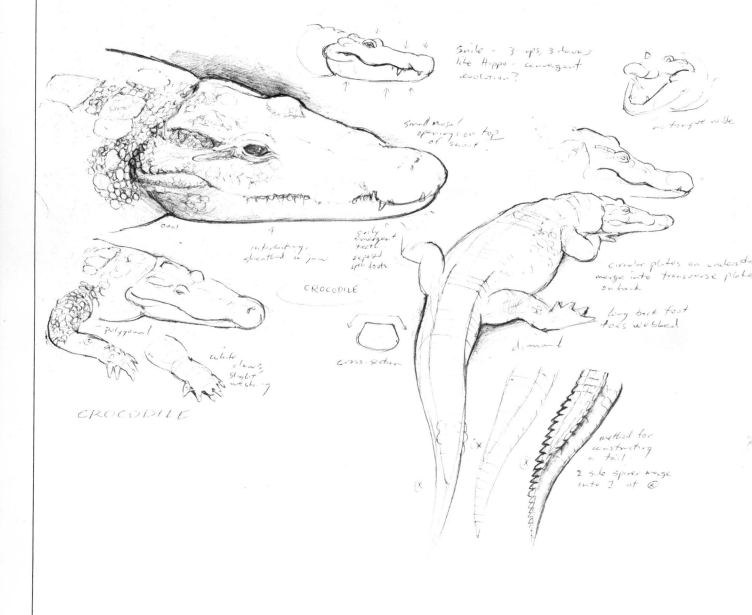

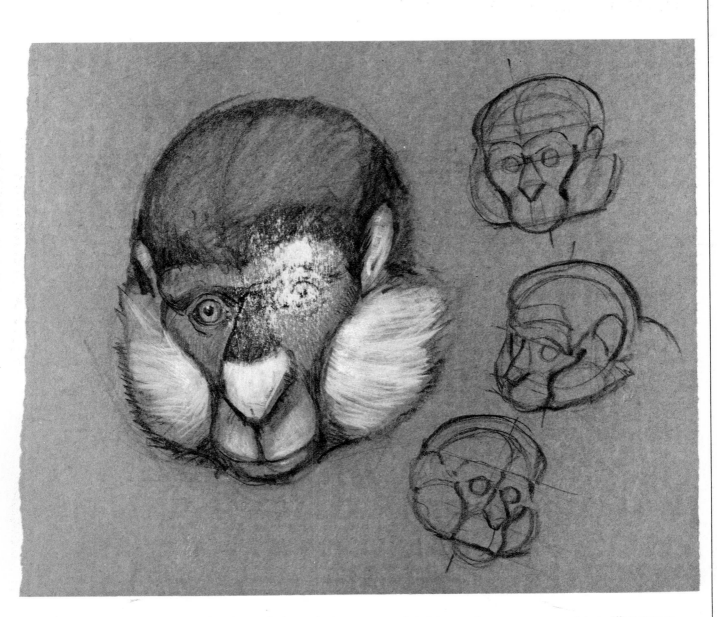

If it's animals in motion that you're after, the zoo is the perfect place to go. You can help yourself enormously if you take a few minutes to watch a moving animal before you begin drawing. Zoo animals have cage habits, which are repeated forms of behavior that they've learned in captivity. The big cats, for example, with roaming instincts from the wild, tend to pace back and forth in figure-eight patterns inside their cages. Bears often sit on their haunches to beg for food. Gibbons swing by their arms along the tops of the cages. Since these motions are repeated consistently, you can be sure that you will have a chance to observe a given pose a number of times. If you start several sketches on the same page, each in a different pose, you will never have to wait for your model to get back into position.

How do you get a restless monkey to sit for a portrait? James Gurney tries every kind of strange noise to keep this white-nose guenon against the chain-link fence, watching him intently as he draws. Having the monkey before him, though always changing position, is actually an advantage, because Gurney is able to see the shape of his head from every angle, and this gives him a full understanding of its structure.

Drawing at the Natural History Museum

As an alternative to drawing the moving animals at the zoo, the mounted animals at the natural history museum offer you a chance to do more in-depth work. In addition, you have an opportunity to get a close look at insects, reptiles, amphibians, birds, and fish. The only handicap is that the lighting is usually quite dark in the exhibit halls. But if you tilt your sketchbook a little bit forward, you can usually get enough light to sketch by.

This is the place to draw the animal that frustrated you at the zoo or to study your favorite animal in detail. Look closely at its markings and the direction of its coat. Try drawing the same pose from two different angles. In your mind you should be making constant comparisons between what you are drawing and what you just drew. Somehow this process establishes a firm understanding of the animal's form in your visual memory.

Most natural history museums also feature mounted skeletons, which can be very rewarding to sketch. To get the most out of them, James Gurney and Thomas Kinkade recommend that you avoid copying the complex pattern of light and shade on the bones and instead try to capture the overall gesture and proportions. Try to develop your own simplified mannequin, which you can then use the next time you sketch at the zoo.

Bird beaks have never been an overwhelming interest of Thomas Kinkade's. But after he starts a single study of the cormorant, he looks around and becomes amazed at the variety of other birds on display. The result is these comparative studies. If more time had been available, he thinks he would have done ten times this number and still not have exhausted the supply!

To make the comparisons as effective as possible, Kinkade uses a ballpoint pen and white gouache to suggest the texture and coloring of the birds. The written notes serve to remind him of significant features of the birds in the event that he ever needs to research any of these for a personal painting or illustration assignment.

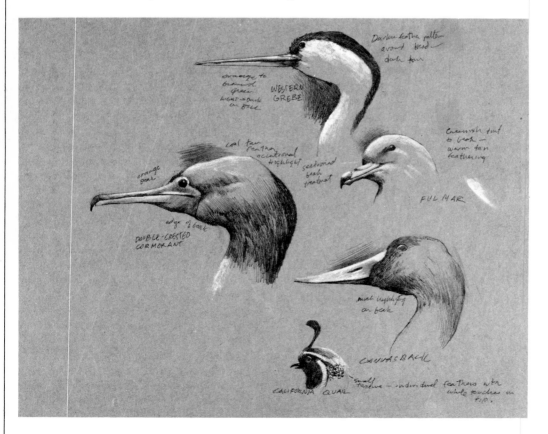

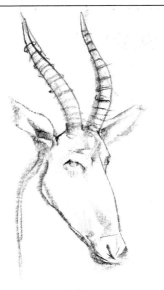

TIANG
rings space farther
apart toward tip.

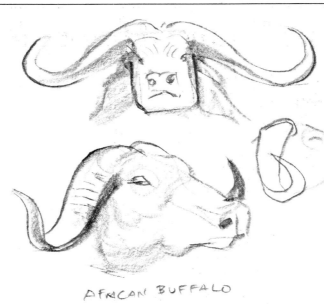

AFRICAN BUFFALO

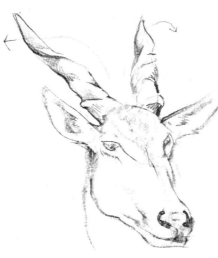

ELAND - spiral
outward

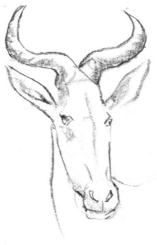

3 head
lengths

GEMSBUCK -
Rings smooth out
½ way up.

Whenever an assortment of related species of animals is gathered in one place, James Gurney enjoys making a comparative study in which he draws a full page of variations on a theme. This approach could be used to study any feature—hooves, tails, markings, or anything you choose. Here he is interested in the three-dimensional spiraling of the horns of an African big-game species. Each little drawing is made with an absolute minimum of line and tone. He holds the soft pencil in his fingertips with the palm facing down, in much the same way you hold a screwdriver. He finds that this position gives his hand enough freedom to shift quickly from the point to the side of the lead for making both lines and broad tones.

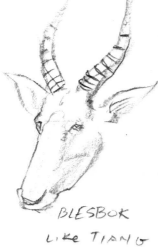

BLESBOK
LIKE TIANG

WHITE - TAILED GNU

Developing Form Sketches of Deer

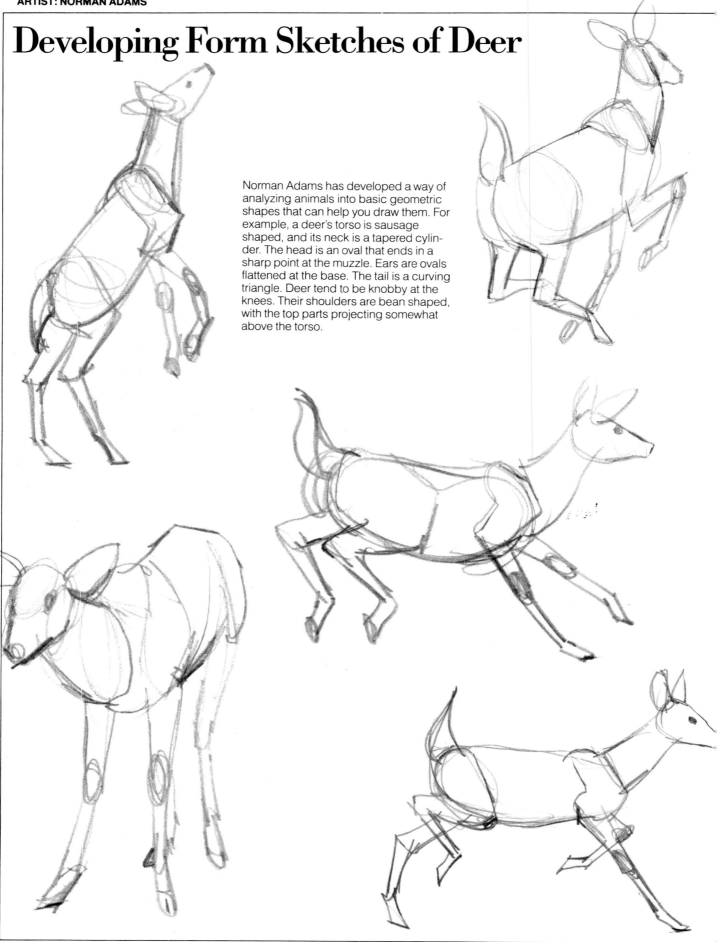

Norman Adams has developed a way of analyzing animals into basic geometric shapes that can help you draw them. For example, a deer's torso is sausage shaped, and its neck is a tapered cylinder. The head is an oval that ends in a sharp point at the muzzle. Ears are ovals flattened at the base. The tail is a curving triangle. Deer tend to be knobby at the knees. Their shoulders are bean shaped, with the top parts projecting somewhat above the torso.

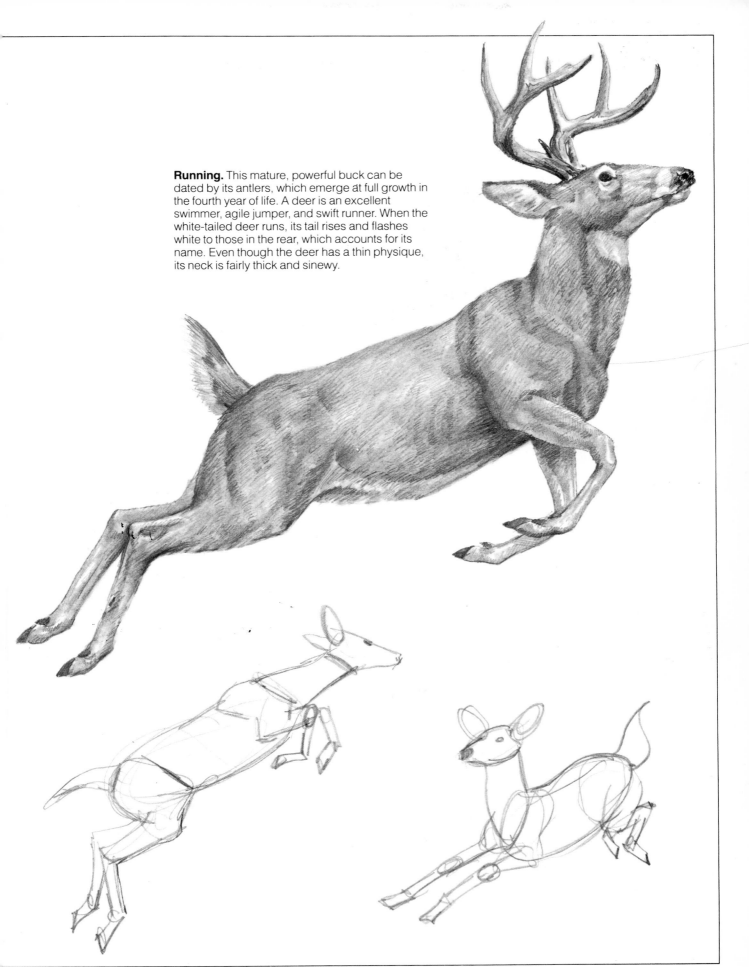

Running. This mature, powerful buck can be dated by its antlers, which emerge at full growth in the fourth year of life. A deer is an excellent swimmer, agile jumper, and swift runner. When the white-tailed deer runs, its tail rises and flashes white to those in the rear, which accounts for its name. Even though the deer has a thin physique, its neck is fairly thick and sinewy.

Developing Sketches of Monkeys

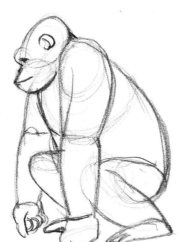

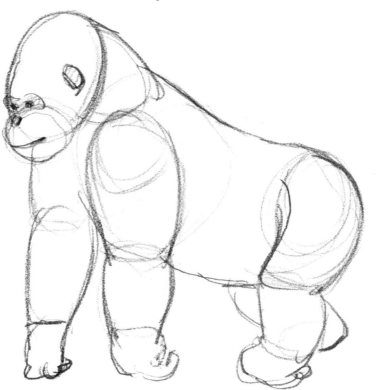

This series of sketches shows you how to visualize the shapes of primates. Think of the heads as circles, with the muzzles as smaller circles within the larger ones. The bodies are sausage shaped. Arms and legs are tubular, with breaks at the shoulder, elbow, and wrist and at the hip, knee, and ankle. The hands and feet are rectangular—with fingers attached. The gorilla at the top has some unique features: its form is bulkier and its ears are smaller than the other primates. The baboon in the middle has a doglike muzzle and a tail.

Swinging. In this drawing a baby chimp uses a traditional means of simian loco-motion while its father sits by, observing his offspring. To separate the forms of the two animals, Norman Adams draws the baby chimp in heavier tones, rendering it the darkest element in the drawing. Note that its left foot is reaching for the other vine. To emphasize its right foot grasping the vine, Adams accentuates the length of the father's right arm by darkening its outer edges. His muscle structure is evident in the chest area, where chimps are characteristically less hairy.

Developing Sketches of Elephants

The torso is an oval with the highest point at A (shown at right). The elephant's neck is a thick tubular form, the head is egg-shaped, and the trunk is a coiled, tapering tube. Elephant legs are cylindrical, broken at the wrist in the forelegs and the heel in the hindlegs (shown below in B). The forelegs meet the torso at the elbows and the hind at the hips.

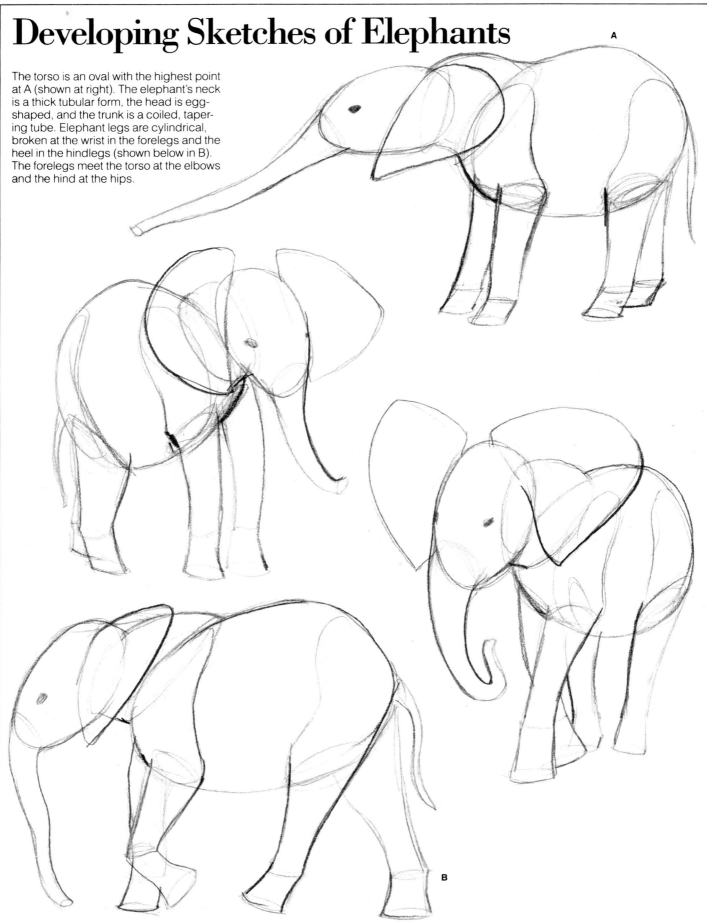

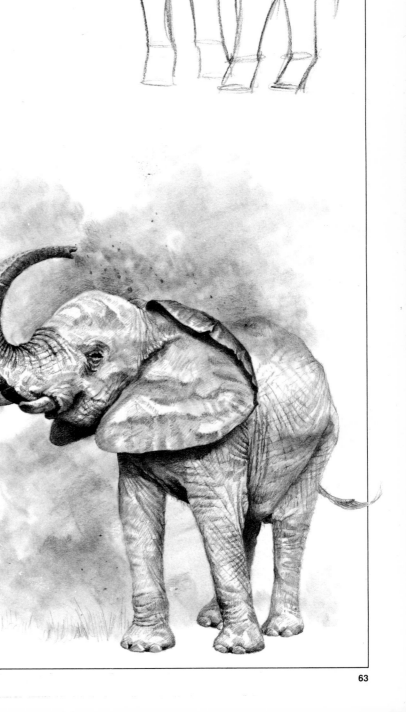

The Dust Bath. To keep itself free of the hordes of annoying insects and parasites that pervade Africa and feed on mammals, the elephant regularly washes down with water, mud, and dust. Because its tail is too short for such purposes, this is the animal's only means of relief from annoying pests.

To create the effect of the dust, Norman Adams sprinkles some graphite powder on the drawing and rubs it with a French stump (a rolled, pointed paper stick used to soften and blend pencil strokes). He includes some darker particles of graphite to give the sense of soil and pebbles that the animal may have sucked up with its trunk. Unfortunately, this magnificent species is on the verge of extinction.

Conveying Movement with Watercolor

Here are six easy steps to drawing an action pose with a wash silhouette. Because the whole body is involved in any action, try to paint several sections at the same time, including as much as you can in a single, continuous stroke. As you begin, think of the relationships that unite the figure into a flowing, graceful form.

1. Before you begin a walking figure, study and analyze the pose. Make sure you understand what the figure is doing before establishing the head. Note that the body isn't directly under the head but is thrust forward.

2. Then draw a line down from the head starting at the ear. This line should come close to the back of the waist and hit the front of the right knee. Since the body thrusts forward, the left leg is a natural extension of the front of the torso. It's better to exaggerate this than to under-state it, so make sure the stroke curves forward as well as down. It's not crucial how the curve describes the leg; what's important is that the stroke describes the torso's thrust. If you get this, the rest of the figure will fall into place.

3. Where do you place the shoulder line? Although there's no definite distance from the chin to the shoulder, assume that the front of the neck is about a fourth of a head-length long. But note that the shoulders aren't level. You'll need to make sure the shoulder section to the left of the neck is longer than the shoulder section to the right of the neck. Remember that the shoulders are equal in length only when the figure is seen from the front. Continue the stroke from the end of the shoulder to start massing the upper torso.

4. Beginning at the left end of the shoulder, make a free, curving line to describe the right leg. This stroke ties in the upper torso with the leg, showing the relationship between these two areas. Make the right foot lower than the left foot.

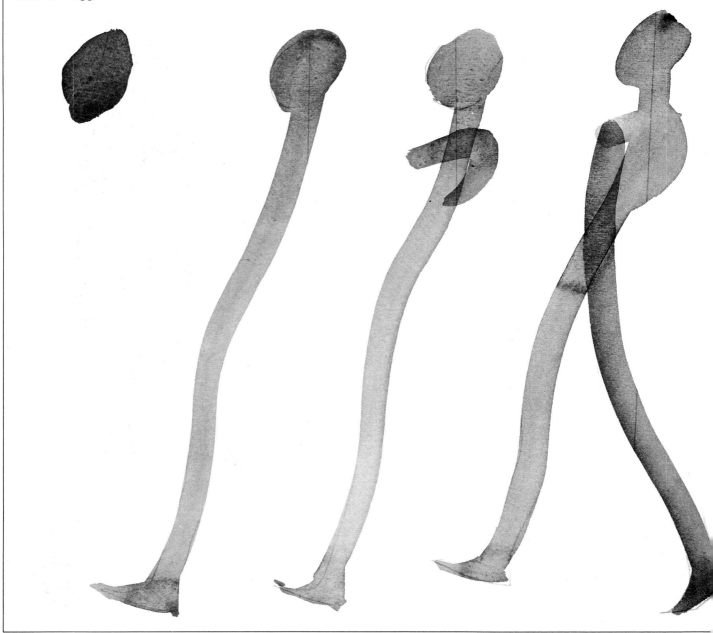

5. Finish massing in the upper and lower torso. The major decisions have been made, and the big relationships have been created. This is really just filling in. However, try to get as close to the correct shape of the torso as possible.

6. Finally it's time for the arms. Start with the left hand and continue in a single stroke up to and through the shoulders and down the right arm. The single stroke shows the relationship between the arms.

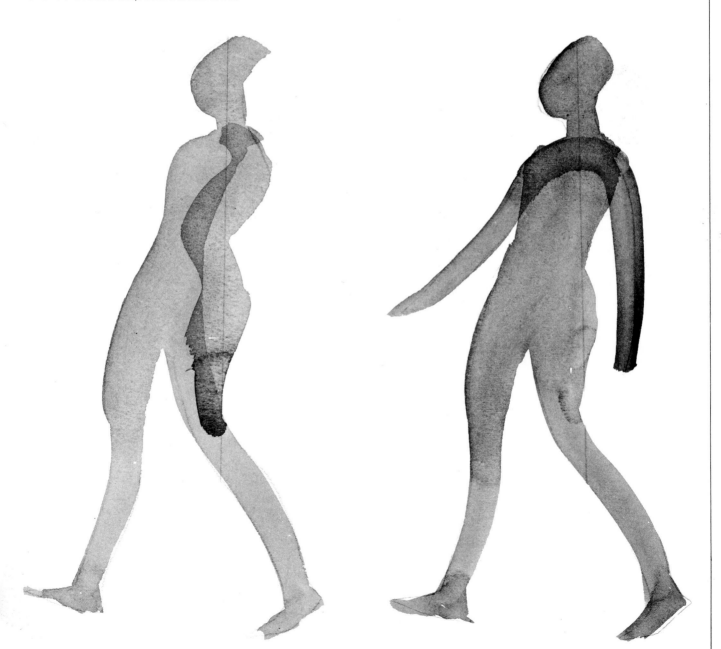

Practicing Movement Variations

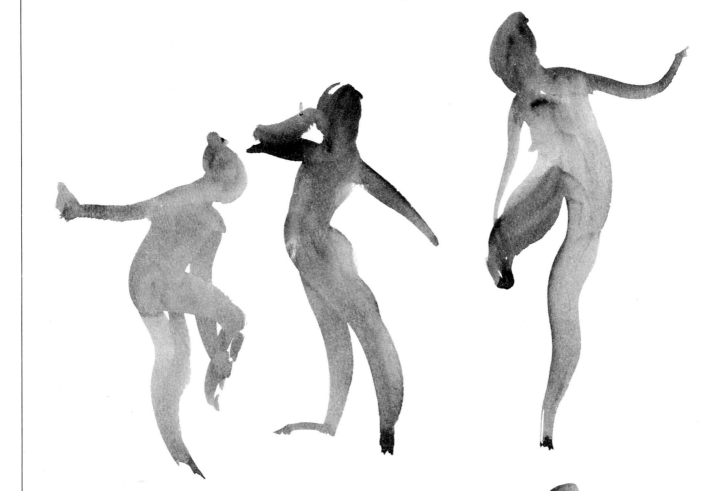

Here are two unedited pages of action figures. Some of them are better than others, and one or two are failures. Make several attempts at each one just for practice. Expect to make some errors and clumsy figures. And, above all, don't worry about correcting your mistakes.

The point is not to strive for beautifully formed figures, but to get an idea of the interrelationships of the parts of the body. Your emphasis should be on conveying an action or gesture, rather than rendering the form exactly.

What should you use for models when you practice on your own? If you're fortunate enough to have a sketch class with a live model and quick poses, that's fine. Or perhaps you can entice a sympathetic friend into giving you some time. Working from life is the best of all possible references. There's a special quality that's impossible to describe; work done from life always seems to be more realistic.

But if that's not possible, then Charles Reid recommends you work from photographs. In addition, there are several good books with nude action poses, and the sports pages of your newspaper and most magazines also have plenty of material to keep you busy. What's most important is that you get enough practice under your belt so you'll be able to work with a model in motion.

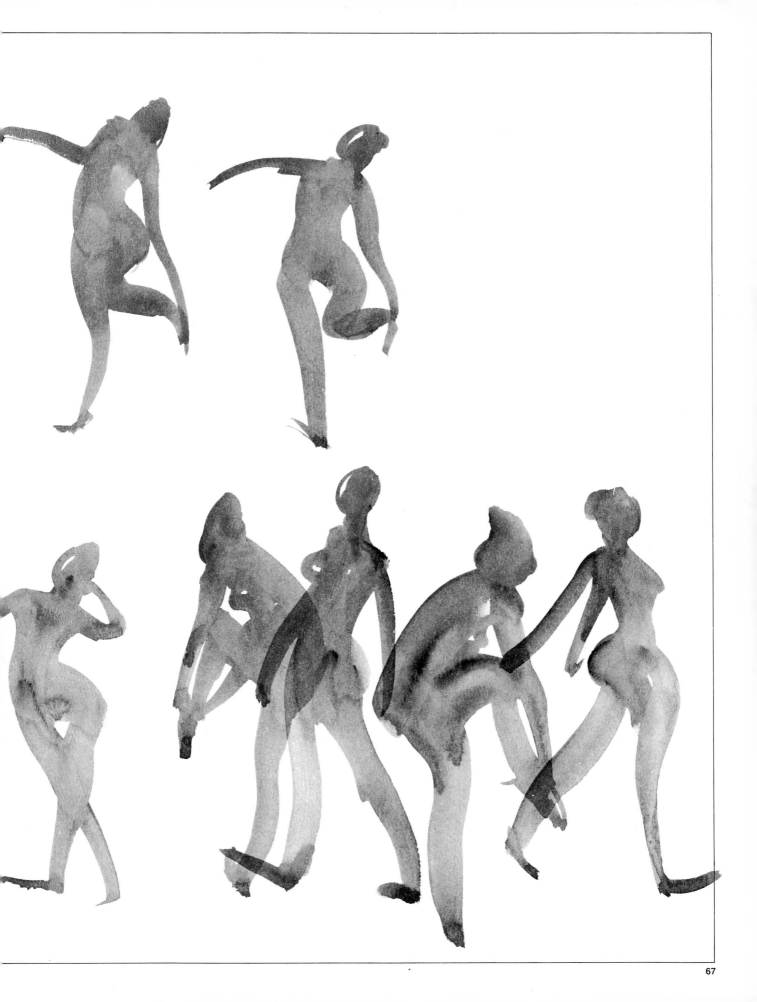

Capturing the Feeling of Dance

It is understandable that Shawn Dulaney draws figures in motion—she's been a dancer since she was eight years old. She says she views the world in terms of movement. Using her knowledge as a dancer and an artist, Dulaney has become adept at drawing the illusion of motion.

In these preliminary drawings Dulaney works with models who pass through a series of dance movements while she makes very fast contour sketches with a stick of graphite on a roll of drawing paper spread out on the floor. The paper is 36″ wide and several yards long; and it's heavy enough so that she can actually crawl on it without tearing it.

Dulaney draws up to three dance movements in a row before unrolling the paper. This allows her to move quickly from one drawing to the next, without interrupting the flow of movement by changing sheets of paper.

Dulaney likes to work fast and big, using as much of her own body as possible. When you use your whole arm and shoulder to draw, the looseness of your body helps create a more fluid line that reads as motion.

These gesture drawings are executed with fast, loose, flowing lines. Dulaney is concerned with capturing the continuous shape and lines of the movement; so she draws only the anatomical features that express the position of the body. She wants to show what the figure looks like as it is coming from somewhere and going someplace else. If the legs are especially important, as in a jump, she emphasizes the legs. In a contraction, where the whole body is curled up, Dulaney focuses on the curve of the spine. Rarely is the face indicated by more than the simplest suggestion of features.

Dulaney is especially concerned with showing the thrust of movement and the balance of weight. If there is an important bend or twist of the body, that will be stressed.

One big difference in the drawings on these pages is created by costume. The woman here is wearing a skirt; the drawings show the shape and movement of the fabric. On the facing page a man is in tights; those drawings have more of the feeling of underlying anatomy.

Dulaney is concerned here with refining the expression of the dancer's movement. At the right it is an upward, leaping gesture. The movement is stated with the outstretched arms, tilted head, and extended back leg. The sense of motion is intensified by the repetition of the figure. Notice the interesting shapes Dulaney has created in the negative space.

Here Dulaney has repeated the shape of the body to strengthen the sense of movement. She draws two large figures in the center of the format and one partial figure in the lower left corner; this placement is chosen for the sake of design. Notice the patterns created in the negative space.

Refining Your Sketches

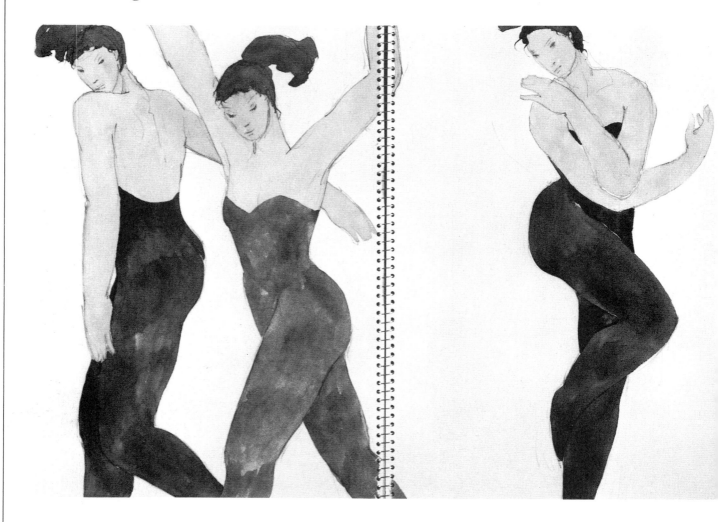

In these sketchbook drawings Shawn Dulaney refines her basic gesture studies. Her primary concern is to combine several poses into one composition that will create a strong design and convey the movement of the dancer. She is also very sensitive to the patterns of negative space. First, she makes a simple contour drawing with a pencil and then enhances each with watercolor washes. This combination gives solidity to the figures.

Here Dulaney works out three consecutive poses of one movement. She places two figures together and one alone for an interesting design. She thinks that when one figure is very strong, putting another figure with it detracts from its strength. In other cases, grouping two or more figures gives each of them more power. Notice how she extends the central figure across the divider; this helps unite the two pages. Dulaney says that each of her sessions with a dancer has a particular mood or feeling. This one had an unusually high level of energy. The dancer did repeated leaping movements that expressed the feeling of flight. In this drawing Dulaney is most concerned with projecting the feeling of the dancer's flying.

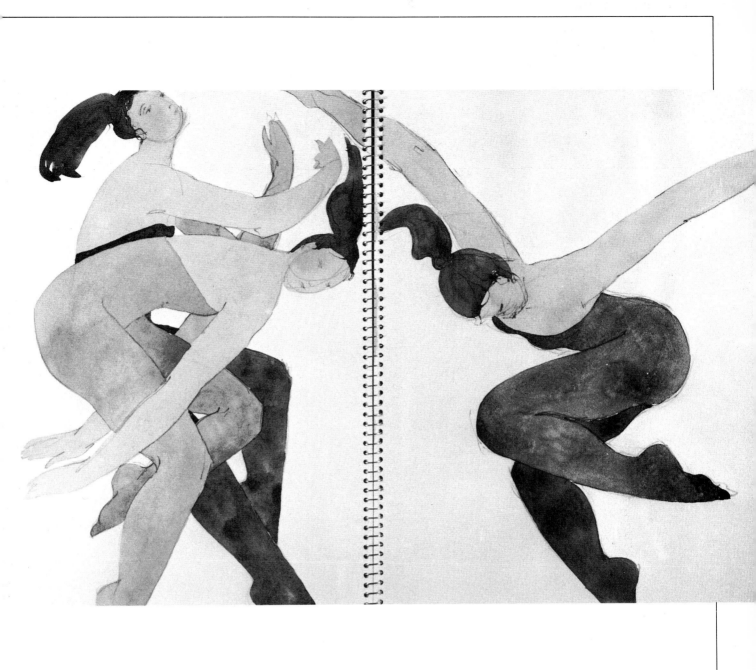

Drawing People: A Moving Target

David Millard suggests that you draw people who are moving about by combining rapid contour line with freehand sketching technique. Practice sketching from memory. You should count on there being short gaps between a look with the eye and a stab with the carbon.

Let Your Pencil Fly. Freeze in your mind the image of the group under the two umbrellas. Take a quick stare and then go to your sketchbook, swiftly sketching the after-image that's in your inner eye. Your first few pages should be warm-ups. But you'll get it with repetition.

When you're working with an active target, as with animals, catch the gesture. Keep trying. Much of this should be memory sketching. When you see a pose you like, remember it and sketch it in.

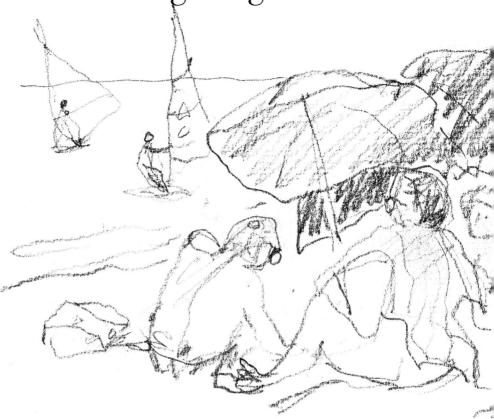

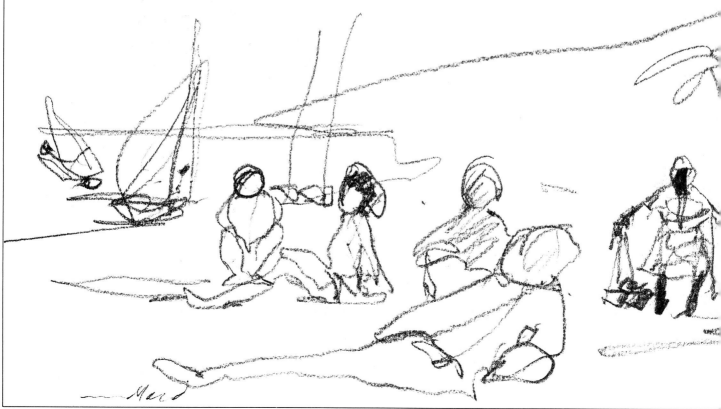

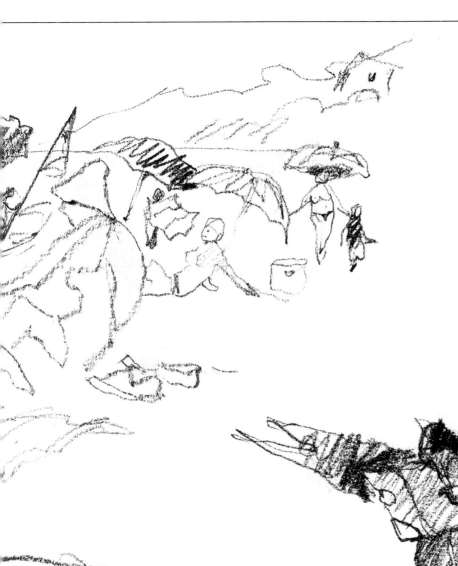

Try Abstracting Your Work. Below, Millard abstracts pieces of a tree, feet, bench slats, and shadows to create this sketch, which he titled *Central Park Library*. He recommends that you try abstracting a scene as a shorthand way to capture quick movement.

Set Your Stage like a Still Life. David Millard estimates that he did about forty sketches a day during a week on the French Riviera. Here he sees a man from Dakar moving up the beach, hawking handmade leathers and woolens. The man's blackness makes him stand out as he moves among the nude bodies.

Millard suggests that you begin this sketch by placing the two groups on the left. Select poses that will complement the trader; be sure to leave room on the right for him. Imagine his size and gestures as he approaches. Now put in the two figures leaning to the right. Compose your sketch like the Italians did frescos: feel the rhythm—be free. Lastly, drop in the beach huts and palms to create the setting. Make sure all these moving figures are animated by a constant glow of gestures. Now find a moving figure grouping to sketch in your own locale.

Learning to Draw Body Language

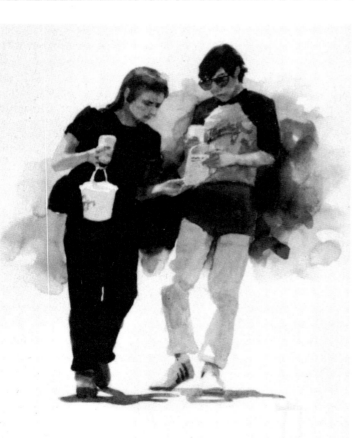

Kim English enjoys drawing people enjoying life. His work shows unselfconscious people, relaxed and comfortable. His drawings work well because he is adept at capturing gesture.

Bee Sting. The girl is concentrating totally on her foot. Her back and arms make a circle encompassing the foot, thereby focusing the viewer's attention there. English has left most of the background light. This makes the dark area more important, emphasizing the gesture.

English uses his sketchbooks to plan out elements of composition for future works. In the sketch above, he indicates the position and gesture of the figure, the division of negative space, and the placement of light and dark values. English knows that if a composition doesn't work in such a small version, it probably won't work well any larger.

News. The boy is showing the woman something he's just read. Because he's already read it, he's standing up straight, not quite as involved. They are both focused on the newspaper, but they are walking at the same time. The motion is established by the shape and position of their legs.

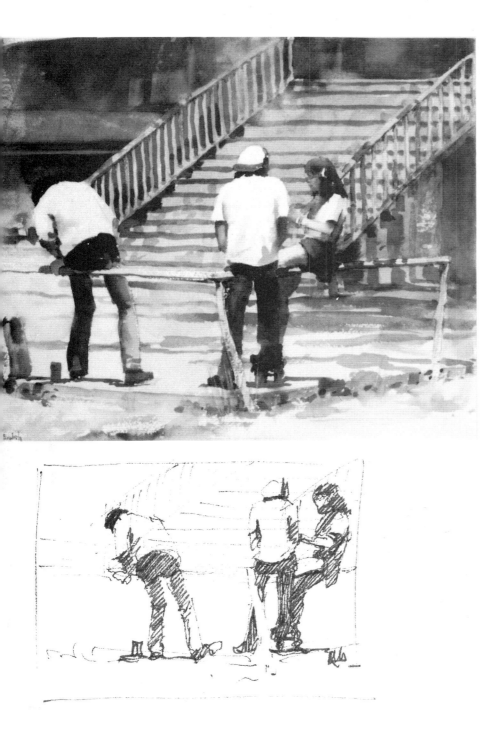

Red Skates. There are three figures in this composition, but English has divided them into a couple and a separate figure. Note how that placement affects the design, while it also helps define the interpersonal relationships. The artist has created an intimacy between the couple by placing them so closely together that they become one shape. The third figure is separated by space and also by the gesture of leaning away from the others.

In the sketch you can see how English begins to work out the gestures and values for a finished composition. This is a simple diagram where he has loosely indicated the background and concentrated more on the placement of the figures and their gestures.

Assignment. One of the skills necessary for capturing gesture is the ability to draw fast. The only way to achieve this speed is to practice. A good place to begin is when you are watching television; keep a sketchpad and pen or pencil in your lap. At first just observe people as they move on the screen. Don't draw yet. Ignore their facial features and details of clothing; concentrate only on the position of the body and on the angles of the torso and limbs. Try to feel the movement of the television figures in your own body. If the figure on the screen moves a leg, feel it in your own leg.

After 5 minutes of just looking at the gestures, begin to draw. Do 25 gestures at a time. Use fast, flowing lines. Remember that you are not trying to capture details, but showing the most important positions and movement of the total body.

Work from television figures until your drawings begin to convey a sense of the gesture. You should be able to go back to any gesture drawing several days or even weeks later and, just by looking at the sketch, recall the entire gesture.

After you are comfortable drawing gestures from television, take your sketchbook into public places where you can draw real people as they move. Start with places where people sit, like restaurants and bars. As you are able to draw faster, try to capture people walking, dancing, or playing ball.

SKETCH TO DETERMINE SHAPES, PATTERNS, COMPOSITION, AND VALUE

Sketching is a way of working through the design problems that come up in every serious endeavor to make art. All the elements of a drawing or painting must be correct before a work of art is successful.

Included in this section, still life artist Rudy de Reyna shows you how to arrange a harmonious still life grouping by balancing the overall tonal scheme, textures, and edges. Charles Reid gives you ways to determine the correct arrangement of values needed to convey a feeling of solid form in the figure or portrait. David Lyle Millard illustrates how to use values to impose structure on subject matter, making a coherent abstract form out of the chaos that nature presents us with.

Learning to Control Large Forms

Learn to think of figure painting in watercolor, advises Charles Reid, as large, simple, flowing masses. You have to concentrate on shapes, so you can get as close as possible to the human silhouette. That requires controlling the width of the stroke to make it change at just the right place. This takes a good deal of practice. But don't worry; your shapes will improve as you get the feeling of moving the brush freely.

1. Paint a stroke about 5″ long and ½″ wide with a No. 8 Winsor & Newton brush. Don't press down too hard.

2. Reload your brush and make another stroke, beginning just as you did in step 1. But this time vary the pressure on the brush. After beginning the stroke at ½″, slowly but steadily increase the pressure until the stroke becomes about ¾″ wide. Then slowly decrease the pressure until you have a very thin section about ¼″ wide. Repeat this process several times. These first two steps are practice strokes. Work on them until you feel confident enough to try a figure.

3. After recharging your brush, start with a simple stroke about ¾″ wide for the head. But *don't* let the brush actually leave the paper. Remember your goal is to make as few strokes as possible and you're still making a stroke as long as your brush doesn't leave the paper. After about 1″, start letting up on the pressure. This narrower part will form the neck. Continue the stroke for another 1″ for the upper back. If you've got enough paint, backtrack and indicate one of the shoulders. Move the stroke over from the neck about 1″ or less. Don't worry about the proportions.

4. Recharge your brush before going on

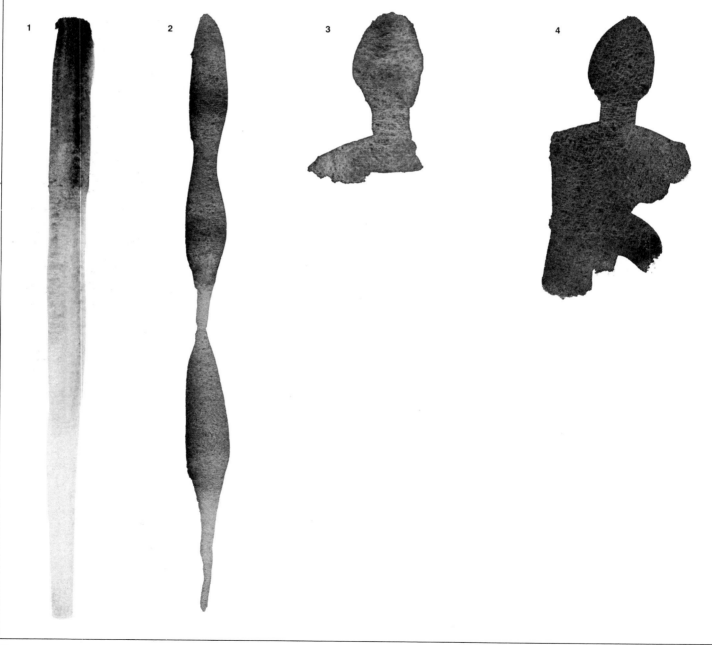

to the other shoulder, but work quickly to pick up the first wet stroke where you left off, continuing back across the torso to indicate the second shoulder. Block in the upper and lower torso. Recharge your brush again if you need to. The silhouette may be irregular, but don't worry if your first attempts don't look very human. You'll improve with practice.

5. Your practice in varying the pressure on the brush will come in handy as you block in the legs. Make the upper leg about the same width as the head. As

you proceed downward, gradually lessen the pressure on the brush, but not too much. By the time it gets to the knee, there should be a definite narrowing of the stroke. The upper and lower leg should each be about 2″ long. Now start increasing the pressure to indicate the calf muscle in the lower leg. Then gradually decrease the pressure for the ankle, indicating the foot with a small triangular form.

6. Follow the same procedure for the other leg.

7. Once you do the arms, you're finished. Go back to either shoulder with a loaded brush. Start at the end of the shoulder painted in step 2, and be sure not to continue the width of the shoulder as you pick up the stroke. Narrow it for the elbow and then widen it once more before tapering it quickly for the wrist and then the hand. Repeat the same kind of stroke for the other arm. The arms should each be about 2″ long. Now you know how to paint a figure in eight strokes or less.

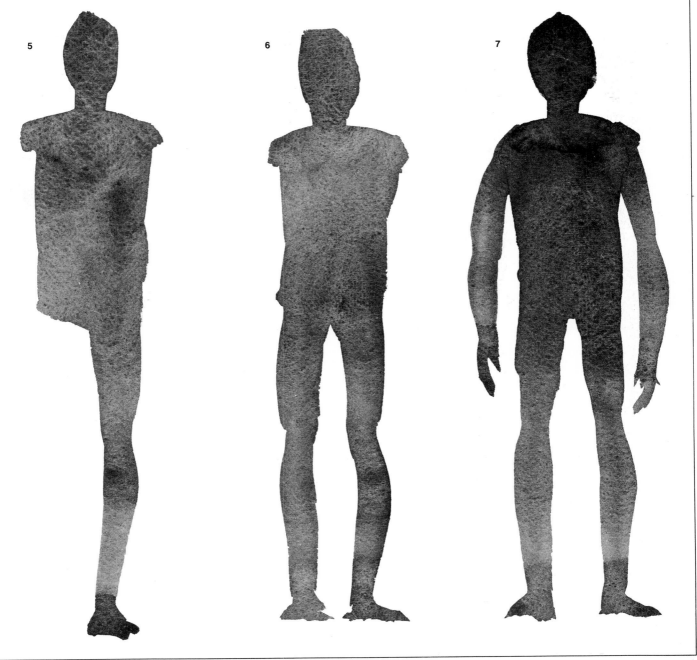

5

6

7

Seeing Shapes Accurately

In more advanced figure work, you have to learn how to draw the form's size and shape descriptively and accurately. The human form is a combination of curving and straight lines. Angles work against curves and curves against straight lines. Variety and contrast are key. Observe the kinds of shapes that make up the figure's boundary. For example, compare the shoulders in step 4; the left one has a simple curve, while the right one is angular.

You'll see that the two sides are shaped differently.

Always begin by observing and studying. Don't assume that all human figures should be painted the same way. Your main job is to describe a *particular* figure. To convey muscle and bone structure accurately, you'll need a basic understanding of anatomy. Simplicity is essential. Concentrate on the major planes that describe the mass of the figure.

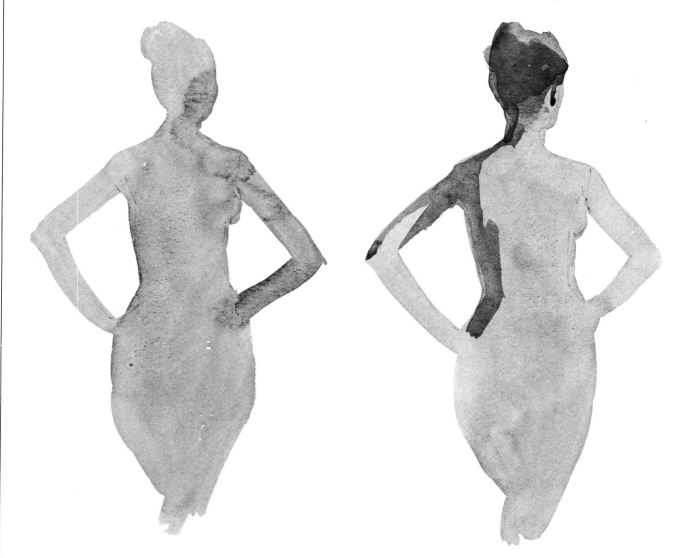

1. Make a simple silhouette. Sketch just the torso and upper legs to establish the involved construction of the back. It's good practice to work with your brush without pencil guides, but a pencil outline is fine too. But don't just fill it in.

2. Mix up a shadow value. Don't worry too much about getting an exact value; just make sure it's obviously darker than the one used in step 1. Remember the general rule that the shapes and sizes of the shadow masses are affected by the construction of the figure.

Start with the hair; then narrow the stroke to describe the neck. The stroke changes direction at the base of the neck. As it follows the line of the shoulder, it slowly gets fatter until it reaches the side plane of the shoulder blade. Block in this plane and the shadow of the left arm and its cast shadow. Continue the stroke to the bottom of the shoulder blade, where the wash should extend farther out to show the rounded form of the ribcage. This shadow form describes the whole side of the torso, including the arm. Make it a nice, easy stroke that gives a broad idea of the torso's construction.

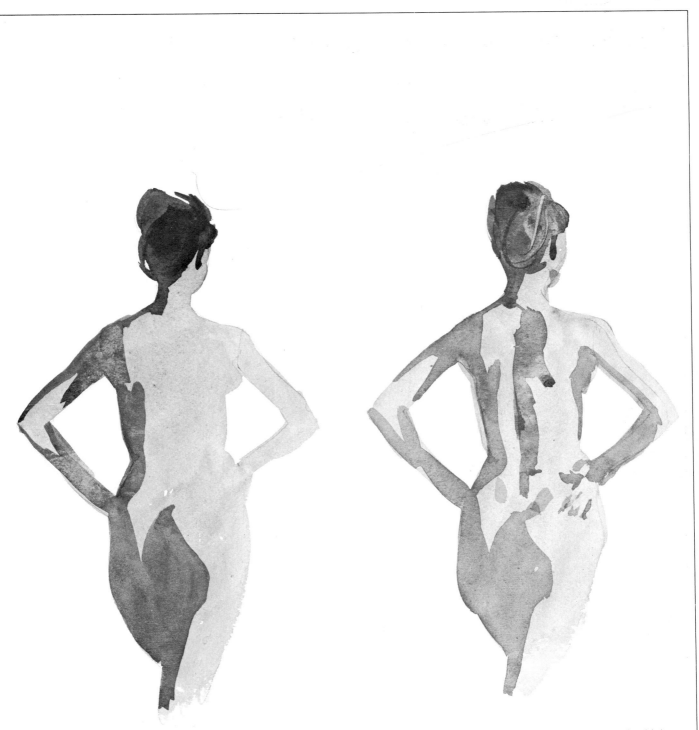

3. The wash should now define the side plane of the lower torso. The inside shape here is quite straight, contrasting with the curving forms indicating the lower back. Block in the whole shadow plane with a single shadow. A big shadow shape like this is very descriptive. One value does what it would take many small, subtle value changes to accomplish. But one value works as long as the shadows are light in size and shape! This shadow shape makes a subtle curve over the backside and takes a straight jog down the leg.

4. Make the side plane of the right shoulder blade quite thick, as opposed to the much thinner plane running down the backbone. The brushstroke should emphasize the straightness of these planes and their slightly angular quality. You're showing the boney, much sharper form of the back in contrast to the more rounded forms of the lower torso. The shadow cast by the upper arm follows the rounded form of the ribcage and disappears as it approaches the hip. Make a large, simple shadow on the lower arm. This big shadow shape shows that the arm is pulled back, causing the lower arm to be away from the direct path of light. If this arm had been in the light, you would have had to show that the elbow was pulled forward.

Creating Figures in Three Values

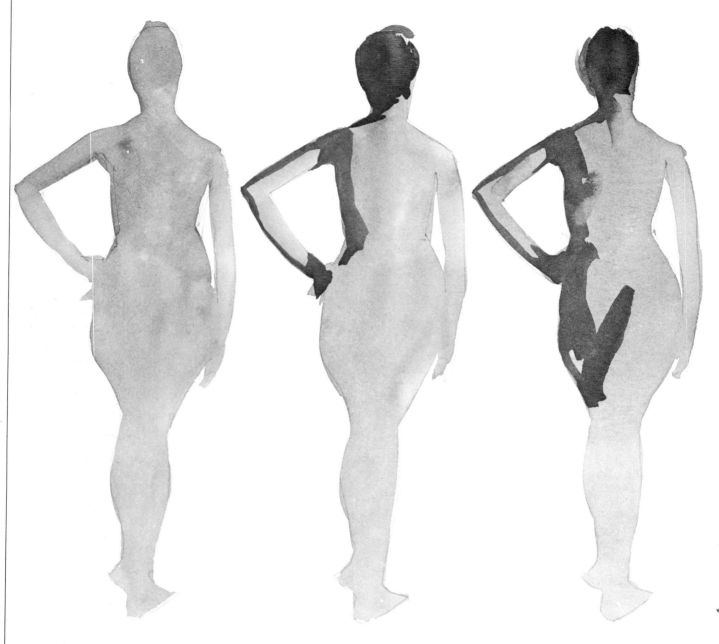

Now you're ready to establish a middle value between light and shade with a damp brush. The shadow should actually run into the light to create a third tone. Using the brush like a sponge, you'll work to soften the edge between the light and shadow. Although this may seem easy, it is only if you control the amount of moisture in your brush. If it is too wet, the water will dominate the shadow color. Paint consistency is also important, since you're only blending in selected sections of the shadow.

1. Make a simple silhouette and allow this first wash to dry.

2. Now, with a considerably darker value, block in the shadow shapes, beginning with the hair. Remember that the amount of bleed (or blend) you'll get in the next step depends on how wet a brush you use and how wet the shadow is. Don't paint all the shadows. If you paint in all the shadow shapes right down to the feet now, the shadows in the shoulder and upper back might become too dry for blending.

After doing about half the shadows, prepare to go back and do the blends by rinsing your brush and giving it a good shake

3. First, soften the neck shadow by running the damp brush along the shadow boundary, allowing some shadow value to bleed out into the upper middle of the back. Don't overwork this; make just one or two passes with your brush. If the bleed is going too far, blot the brush lightly with a tissue after each stroke as needed. Since your damp brush acts like a sponge, you can control the amount of bleed with it. Soften the shadows in the middle of the back. The shoulder blade is often bony, so leave it untouched. The back is less definite so make it softer. Finally, begin to fill in the lower torso.

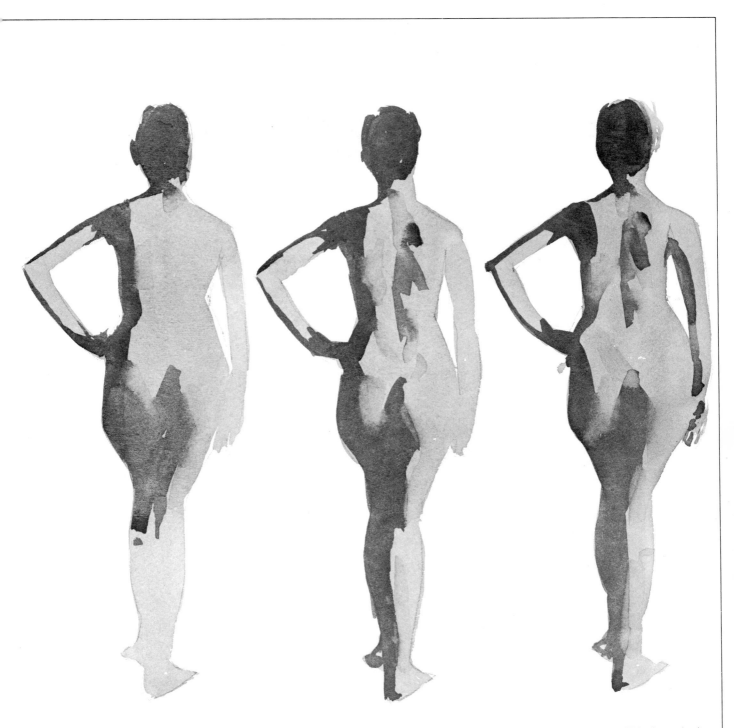

4. Soften the shadows on the rounded forms of the buttocks to contrast with the harder edge in the upper section of the lower torso. Sometimes, hard edges, like the one on the hip near the hand, are left purely to differentiate them from the adjoining soft edge, and vice versa. When all edges are soft, the figure looks mushy and formless; all hard edges make the figure look like a cutout. Strive for a combination of hard, precise edges and soft, sometimes "lost" edges.

5. Add the rest of the leg shadows along with some shadows to describe the middle of the back. Blend the leg shadow. Notice that by the time you do this, the leg shadows will be almost dry and won't blend too well.

6. Block in the right arm. This time, don't blend any edges; just *blot* the lower arm shadow to lighten it and give the appearance of a soft edge. Shadows can be blotted to lighten those that have become too dark or just to create a subtle value change within the shadow. Here, blotting gives a suggestion of softness.

Seeing Positive and Negative Shapes

Positive shapes usually suggest an object or figure in a painting, and negative shapes suggest what's behind it in the background.

Example 1. In this set-up, the model is sitting on a bench on the model stand, and there are two stools on the right. There are also some pictures and a window in the background. In defining which space is positive and which is negative, you must decide what items are in the object area (positive) and what is part of the background (negative). Obviously the pictures and window are objects. But they're also part of the background. Your decision is one of choosing a focus.

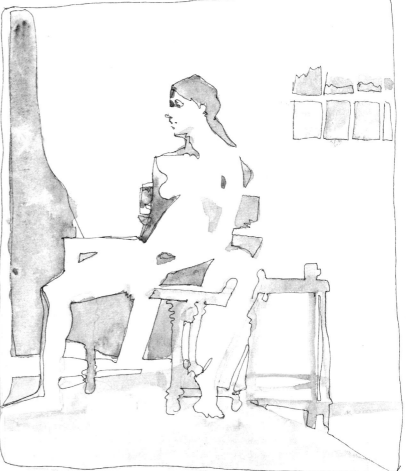

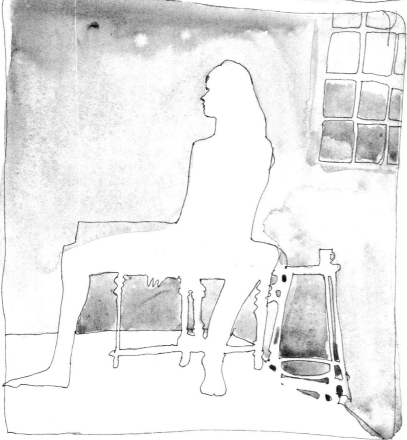

Example 2. Charles Reid finds it helpful to think of negative and positive shapes in terms of value. Here he paints all the negative shapes dark and all the positive shapes light. The result is that the figure, stand, and foreground objects are positive or white shapes and all else is dark or negative space.

But Reid doesn't think the example here works very well as a picture, though. It lacks subtlety. But there is one advantage: Simplifying what he sees forces him to mass the foreground figure and objects into a single large shape.

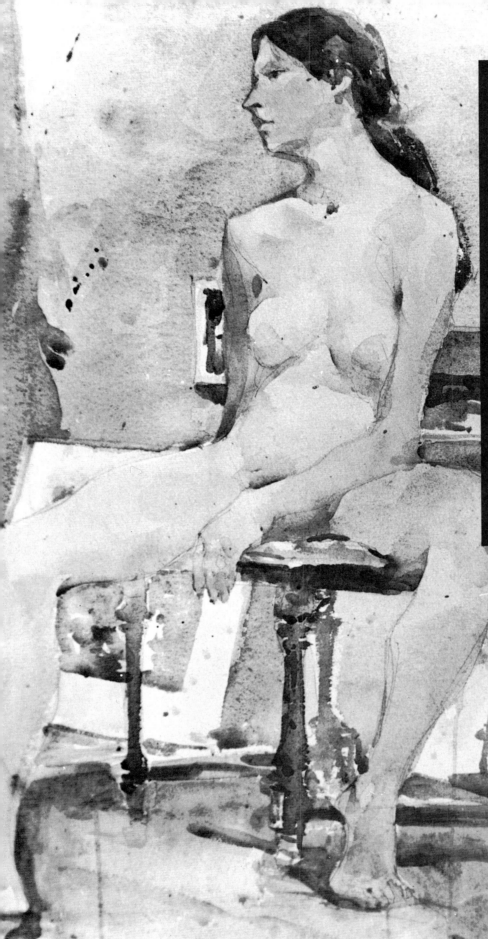

Assignment

1. Make a contour drawing of a model or a still life (see pages 20–21 for an example of a contour drawing).

2. Now divide the drawing into two values: a light and a dark. Deciding which values to leave white and which to make dark can be a problem, so drawing a value scale with six values should help. (The darkest should be 1 to 3, decreasing in value to 6, which is white.) Leave the lightest values in your painting (4 to 6) as white paper, and begin by filling in the darker tones (1 to 3). Reid paints the darks a 3, but you can use a darker value. Just don't use black (1) because it will look too harsh.

This exercise depends on getting very descriptive shapes, with the right proportions. Also, look for connections between the shadows on the figure and the background darks. For example, some of the shadows on the legs connect with the wall and the bench.

Look at the lights. Notice how many "escape routes" there are—places where light areas on the figure flow out into the background. These connections keep the figure from appearing isolated. They also relate the figure to the background so that it doesn't look cut out and pasted down on the paper.

Emphasizing Dark, Negative Shapes

A sky or land shape is easy to design when you have strong abstract silhouettes of landscapes and seascapes to inspire you. But suppose your subject is just a mass of bushes? How in the world can you abstract them into shapes? How can you design negative shapes within a solid mass? You will need patience and a seeing eye to impose a structure on such a subject. You will also need a bit of imagination to shut off the reality and look at this group of foliage as a design problem—as abstract forms. David Millard suggests you break this mass into four values—a white, a light gray, a midtone, and a very dark gray.

Mass Details into Basic Shapes. The first step is to plan your whites. You decide these are to be your tree trunks—don't worry about the reality; you're designing it! Note how the diagonal chunk of white at the lower left fills the corner and supports the midtone diagonal band above it, providing a base for the white trees.

The next step is to start massing your light gray tones by holding your carbon pencil lightly, as if to scrub it on. Be careful not to smudge these tones with your hand or cuff. If you're right-handed, start at the top left and carefully work your way across and down. Select part of a negative shape and render it. Then choose another and another until you've covered all but a few sky peep holes.

Now add the midtone. Remember to squint. Do you see the midtone band running from the top left diagonally down to the lower right-hand corner? Rnder this darker midtone just within that envisioned band. This band didn't exist until Millard designed it, which is an important lesson to learn from his approach to composition. He suggests that you always think in terms of design and poetry as you draw. Use your wits, dream, be original!

Put in the deepest gray tones last—but only within the mid-tone band. Then look at nature—even when it's in front of you, you must learn how to design it—and decide where you want the blacks. Remember that you must lead the viewer's eye, and not overdesign your picture. Learning to understate is essential.

Design Landscapes with Darks, Vignettes, and Shapes. An attractive clutch of buildings makes a natural subject for a painting. In fact, it is almost too pretty, too much like a postcard. So much so that Millard decides to redesign it.

First, he feels that it is necessary to elongate the composition to get rid of the postcard shape. Then, he visualizes a "cascading" row of black fingerlike shapes above the bushes at the entrance to the house. Luckily, the truck drove into the scene at just the right moment, adding its dark gray body black under-pinnings, tires, and differential. These horizontal darks are just enough to stop the cascade of blacks around the birches from moving the eye out of the picture at the bottom. Since the eye is still being pulled to the right, Millard puts in a jet black shape on the roof of the shack for balance.

Can you see how important the shape of the sky piece is to the sketch? Notice the soft, round shapes of the trees and the complimentary angular shapes of the roofs. Do you see why the chimney was *not* placed in the center? The decision to leave the ground line soft and unemphasized helps give a vignetted feeling to the bottom of this drawing.

After a while, if you sketch long enough, you will begin to "see" paintings when you spot a subject. Even before you sketch, you will feel a tingle, and the design will "fall right off your brush" when you come to paint it.

Design Figures with Darks, Vignettes, and Shapes. Whether you're drawing landscapes, still lifes, or people, David Millard believes that the same design principles hold true. This picture is very much like the preceeding ones: Carefully selected black negative shapes concentrate your attention—this time on the legs—as the center of design interest.

Millard suggests that you add two wedge-shaped pieces to define the back edges of the table at which the model is seated. Then smudge the tones with your finger. As you smudge, the soft shapes of the shadow sides of the rest of the furniture emerge in quite an abstract fashion and you decide to keep this vignetted shape on the top and two sides. Finally, add the two upper darks. The one on the left pushes the shoulder out toward the viewer and is a negative shape. The other dark is just there for balance.

Would you have put darks only around the legs and tabletops? Turn the sketch upside down and see how well they relate to the composition as a whole. Now would you consider entitling this sketch *Legs*?

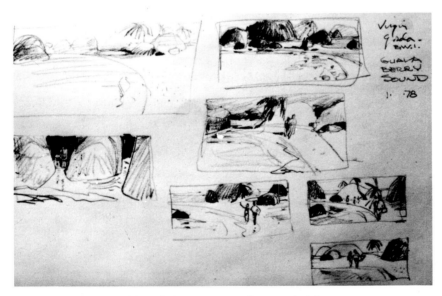

Work Out a Composition. An important use for your sketchbook is as a place to work out ideas for a composition. It's fine to sit down with your watercolor paper and do a beauty of a painting, but by working first in your sketchbook you'll capture a number of possible compositions, you'll gain intimacy with your subject, and you'll learn a lot more about composition as well.

Afterward, when you settle down to do your watercolor, you not only have that to take home with you, you also have enough material to inspire several more paintings. The experience of working out these compositions will also help you learn to "see" what you want to paint.

Establishing the Composition

Whatever the subject of your still life, you must first draw its elements correctly. Just as a builder doesn't worry about a roof until the framework is ready to support it, an artist must establish the big shapes, proper proportions, and relationships before adding detail. In a still life, Rudy de Reyna feels four points must be considered: the overall silhouette of the grouping, its tonal scheme (balance of lights and darks), textures, and edges.

An edge, according to De Reyna, describes the character and texture of its entire surface and is usually either hard or soft. The edges of a bottle are hard, for example, while those of bread or a napkin are soft. But you can alter edges to suit your own artistic purposes. Sharpening them can make them seem nearer, while they will recede if you make them soft and smudgy. You can render edges to suit both the character of the object and your own compositional requirements.

As a rule, the artist needs to develop and refine a drawing through many rough sketches. Each rough provides a chance to work out problems in a composition. Often what appears perfect in the mind's eye needs modification when set down on paper.

Take a well-shaped bottle, a wine glass, a loaf of bread, a knife, and a napkin, as De Reyna does here. Arrange them in many variations, and do at least a dozen roughs, focusing on the big shapes and overall silhouette, rather than on details. Charcoal, in either a blunt pencil or a stick, is admirably suited to this kind of exploration because it's so easy to manipulate. You can darken and strengthen a good line or lift out a bad one with a kneaded eraser.

1. All the elements here are vying for attention. The diagonal from the top of the bottle down to the bread is too insistent.

2. This has possibilities, but the drapery in the background, combined with the napkin, steals the show from the center of interest.

3. While De Reyna likes this as an arrangement of shapes, he feels the bird's-eye view is contrived.

4. De Reyna feels he has moved in too close in this sketch, and he doesn't like the negative suggestion of the inverted glass.

5. Isolating the glass gives it undue importance, while the loaf of bread and the bottle make the picture heavy on the left.

6. De Reyna feels this is a very bad arrangement. The three main elements are lined up, and the knife only serves to accentuate the monotony.

7. This is the one De Reyna likes. He feels that with a few minor changes this composition will provide the foundation for a very nice drawing.

Sketching Still Lifes to Learn Composition

There are two typical 5-minute contour draw-ings on this sketchbook page. The drawings show the outside shapes and lines of a set-up, and there are value smudges (done with the side of a finger or a small piece of chamois), along with some rapidly drawn blacks. The vitality and freedom of these black lines main-tain the loose, sketchy quality of the drawings. Each still life has a different shape.

Trapezoid Shape. The shape of the draped fabric under the still life gives a direction and orderliness to the composition. The garlic, fruit, and pineapple-shaped sugar bowl follow this line of direction. The best place to put the vase of flowers is behind and to the right (see diagram below).

Parallelogram Shape. The grid behind the still life provides the baseline for the sketch and helps you orient the directions coming off the mustard tin. The end and top of the tin create two angles, which interested David Millard in working on this parallelogram. He sees the robust, deep quality to the lines and tones in it as indicating that when painted, the colors will be richer and the values darker than those in the top sketch. (The upper sketch is higher in key and suggests lemon, orange, lime, and pink colors.)

Assignment. Whether you're a novice or an advanced artist, you should practice drawing still lifes.
1. Begin with two or three 5-minute contour drawings of your subject.
2. Pick one of these quickies and do a 20-minute value study of it.
3. Now draw the outline on your watercolor paper and paint it, working directly from your *study* of it—not from the still life itself. Why? Because you have already made your intuitive interpretation of it. Just refer to the original set-up for minor details and color or to see how a shadow or edge looks. This is known as "mem-ory painting."

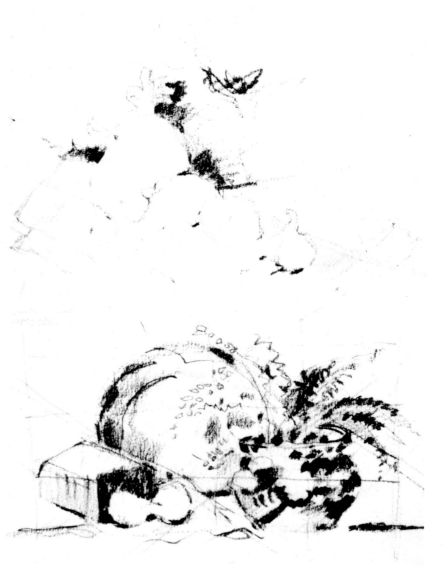

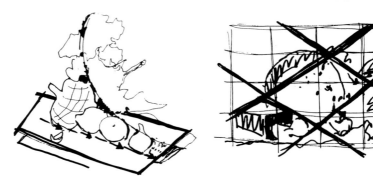

Select a Good Vantage Point. This still life is composed to please your mind's eye. When setting up an arrangement like this group of fruits, vegetables, salt-shaker, and pepper grinders move the objects around until you have a satisfied feeling about the relationships they establish with each other. Make your unshaded contour drawing a frontal composition, as in the first ilustration. Box it in so that you can see the negative shapes as the objects relate to the four sides. Be sure to look for good shapes!

Now move to the right around your setup until you have an equally exciting new composition. You haven't moved a single

item, and yet you've discovered a new set-up for your next painting. Orient yourself by the angle of the knife and the cut onion.

This is like landscape painting. You encircle a still life setup just as you would walk around a barn to see what's on the other side. One painting does not exhaust all the potential compositions in a set-up. Painting still lifes is where you learn to compose. You could make six or a dozen sketches from different angles of the same set-up. You can do the same thing in a life class by just moving around the model.

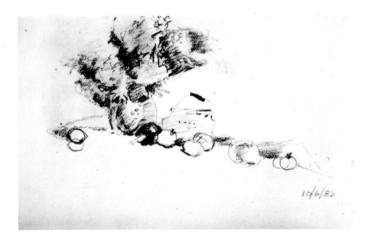

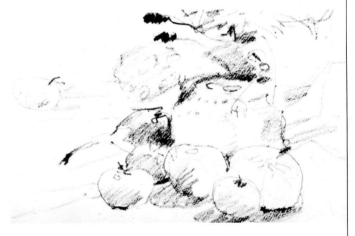

Let's Take Another Example. This time the angle is running slightly diagonal. Draw your contour in a flat, frontal view as in the set-up above. Now draw in some simple shading as illustrated to get a feeling of depth. Concentrate your darks on the handle and on the eggplant. This should be all you need to trigger a good painting from memory. Try it!

Now go around it and look at the end view. It's the same set-up; nothing moved but you, but you now have a new composition

for a new painting. Follow the illustration here for shading. Note that the vertical alignment of the darks accents the side of the earthenware pickle crock.

Assignment. Now try a new memory painting from your carbon drawing. But this time try working without the black-and-white drawing to "guide" you. Paint it directly!

Drawing Like a Painter Thinks

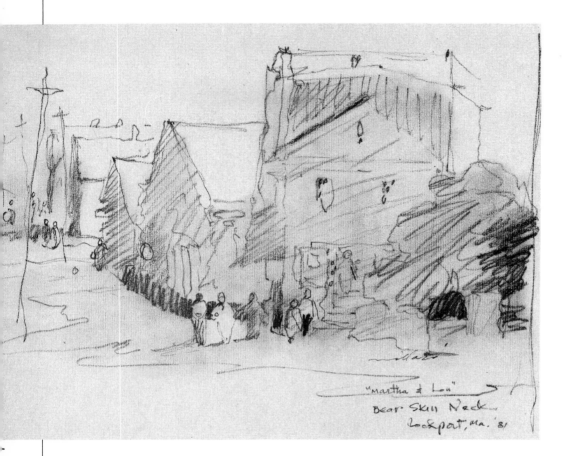

To learn to isolate the light pattern in a composition, follow these basic rules of painting:

1. Pull all your darks together into one gray mass.

2. Pull all your whites into a single large unit. Here, the big negative includes the roofs of three houses. (Be sure to keep your ridge line very light so the sky piece locks down into these buildings.)

3. These figures have a staccato quality, as they come in and out of the light. Design your black accents with care.
 Note that this sketch was done on toned paper.

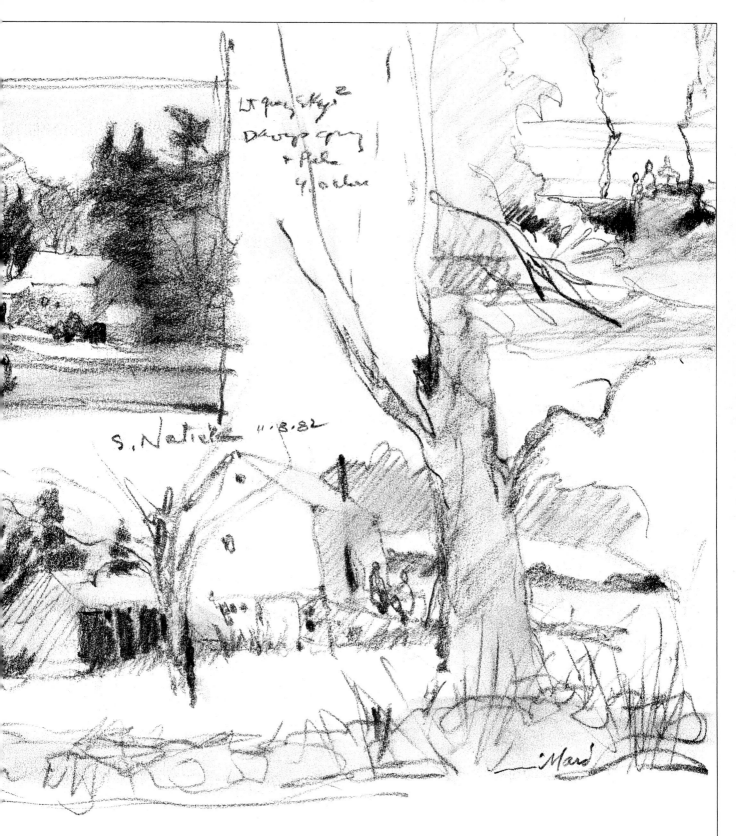

S. Natick 11·18·82

Special Use of Dark Negatives. Make this a fast contour, freehand drawing. Push yourself to work freely! Remember to keep all the dark negatives to the left—the carriage house interior and all the trees and bushes. But don't just dash them in willy-nilly; design them with affection. Note the snow pattern on the right and the two figures in sun and shade. Look at Andrew Wyeth's beautiful pencil studies, like *Pig Pen* or his Kuerner Farm drawings, and be inspired!

Determining Local Value versus Light and Shade

If your paintings look jumbled or confused, Charles Reid believes that it may be due to the awkward or unattractive selection and arrangement of values. You might be trying to duplicate the effects of light and shade on objects, but not know how to apply your values properly.

Reid believes that having a basic understanding of the rules of light and shade should not be underestimated, because light and shade makes objects look real and gives them form. But if you add light and shade before establishing the basic values, you may make the lights too light and the shadows too dark, ending up with a confused muddle of unrelated values.

Local Value. Many years ago when Reid was a student at the Art Students League, he remembers his teacher, Frank Reilly, saying, "The darkest dark, out in the light, is darker than the lightest light in shadow." What Reilly meant was that the lighted side of a black object is always darker than the shadowed side of a white object because of its intrinsic nature—its local value. It is the local value of an object that always influences the values of

light and shade on it, regardless of the intensity or dimness of the light. Therefore, to avoid breaking up your main values, you must establish the local values of your subject first and then paint your light and shade.

You can determine the local value of an object by squinting. Because the longer you look at a subject, the more detail you see, squinting makes you much more aware of the overall shapes and silhouettes and helps you screen out the complicating details.

Once you have established your local values as broad, flat areas and shapes, you're ready to add light and shade. But remember, the local value of each object is never changed by more than a value either way when light and shade is added. If you go much darker or lighter than that, you will destroy the local value of your subject.

The sketches here are based on an exercise Frank Reilly assigned his students to help them understand local value and the effects of light and shade on it. Refer to the value scale described on page 85 as needed.

1. Local Value. Here Charles Reid paints three versions of the same man. The first one is done entirely in local value. No particular light is visible: The coat is simply black and the shirt white. Notice that Reid has tried to use all six values in this sketch. Can you identify the ones he used? Matching them with the grays in the value chart you did on page 85 will help you practice recognizing them.

Notice the clear, simple quality of this sketch. This is not a great painting, but at least it's understandable and obvious. That's what painting in local value means—nothing complicated or difficult, just a simple, clear statement of what you see.

2. Adding Light and Shade. Now let's shine bright light on the little fellow. Notice that the local values in the light are about one value higher (lighter) than they were in the earlier version, and the values in the shadow have become about a value darker. (Reid can't paint the black coat any darker, so he simply leaves it black in this very simplified solution!) The point of this drawing is to show you that even if you add light and shade, it should never destroy local value.

3. Confused Version. This example shows what happens if light and shade gets out of hand and destroys the local value of objects. Perhaps in the right hands this fragmented approach would be fine; in fact, you may find this the most expressive sketch of the three. But let's take a closer look. Notice that there is no real value identity in any area and no clear foundation for those slashing accents that, with a solid foundation of local value, could have brought an exciting approach to this painting.

Many fine modern artists have deliberately disregarded traditional rules of painting. But breaking these rules was a conscious decision, based on what they wanted to say. They did not do it out of ignorance or ineptitude. First, you must know the rules in order to break them.

Controlling Values

Now that you understand the difference between local value and light and shade, look at sketches Charles Reid did from an old photograph of Civil War soldiers. They will teach you something about values. The sketches illustrate how to connect shadow values and emphasize textures.

Civil War Soldiers. Compare these two sketches of Civil War soldiers. Why is it that one appears jumbled and confused while the other has clarity and strength? Reid deliberately limited himself to the same three values in both sketches, so the weakness of the first sketch is not due to the selection of the wrong values. So what is wrong with it?

Sketch 1. The error lies in the arrangement and grouping of the values. There are too many small pieces of unrelated value details in the sketch, and they are breaking up the picture as a whole. This is the same mistake that created confusion in the last drawing of the little man.

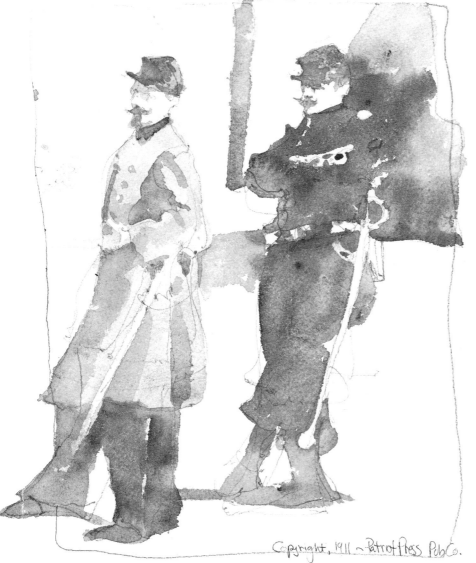

Sketch 2. To eliminate the confusion in this sketch, Reid simplifies the values by grouping them into larger shapes of the same value. To do this, he looks for two different types of shapes: outside shapes (like the silhouette of the figure) and inside shapes (smaller shapes within, such as the shadow on the soldiers, their buttons and metals, and their swords). Wherever the local values are similar, Reid masses these shapes together. For example, he ties in the dark costume of the soldier on the right with the shadow behind him. Notice that he keeps the costume dark even though light shines on it.

Reid also makes shadow shapes descriptive—they follow the forms they are on. For example, notice how rounded the shadows are on the chest and arm of the soldier on the left and how much more interesting its shape is here than it was in the first example. Wherever there is no definite shape, Reid leaves the paper white. Halftones are also left as white paper.

Copyright, 1911 ~ Patriot Press Pub Co.

Planning a Basic Value Scheme

Most of us think of composition in terms of objects. We worry if the subject is too close to a corner or too much in the center of a painting. It's true that sometimes the placement of your subject is very important, but, to Charles Reid, value is very important in composition. For example, when you put a dark object against a light background, you make it seem very important, but if you place it next to another dark object, it doesn't seem important at all.

Judy. This portrait of Reid's wife was done a long time ago. In those days Reid wanted to paint like Andrew Wyeth. But after he realized that there is only one Andrew Wyeth, he went on to try to find "Charles Reid." However, he still finds Wyeth a first-rate artist. One of the things he admires most about Wyeth's work is the abstract foundation of his paintings. His compositions can often be broken down into two or three major value areas. That's what Reid was trying to do here.

Sketch 1. Even though the actual painting contains five or six values, they could easily be reduced to two basic values. To do this, Reid forces the darks and middle values together as one value and masses the light values together as a third group (shown as the white paper).

This is not as difficult as it seems. You just group the halftones (values between the lightest and darkest areas) with either extreme, according to the effect you want. For example, if you want to concentrate attention on the form of the face, you would group the halftones with the darks. But if you wanted to stress the eyes, you'd want a flatter, more two-dimensional effect. In that case, you would group the halftones with the lights. The important thing is not to confuse your value areas by stressing minor variations.

You must make your shapes very strong. Therefore, you wouldn't make the darks in the sweater as dark as the background or hair, and you wouldn't want to complicate the dark hair mass with small, unimportant highlights.

The point here is to be aware of economy of means and simplicity. Focusing on these two values forces Reid to establish the "big idea," the major theme of the painting. Of course, hue and intensity also help show variations between areas. But since the point here is to concentrate

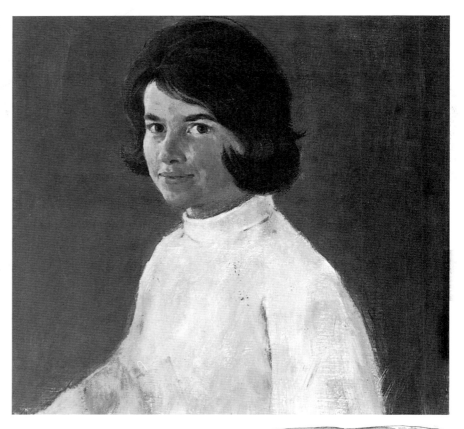

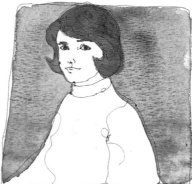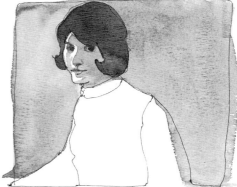

on values, you should start thinking in terms of simplifying them into large masses.

Sketch 2. Now Reid adds a third value to the sketch—a middle value. Notice how it helps strengthen the composition. Of course, you need more than three values to make a decent painting, but that's not the point. These sketches are to show you how to plan a basic value scheme.

Judith with Sarah. This is another portrait of Judy—before she gave birth to the Reids' daughter, Sarah. To show you how values can balance a composition, Reid also includes two sketches of this painting. The first one illustrates the unorthodox placement of the subject on the canvas, while the second shows how the arrangement of lights and darks makes it into an acceptable (and interesting) composition.

Sketch 1. Normally a face and hands are considered the main focus in a portrait and are therefore usually positioned in a central area of the painting. But here Charles Reid puts the face in the upper center and the hands in the lower right-hand corner. Theoretically, this is an error. You're not supposed to center a subject and you're not supposed to put a focal point near a border or corner. But he finds it fun to ignore rules (at least in composition), and proper subject placement is one rule he particularly enjoys disregarding.

In fact, Reid likes this composition because he thinks that placing a person near and facing into the border creates a certain tension in a portrait. It also eliminates what he calls "background worry." Had he placed Judy further to the left, he would have had to create a lot more background on the right-hand side of the painting. Besides, this compositional device is not without historic precedent—Degas used it too!

Sketch 2. Here the problems of figure placement are no longer apparent. Now you can see that the painting is balanced by shapes of different weights and sizes. Notice how important negative shapes are. They literally carry the whole painting. Now compare these two sketches with the finished painting. The "incorrect" composition is balanced entirely by the abstract arrangement of the value pattern.

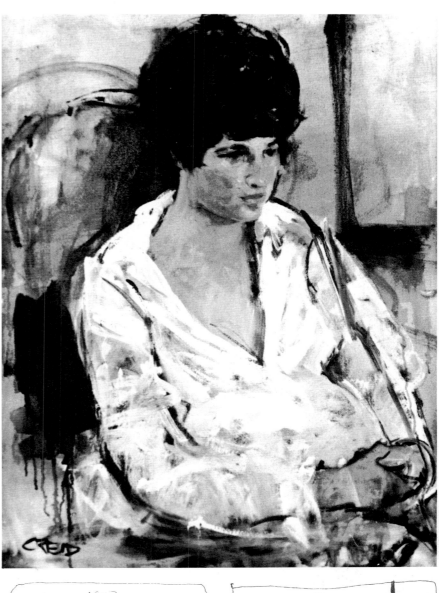

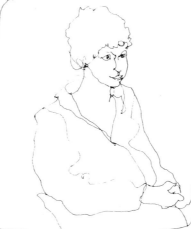

FROM SKETCH TO FINISHED PAINTING

In the last section, you observed ways in which sketching provides the artist with a highly effective method for solving problems of composition, value, and massing. In this section, you'll see how eight artists apply what they've learned from sketching to their finished paintings. Here, you'll see how these highly skilled and very different artists develop and refine their ideas for paintings through the use of the simple sketch.

Sketches serve many purposes for the artist who is planning a painting project. Initially, sketches are used as a method for stating the essential idea or concept of the painting. These small studies can help you discover ways of simplifying shapes and of coordinating masses into a harmonious whole. As the painting develops, sketches can help to determine value and color patterns; map out the rhythm or path of visual movement; and indicate the focal point. In the final stages of a painting, sketches continue to be part of the painting process; a quick sketch can point out where a change in value or in massing forms can bring you closer to a successful painting.

Building an Illusion of Space from Intricate Detail

The endless variety of abstract patterns found in nature fascinates William McNamara. Over and over again in his paintings, he explores how color, light, and shadow meld together, creating subtle yet complex designs. He chooses his subjects intuitively, rarely stopping to analyze what draws him to a particular spot, yet all his works share a preoccupation with color and shadow, positive and negative space, and opacity and transparency.

The sheet of drawings on the right includes the first steps McNamara takes when he selects a subject. Working rapidly, he tries to capture the essence of a scene—here recession into depth as well as the pattern of darks and lights. The drawing on the lower right side is more detailed than the other three. In it, McNamara explores the value scheme he will use in the painting.

Winter Waterfall is the last in a series of snow paintings that McNamara executed. He uses more color in the snow than he had attempted before. The work also has a stronger sense of depth than most of his paintings, yet again deals with pattern—here the patterns created as light plays on the uneven surface of the snow.

He begins the painting by establishing the darks, using a very pale wash of Van Dyke brown applied with broken strokes over the entire surface. Layer upon layer of broken strokes are then applied on top of this underpainting as McNamara picks out forms and patterns with his brush. As a final step, he pulls portions of the surface together with very subtle washes of pale blue.

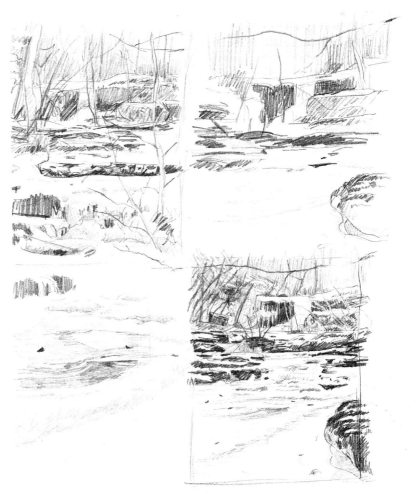

General Working Methods.

McNamara's palette varies from painting to painting, often depending on what he has on hand. He never uses white or black, and he works with just one brush—a high-quality red sable No. 12—on linen-rag 300-lb. cold press paper.

McNamara usually begins to explore a subject with sketches, as shown here. The first ones are quick action studies. Once he has grasped the essence of a subject, he spends several hours working up a more finished drawing that captures the compositional plan and the value scheme.

McNamara executes another detailed drawing on watercolor paper (not shown here) that acts like a grid when he starts to paint. Underpainting is McNamara's next step. Because the drawing contains so much information about the placement of the various compositional elements, he is now free to react loosely to

what he sees. Typically, he uses a very light wash of Van Dyke brown when he starts laying in the darks. He works all over the paper, laying down short, pale strokes, trying to achieve a balanced feeling.

Once the underpainting is complete, he begins to add other colors, again putting down layers of soft, broken strokes of pale color. He mixes his colors on the palette, carefully regulating the amount of water he uses in each wash. He controls the water content by wiping his brush on an old diaper, usually keeping his brush dry enough for precise work, yet wet enough to keep the color transparent. He always lets one color dry before he applies another layer of paint. McNamara reserves the lightest areas for last. At the very end of the painting, he sometimes puts a pale wash over a whole section to unify it and to strengthen the overall color theme.

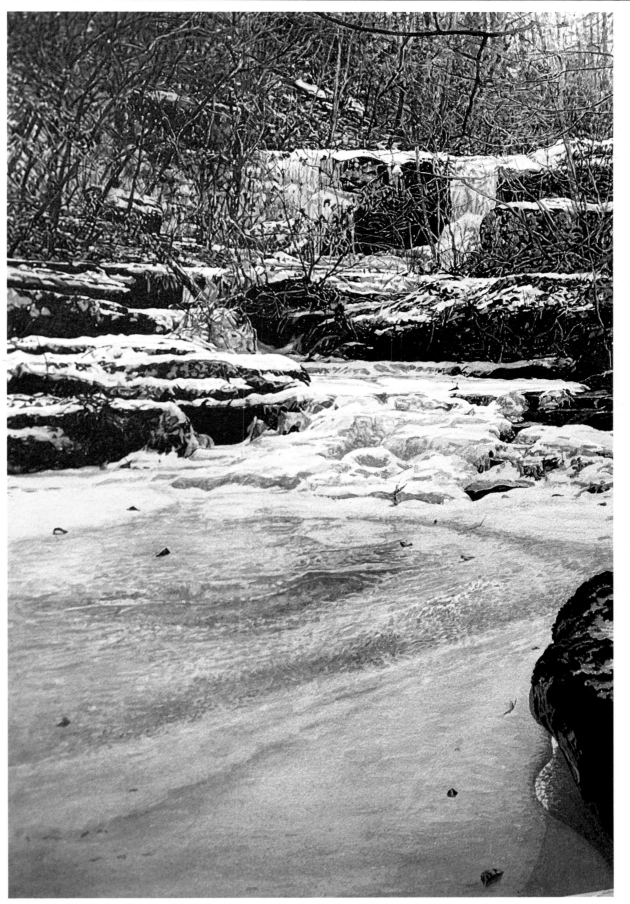

Winter Waterfall, 15″ × 22″ (38 × 56 cm), by William McNamara. Courtesy Capricorn Galleries, Bethesda, Maryland.

Painting a Figure in Light

In selecting her subjects, Jane Corsellis often conjures up distant memories, unusual old visual experiences, or past moods that are triggered by something she is currently seeing. That is exactly what happened in this painting of *Salome*. As a child, she remembers coming into the house from the fields and being told to remove her muddy clothes in the washroom. The memory of pulling shirts over her head mingles with recollections of long dresses hung up to dry, with bright light filtering through them. Corsellis called this painting *Salome* because she felt that the legendary woman must have pulled off her clothing just like this woman before getting into her beautiful veils and dancing for the king with such terrible consequences.

By studying her preliminary sketches, you can follow her thinking about composition, light sources, and values as the painting gradually takes shape. For instance, she wants to show the contrast in form between the flat, angular dress and the soft three-dimensional figure.

She decides to work on a large canvas and begins by laying it on the studio floor and rubbing a very pale solution of burnt sienna, yellow ochre, and terre verte over the surface with a rag to reduce the brilliance of the white canvas. This creates a layer of subtly differing glazes that makes a lovely toned ground to work on. When the canvas is dry, she blocks in the basic shapes with a weak tone of raw umber, which she spreads on with an old cotton cloth folded into a pad. She fills the canvas as lightly and quickly as possible, keeping the forms simple.

As she adds the objects in the room—the dress, window, and wash area—she keeps their values balanced, constantly comparing their sharp, dark tones to each other and to the subtle tone of the lightly glazed walls and ceiling. As the painting progresses, the composition becomes more complete. The air vent in the upper left is put in, scrubbed out, and then put back in again because of its effect on the painting's overall balance. At first she draws the drying rack straight-on, with the ropes going out the top of the painting. But it doesn't work, so she finds by lowering the rack and tilting the rails slightly, the whole composition works better. The clothes line, running across the top, is needed to describe the depth and breadth of the room. Corsellis depicts the woman's skirt sharply in some places and more loosely in others, summarizing its impression with a minimum of realistic detail.

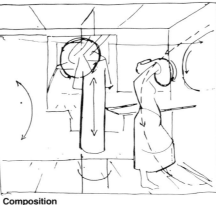

Composition

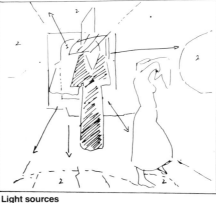

Light sources

Values

Like many painters, Corsellis is never quite sure when a painting is finished. Her acid test is to stand it at the end of her bed at night and study it before going to sleep. When she wakes, she studies the painting again, and if there is more to be done, she usually sees it then. She also often holds a painting before a mirror to check composition and proportions; seeing it in reverse reveals weak or unfinished passages.

Salome, 50″ × 60″ (127 × 152 cm), by Jane Corsellis.

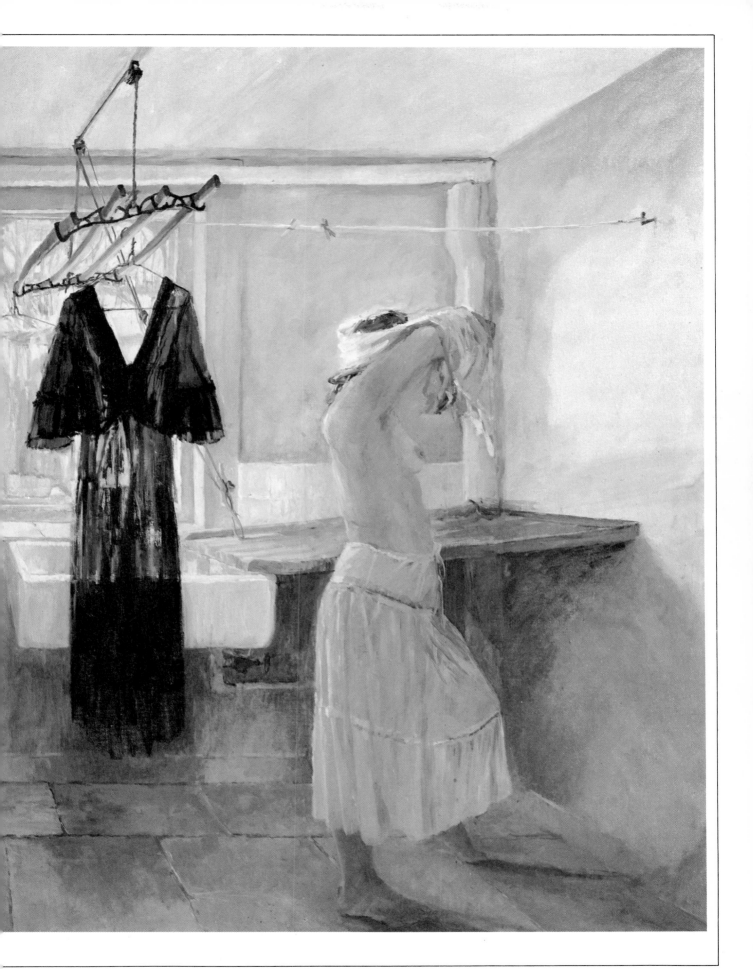

Creating a Mysterious Night Light

The idea for this painting came while Jane Corsellis was visiting friends in Hampshire, England, at a remote cottage once reportedly owned by a femme fatale called Betty Mundy. There, it seems she had lured many a British sailor to his death. The eerie reputation of the cottage was intensified at night by the fact that the only light came from oil lamps and candles—there was no electricity. This, coupled with baying, hooting, and other nighttime woodland sounds, was the atmosphere Corsellis hoped to convey in the painting.

Jane particularly likes painting interiors involving several rooms. After some thought, she decides to place the painting's viewpoint in the front room, looking into the kitchen where her friend is cooking. It is winter and the oil lamp on the table casts warm shadows on the walls and floor—more purple than green—as well as strange reflections on the door. She wants to keep this interior dark and mysterious and so makes the preliminary drawings by oil light in the evening.

Charcoal Drawing. Corsellis decides to paint *Betty Mundy* on a 48″ × 60″ canvas, but working on a canvas that size at the cottage is out of the question. So after doing a series of drawings and watercolors there, she finished the painting later in her studio in London.

Here she uses sized paper and works with charcoal, charcoal pencil, Conté crayon, and white chalk, smudging the drawing with her fingers and lifting out the light areas with a kneaded eraser. She originally intended to wash color over this drawing, but she went too far to do it—even though the drawing still has a certain "gaucheness" because it was intended as a plan for a painting and not a finished drawing.

As she works on the drawing, she keeps the proportions of her canvas and its divisions in mind, thinking in terms of the golden section. The golden section, a classic means of dividing an area, dates back to the ancient Greeks. It is basically a "perfect" proportion of one line to another, a ratio of roughly 1 to 1.6, or 8 to 13. You can see that she places the head against the window in that proportion and locates the door within the wall at that point. The horizontal line of the table within the doorway is also at that approximate vertical level. Corsellis rarely uses a ruler and compass but relies on her eye and intuition instead. She drew the grid over the drawing later when she transferred it to canvas.

Watercolor Sketches. Here Corsellis is primarily interested in capturing the sensations that she feels when she looks at the hanging on the wall behind the door. She also wants to remember certain details of the setting—the shadow behind the door and its effect on the hanging, the wooden framework of the door (though later she replaced it with her own bedroom door), and the position of the light and the way it cast shadows on the surrounding area. She paints a second watercolor with Betty Mundy entering the room from the right side, her profile framed in the doorway, but later changes her mind because the overall effect isn't strong enough.

It's difficult for Corsellis to analyze her own painting because there are always changes she would like to make, even when it's finished. But she has learned to leave a painting alone after some point, because if she were to make it a little bit lighter here and a little bit darker there, before long it would be a very different painting.

Refining a Painting

After she squares up the canvas and transfers the proportions and major compositional lines of her charcoal drawing to it, she begins by blocking in the warm and cool areas, starting with the walls and door. Because the tone behind the door is warm, she introduces cobalt violet (a color she rarely uses), scrubbing it in with a rag. Then she makes a purple behind the door with rose madder and ultramarine blue. The warmth makes the shadow come forward. Then Corsellis paints the door ultramarine blue, rubbing it lighter where the lamp's glare hits the door. The tones on the far wall range from cool near the table to warm in the shadows. The rose madder-colored cloth on the table links the kitchen with the wall hanging.

She deliberately patterns the wall hanging, because it will not balance the figure as a solid color. But she knows she'll have to suggest its pattern, so it won't detract from the figure. She resolves that by accentuating the diamond shapes and echoing them elsewhere—in the crook of Betty's arm, the overall shape of her figure, the lines made by the door and wall against the floor and ceiling, and the shadows in the far room cast by the lamp on the walls and in the window. This creates a rhythm that integrates the painting into a whole. She darkens the strip over the doorway and on its right and places objects on the table. She also scumbles the floorboards with a warm burnt umber and lightens the windowpanes, adding the lamp's reflection. The lighter color throws the head into relief, and since she likes the effect, she decides to strengthen it.

As Corsellis is finishing the painting, she decides to place the oil lamp out of view, only showing its light on the far wall and in the cool patch of color it casts on the floor. She also makes the face darker, lower in tone, and greener. She also darkens the object in Betty's hand so it is less apparent. The pitcher on the left echoes her shape in reverse, as does a second pitcher Corsellis adds in place of the lamp. The vertical lines are continued into the reflections of the figure in the polished table. Even though there's a lot of blue here, the umber shadows and violet wall hanging make the painting seem much warmer. If you compare this with the studies, you will notice many other refinements.

An Evening at Betty Mundy's, 48″ × 60″ (122 × 152 cm), **by Jane Corsellis.**

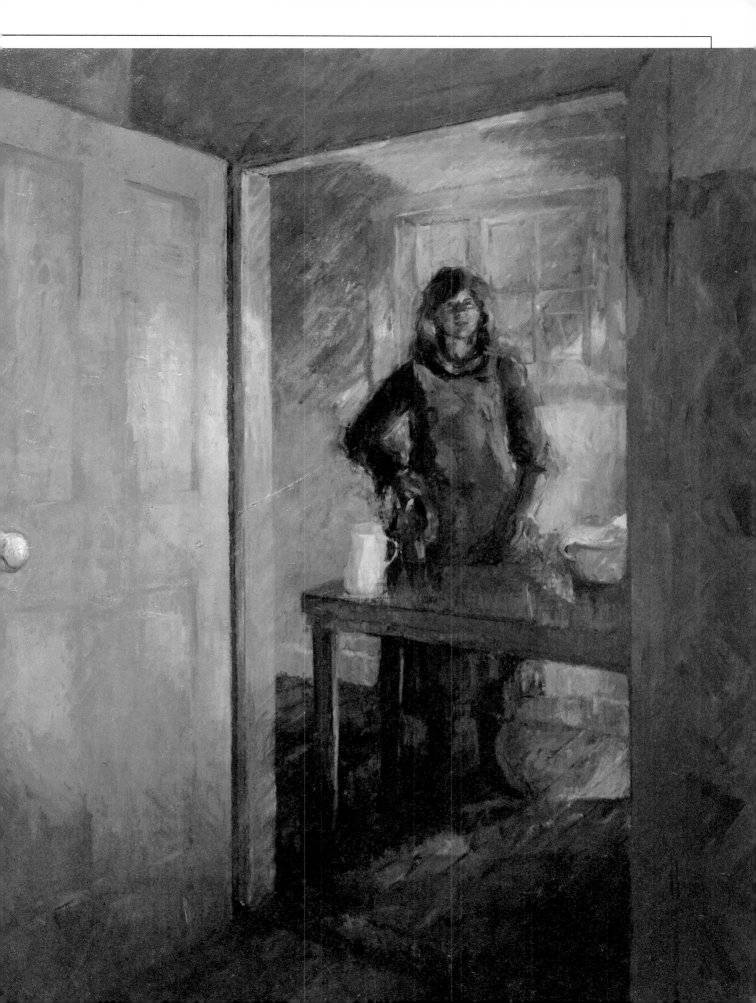

Exploring Color and Light in the Landscape

For years, Alex Martin has explored light and color and his own strong reactions to the mood and mystery of the land. Inspired by the way light fills the sky at different times of day and in different seasons, his canvases glow with carefully balanced masses of warm and cool colors and light and dark values. He tries to begin every painting with an open mind and discover the landscape new each time. Each painting is built up of luminous transparent passages of color that weave in and out, forming the large ephemeral shapes that fill the sky.

Martin usually begins his most successful drawings and paintings thrilled about something he sees in the landscape. This thrill gives his search the momentum he needs to create. In this inspired state of mind, Martin is willing to take chances and allow himself to become one with the landscape and the artistic process of capturing it.

Early Spring Sunrise was inspired by a watercolor Martin made early one morning in late April, just before the buds on the trees began to open. The watercolor captures the exhilarating feeling of dawn in the spring. For Martin, it's a time when things are awakening; it's hopeful, optimistic, and full of surprises.

In the watercolor, and later in the oil, he wants to capture the radiance of the sky and the streaks of light rushing through it that contrast with the dark clouds rolling away. Warm and cool colors collide in the sky, just as they do on the ground, where the reddish-brown land is beginning to be covered with fresh new grass. It's the interplay of light and dark and warm and cool colors that give the painting a bittersweet sense.

Many of the ideas worked out in the oil painting (see facing page) are initially developed through sketches as Martin tries to simplify the foreground space and coordinate the trees and buildings with it. He executes some large value studies in ink to capture the rhythm of the sky and to balance the sky with the ground, as well as gestural drawings in compressed charcoal. Later he makes an 18″ × 24″ (46 × 61 cm) oil sketch to develop the color mood.

Martin often explores a subject with loose drawings before he begins to paint. The sketches help him discover ways of simplifying shapes and of coordinating the land masses with the sky. In the final oil, everything—the foreground, buildings, and sky—has to work together as a unit, and these preparatory drawings help Martin clear away the problems he might otherwise encounter when he begins a large oil.

The watercolor for *Early Spring Sunrise* was inspired by the special light and color of an early morning; it is one of the 30 to 40 watercolors Martin has painted on the same spot. Just as in the large oil, the sky sets the mood of the painting—everything else must work with it. Here the color is set down boldly, with sweeping strokes. The same colors that dominate the sky find their way into the ground below.

Through wash value studies, Martin begins to capture the rhythm of the sky and to coordinate the sky with the land. He is not only working with values, but also searching for bridges between the two areas. In the value drawing here, near the center of the paper, the cloud mass on the left is linked to the ground. The same bridge in color and value exists in the finished oil.

Executed with compressed charcoal on a sheet of paper 18″ × 24″, Martin's gesture drawing captures the rush of movement in the sky. Some of the strokes are flowing and calligraphic. Others, done with the side of the graphite stick, indicate broad, sweeping areas.

To develop the color mood of the painting, Martin does an oil study. Painted on an 18″ × 24″ surface, it is the same scale as the finished painting. Although the study resembles the large oil, each has its own life and vitality.

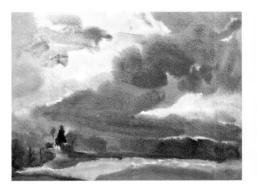

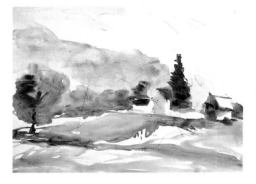

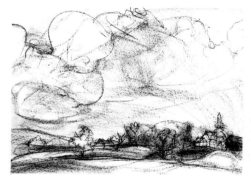

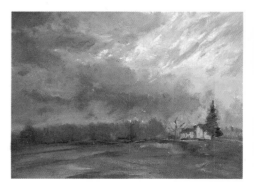

From the top down: Watercolor Study, Value Study, Gesture Drawing, and Oil Study, each 18″ × 24″ (46 × 61 cm).

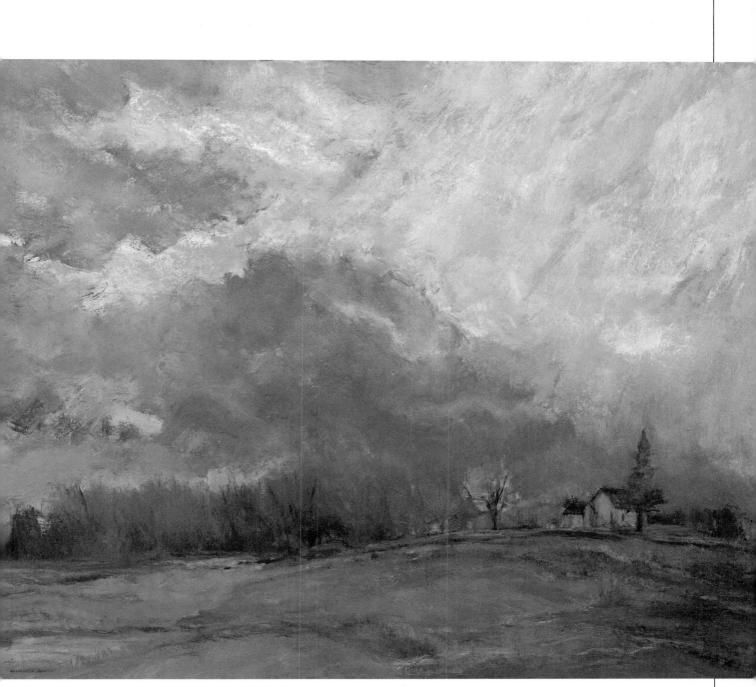

Early Spring Sunrise, 48″ × 60″ (122 × 152 cm), **by Alex Martin.**

When Martin begins the final painting, he uses large brushes and boldly masses in the underpainting. The key color is created from cadmium yellow light mixed with white and a little cadmium red light. The underpainting gets redder near the land and continues to be tinged with red across the ground. While these colors are still wet, Martin lays in cerulean blue mixed with white and a touch of cadmium yellow light. The large break in the sky is created with permanent blue mixed with

cadmium red light. These same warm and cool colors are mixed to create the wooded area.

By using a similar palette for the sky and the ground, Martin found a way to let the sky merge with the land. Here cerulean blue and yellow form the bridge between the two areas. The reddish brown of the trees is also continued toward the bottom of the painting in the grass.

Learning Innovative Landscape Techniques

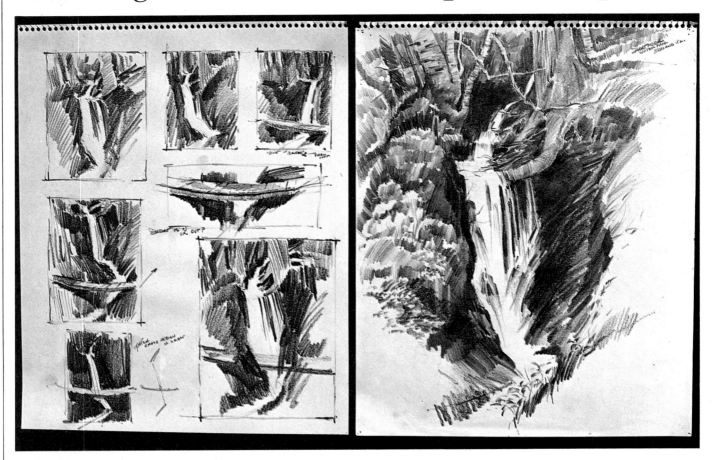

John Koser's paintings bristle with life. Each one is packed with hundreds, even thousands, of speckles of paint that blend together, constantly forming new color sensations. Their fresh appeal is largely the result of an innovative watercolor technique that Koser developed.

Until around five years ago, Koser worked in a fairly traditional fashion. Then, intrigued by how pigment mixed together on his palette, he started experimenting with a noncontact method of painting. Koser now spatters primary colors onto a wet surface, where they come together and mix. Working with just one yellow, one red, and one blue, he creates an infinite range of colors. To regulate his values, he varies the amount of water he mixes with his pigments.

When Koser began working with this technique, he thought that it would be difficult to control. Surprisingly, he quickly learned how to direct the flow of water and color. To create a strong directional sense from the very start of a painting, he flicks water and then paint in the same predetermined direction.

Control also results because Koser builds up his tonal values slowly—his first applications of wash are barely visible. If his subject demands strong contrasts of lights and darks, he first establishes the lights all over the surface of the paper and then goes on to concentrate on the darks.

Koser stumbled upon this waterfall while he was walking alone in England's Dartmoor Forest. He was immediately caught by the mood of the spot—its solitude and the rich moist air that enveloped the area.

Composing the scene is Koser's first challenge. In a series of black-and-white sketches, he plays around with the structure of the scene and with its value scheme. The footbridge wasn't exactly where he wanted it to be, so he toys with the notion of omitting it. These sketches trace the path Koser made as he worked with what he saw.

Eventually Koser decides to delete the bridge. Then, when he begins the paint-ing, he reverses his decision. Changing its position slightly, he works it into the composition.

Finished Painting. Koser wanted to ex-ecute the focal points of the painting—the waterfall and bridge—last, so he blocks them out before starting to work. He cuts out resists from an old mat board and fastens them to the painting surface with push pins. When he begins directing the flow of the paint and water, he works outward, away from the bridge and water-fall. Because all the color rushes away from them, the bridge and water seem to surge with energy.

Notice the rich variety of colors created from three primaries—cadmium orange, alizarin crimson mixed with cadmium red, and Winsor blue. The tiny islands of white that run over the painting's surface are the natural result of Koser's method. Super-fine dry pastels, applied with vertical strokes, highlight portions of the painting, such as the foliage behind the bridge, and reinforce the direction of the waterfall.

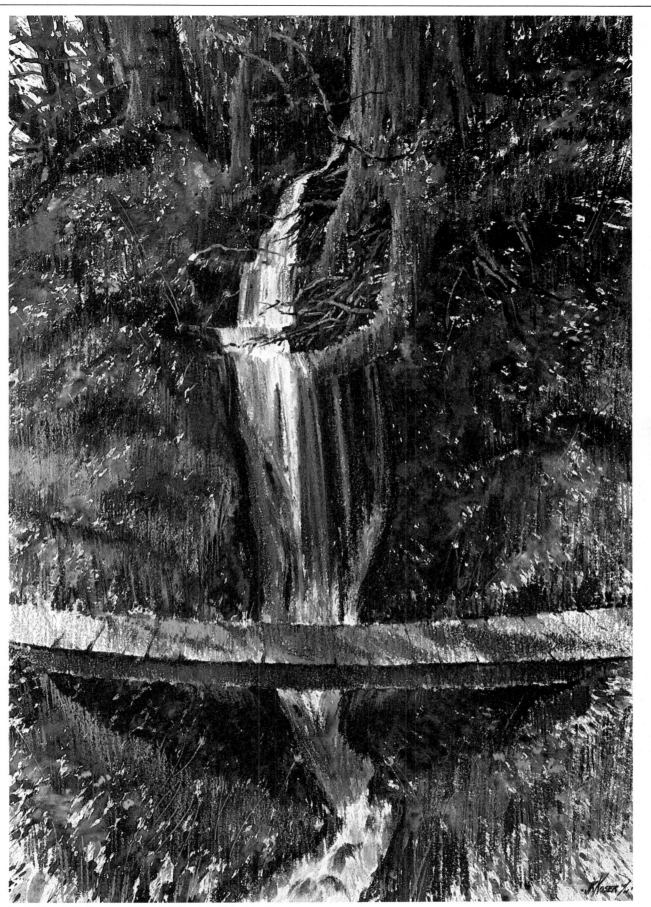

Spring Waterfall in Dartmoor, 19″ × 28″ (48 × 71 cm), by John Koser.

Discovering a New Way to Express Light

A breakthrough in handling light comes to David Millard one day as he sketches. He begins to encircle pieces and patterns of sunlight as it filters through the trees and falls on women chatting in the park. He begins to circle the spots of light on their backs, heads, and umbrellas. This doesn't seem unusual to him at the time, but it becomes the beginning of a new sequence of painting material.

Later from memory, Millard applies color to the sketches in the studio. He notes that had he pulled out his watercolors and started painting then, the people would have fled, and he never would have been able to spot them in these innovative light patterns.

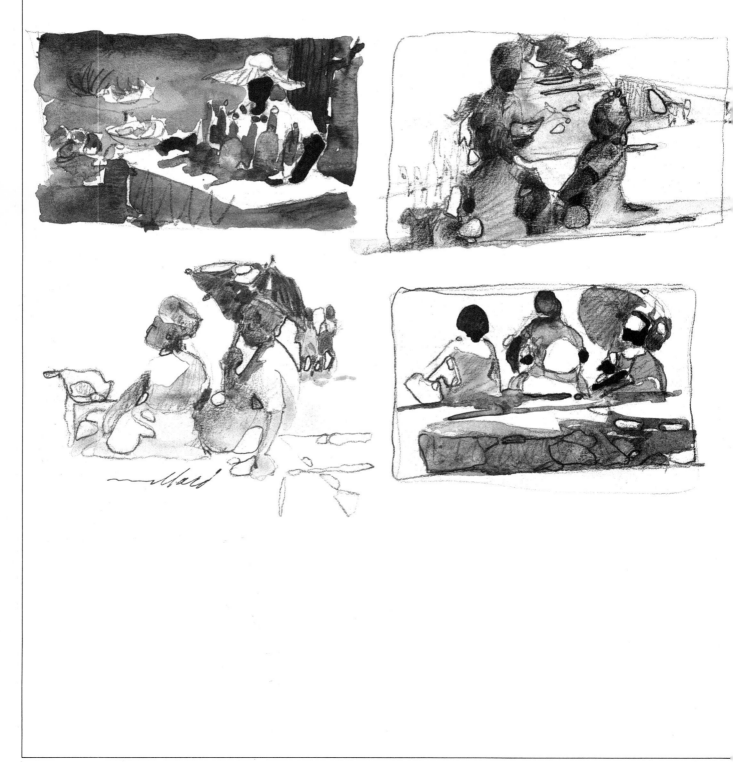

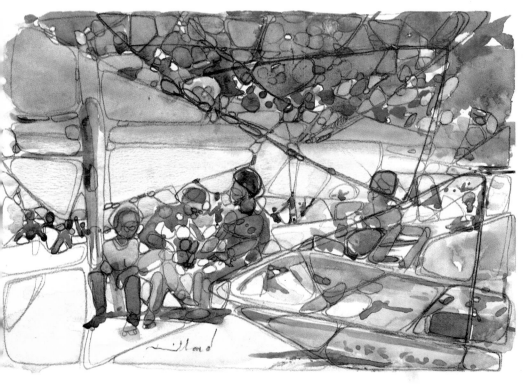

Circles Inspire Other Geometric Shapes. Millard is excited by how uniquely he is now seeing the light. By the next day in the park, he tries putting different geometric configurations over the entire picture—in figures, trees, a stone wall, even in big negative areas. He finds it exhilarating.

What lessons can you learn from Millard's approach? Always be alert to new possibilities; be willing to try new ideas anytime and any place.

Thinking about Design

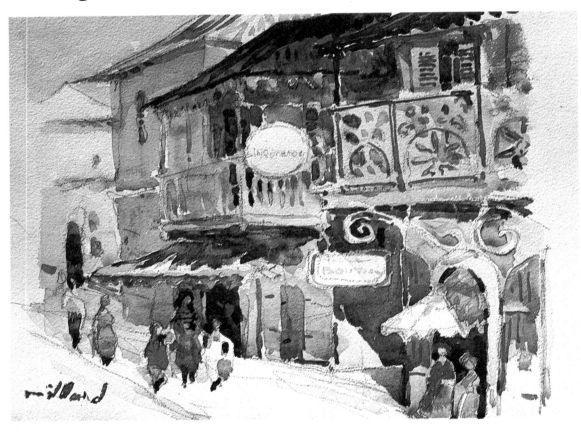

There are many vantage points along a street from which to make a painting. Follow your intuition as to what appeals to you and then put the three essential pieces together—design (pattern), value, and color—to create a painting. The combination of these three elements, listed in order of importance, is what helps you decide how to paint, whether your subject is a street scene, still life, landscape, or whatever.

Think First and Then Simplify What You See. See your figures in your mind's eye—your artist's eye—before you sketch. "See" the negative darks behind these figures in your mind. To capture the local charm of the iron balconies and

underbraces, create the effect of distance; force your viewer to believe what you want. Remember that you're the director of this piece of staging.

Give your painting a geometric structure. This one is based on triangles; observe their intricate interrelationships in the two sketches. Now notice how the cendre blue on the third building carries your eye back. Try closing one eye and covering the blue building with your finger tip. You'll see how, without that cendre blue, your eye wouldn't go back as far. David Millard uses this technique, which he calls his "finger test," in nearly every painting he does. And he constantly teaches it as well.

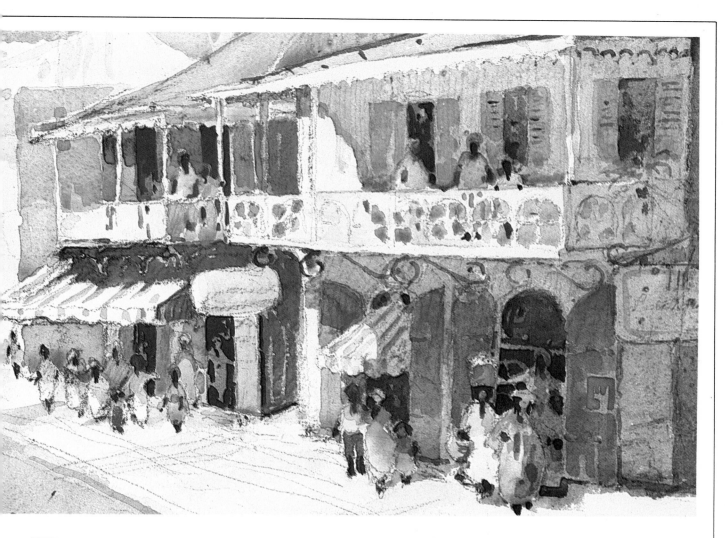

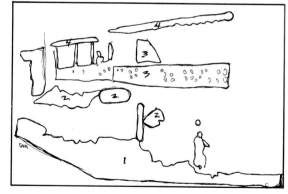

Design Is the First Element in Creating a Painting. The design here involves four strips of white accents and two strips of black accents. David Millard makes diagrams of the accent structure— one for the black and one for the white. Study the geometric alignment of accents before starting your sketch or work this out first in your sketchbook before beginning your painting. Now design your figure groupings. Start with the larger figures in the front.

Design a color sequence using the inventiveness of the right side of your brain. Go from orange to pink to rose in the first building and then from lavender to blue to green in the second building. Make your road a mixture of orange and cobalt violet. Make another finger test by first covering the pink building and then the green. Although green is a deeper value, orange-pink is a more exciting color. Repeat this to study the different effects, moving back and forth like a pendulum.

Using Thumbnail Sketches as a Guide

Gerald Brommer's mastery of color, value, and composition inspires all his work. Basic watercolor techniques form the backbone of his paintings, but experimentation is a powerful force for Brommer. In almost half of his paintings, he combines traditional watercolor with collage, covering a partially worked surface with a variety of handmade Oriental rice papers. He then completes the painting on the newly built surface.

In any one of his paintings, Brommer may turn to sponges, tissues, sticks, or pieces of cloth to add or wipe away the pigment. None of his unorthodox methods calls attention to themselves; they fit into his work logically, helping him to create successful, evocative paintings.

Working in his studio from slides and on-the-spot thumbnails, Brommer begins work on a painting by first executing a number of sketches to recall the impulse that drew him to the site and to determine an appropriate focal point. Here his studies show the California shoreline that inspired *Spring Color/Monterey Coast*.

Brommer works on an 18″ × 24″ sheet of bond paper, beginning with (A) a quick gestural drawing to get the feeling of the location. Next, he isolates the major elements in the scene with (B) a simple line drawing. To help set up possible value patterns and visual movement on the picture plane and to establish the center of interest, Brommer does (C) a quick value sketch. To determine the overall composition, he next approaches the scene (D) conceptually. His three quick sketches done in one value (E) explore different placements of the horizon. To help understand how backlighting influences his subject, he then does (F) a black-and-white sketch. His final drawing (G) simplifies the linear placement of the elements. After this kind of intensive probing, Brommer finds the painting process flows quickly and easily.

Spring Color/Monterey Coast is a demonstration painting that Brommer did for a workshop class at Asilomar on the Monterey Peninsula. He painted it on a full sheet of D'Arches 300-lb. rough paper, a favorite of his. Here the large size comes in especially handy as 40 students watch the painting progress. Brommer's aim is to demonstrate the effects of backlighting on the rocks and on the water. Capturing the contrast between the sun that glared

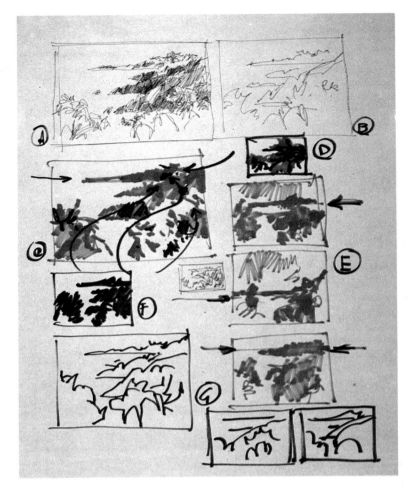

through a foggy sky and the bright textured surfaces in the foreground is also part of the challenge. The method he chooses is to simplify the areas bathed with light and to darken the shadowy areas with grayed color and deep values. In the foreground Brommer emphasizes texture and color.

To make the foreground the focal point of the painting, Brommer pushes the composition toward the top of the picture plane. He surrounds the cliffs in the background with halos of light to suggest how the sun fell on them. He bases his color selection on the scene's true colors. As in most of Brommer's paintings, earth tones predominate, with brighter colors reserved for accents.

Control of tonal values begins right

away. Brommer starts with the lightest values, gradually adding the darks. Whenever he lays in a dark stroke, he compares it with what is happening in the rest of the painting. If anything gets too dark, he immediately sponges it out and lightens it.

Toward the end of the painting, Brommer intensifies the shadows with blue-gray washes and then lifts out some areas to get the feeling of reflected light. To do this, he wets the areas with a nylon bristle brush and then lifts up the pigment firmly and quickly with absorbent tissue. Once the feeling of the backlighting became very intense and the contrast between the glaring water and the bold, cool rocks became strong, Brommer knew the painting was complete.

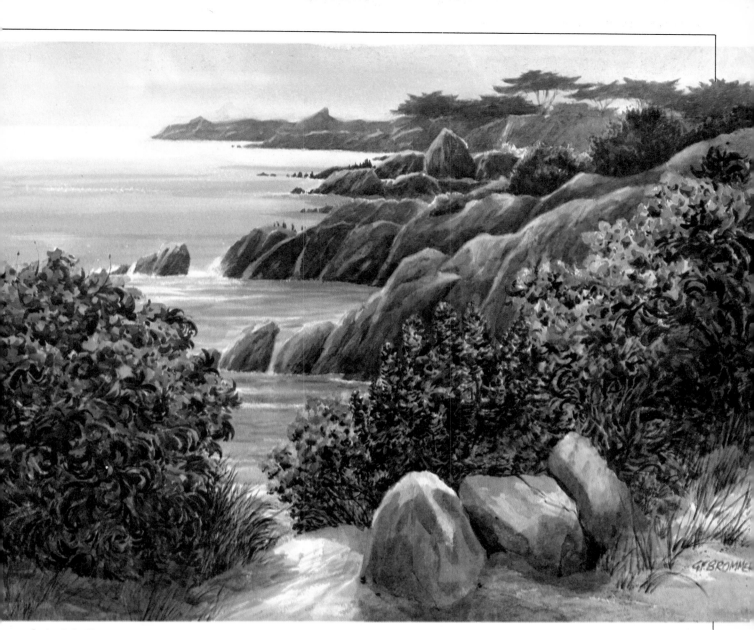

Spring Color/Monterey Coast, 22″ × 30″ (56 × 76 cm), by Gerald Brommer.

Detail. Everything about the foliage in the foreground pulls it right out at you. The colors are bright and clear, the brushstrokes strong and decisive, and the composition moves quickly toward the front of the picture plane. Yet the painting's recession into depth isn't abrupt. Right behind the bushes in the foreground, the rocks are tinged with deep pink. Farther back, the touches of pink become less intense, and in the distant background they are scarcely apparent. The crest of each rock mass is surrounded by a pale halo, clearly suggesting how the sun hits the back of the cliff, reflecting the light upward.

Thinking Through Ideas with Small Studies

The most conventional method of developing a painting is doing a small sketch first. The purpose of the study, of course, is to work out your major ideas on a smaller, more malleable scale. This is the method Philip Jamison uses in the two pairs of paintings shown here: The small watercolor was followed by a much larger one of the same subject.

Study for Railroad Crossing, 10″ × 14″ (25 × 36 cm).

It is appropriate to find the right scale for your finished painting, although many artists feel they must do their important work very large. Through the ages, many artists have painted on a large scale, but it's been primarily since the 1950s, when the abstract expressionists hit the scene, that painting large has become fashionable.

Today, with the advent of oversized paper, even watercolorists are getting into the act. Although a large painting is certainly more conspicuous, it isn't necessarily any better than a smaller one. After all, such respected watercolorists as John Martin and Charles Demuth nearly always worked on a relatively intimate scale. Quality has nothing to do with size. And if you are going to do a *bad* painting, Jamison advised, be sure not to do it big! It has always been his philosophy that an artist should paint on the scale that he or she finds most comfortable.

Jamison painted *Study for Railroad Crossing* quite rapidly. When it was completed, he studied it further and made

some changes that are not apparent here. For example, there was originally a dark gray macadamized road at the extreme right that extended downward from the horizon line to the very bottom of the paper. This heavy shape seemed out of balance with the rest of the watercolor, so Jamison scrubbed it out, leaving "snow" in its place.

The larger version of *Railroad Crossing* is a blow-up of the smaller study. However, if you compare the two, you can find many changes that Jamison made as he did the final painting. The major one is the enlargement of the grassy area in the foreground. This, he thinks, makes a much stronger composition because it introduces a dominant color and divides the paper into more interesting shapes. Other, more subtle changes include strengthening the distant hills and trees, changing the shape of the barn, and refining the pattern that the snow makes on the barn roofs as well as in the field. All these changes, to Jamison's eye, are an improvement on the original sketch.

The watercolor *Study for July, 1981* is a

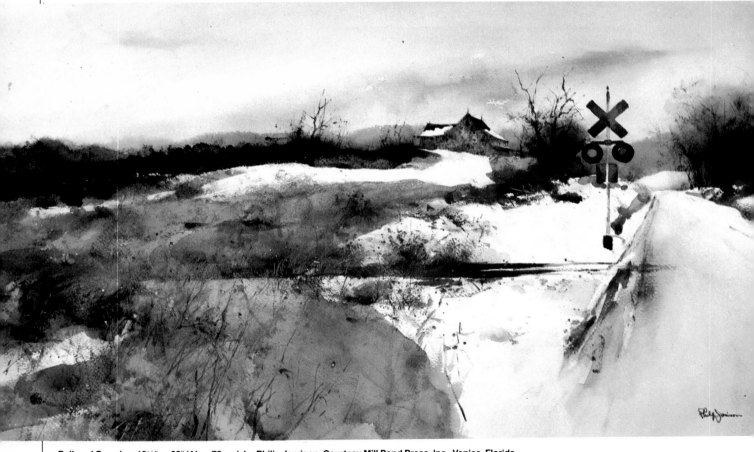

Railroad Crossing, 16¼″ × 30″ (41 × 76 cm), by Philip Jamison. Courtesy Mill Pond Press, Inc., Venice, Florida.

fairly literal representation of what Jamison saw in his studio at the time. As the sketch neared completion, Jamison did remove some large rectangular drawing boards that were behind and to the right of the table. Their shapes were too ungainly, just as the shape of the road was in the original version of *Study for Railroad Crossing*. His use of charcoal in the lower half of the sketch helped mask and subdue the clutter of chair and table legs that competed too much with the watercolor's center of interest.

The study provided a composition that Jamison thought could be developed into a larger watercolor. He made several refinements while painting *July, 1981*, primarily in the relationships between the lighter spaces. The major change, of course, is the addition of the bouquet of daisies in the foreground. These were not added merely because Jamison wished to add them, but his principal motivation was to enhance the design by interjecting and isolating a white shape against the large, dark mass of the table and floor.

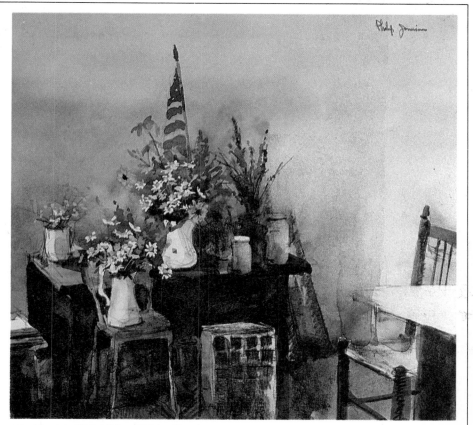

Study for July, 1981, 11¼″ × 12″ (29 × 30 cm).

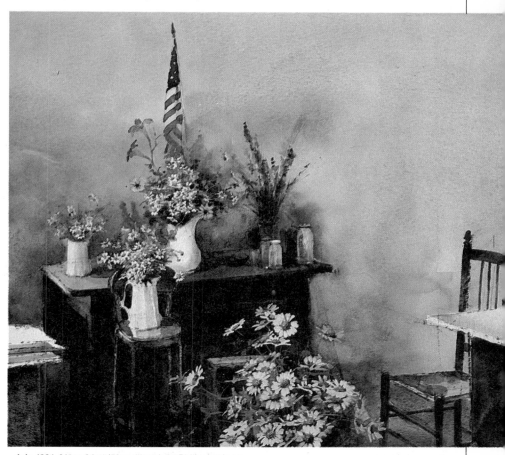

July, 1981, 21″ × 24½″ (53 × 62 cm), by Philip Jamison.

Different Ways of Approaching the Same Subject

Both the eye and the mind are required to produce a painting. The eye sees nature, and the mind interprets it. Thus, all art originates from the eye. The mind transforms it into line and color. It's the artist's imagination that determines the quality of the art produced. While the imagination is the truly creative component of painting, there are many other elements employed in the painting process. These include drawing, composition, and color, with an infinite number of variations and combinations.

Prior to starting this watercolor, *In Burt's Fish House*, Philip Jamison did these four pencil drawings, each from a different viewpoint but including the window that would be the subject of the painting. The fourth drawing is the direct inspiration for the final composition.

Jamison has often spent bad-weather days sketching in this fish house, a space about 14' square that is crammed with a constantly changing assortment of the paraphernalia of Burt Dyer's trade as a lobsterman on the island of Vinalhaven, Maine. The only major change Jamison made in the watercolor was to add the tin can of daisies on Burt's workbench.

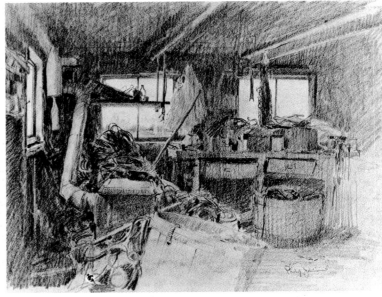

Study no. 1, 11″ × 14″ (28 × 36 cm).

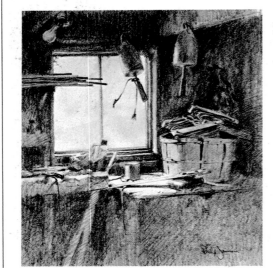

Study no. 4, 10⅜″ × 9½″ (26 × 24 cm).

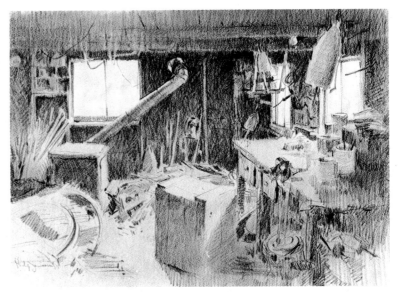

Study no. 2, 11″ × 14″ (28 × 36 cm).

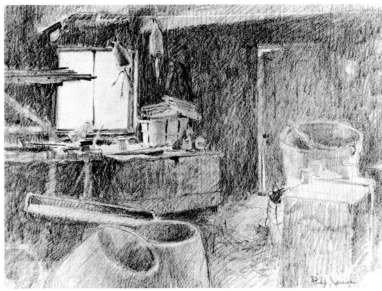

Study no. 3, 9″ × 11½″ (23 × 29 cm).

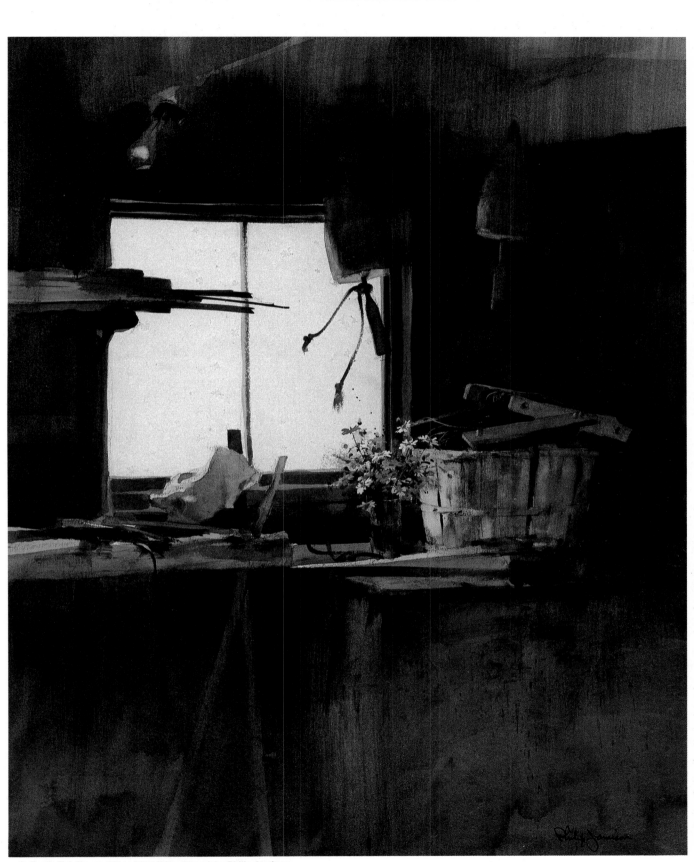

In Burt's Fish House, 18″ × 14½″ (46 × 37 cm), by Philip Jamison.

Working Out Details Through Sketches

On the island of Vinalhaven, there is a place called Ambrust Hill. It rises quite steeply in back of Bridgeside Inn. For years Jamison's family has used the hill for walks, picnics, blueberry picking, or just sitting and gazing at the harbor, the sea, and the outer islands.

At the turn of the century, the hill was a bare, solid mound of rock where granite was quarried and shipped to many distant places. But with the advent of concrete and the increasing costs of shipping, the granite industry of Vinalhaven gradually disappeared. Today Ambrust Hill is slowly acquiring a coat of blueberry bushes, spruce trees, and anything else that can survive on this rocky foundation. And it is here that Jamison has probably painted more of his watercolors than anywhere else.

At first he used to climb the hill, look seaward, and paint the houses of the island below. Over the years, he became increasingly aware of the hill itself. Today Jamison seldom paints "from" the hill—

he paints *the hill*. The reason for this is that he's become somewhat tired of the obvious—the spectacular vistas from the summit, the panoramic views of the harbor. His interest now is drawn to the essence of the hill itself. It is more subtle and personal to him. Each painting or sketch that he does on Ambrust Hill almost invariably leads to another. The constantly changing weather, as well as the color of the grasses, only adds to his growing awareness of this unique place.

The watercolors on pages 122–125 explain the process Jamison uses in trying to analyze and understand Ambrust Hill—from his visual "notes" on details of the vegetation through compositional studies to finished paintings.

Flora of Ambrust Hill is merely a notation made for his own study. It describes some of the details of the bushes that grow on the hill. Although he seldom uses such explicit details in his paintings, he finds it helpful to be familiar with them—just as an artist should have some knowl-

edge of anatomy in order to paint people. It stands to reason that if you understand how a tree grows, you will be better able to paint it.

Clump of Daisies, which was completed in about 20 minutes, was also done as a study. It was one of Jamison's first paintings of daisies. Jamison did it basically to familiarize himself with the flowers themselves and to figure out how to handle them in watercolor.

A wider expanse of a section of Ambrust Hill is shown in *Quarry Ledges*, which is a more sustained watercolor. The lower section of the painting is green. In actuality, this portion of the hill is light-colored, bare granite like the strip that runs horizontally through the center. Jamison chose to paint it green because he thought a large, light area would be too pronounced. By painting it a darker value, he could subdue it. This permits your eye to pass over it and go to the more important section of the painting.

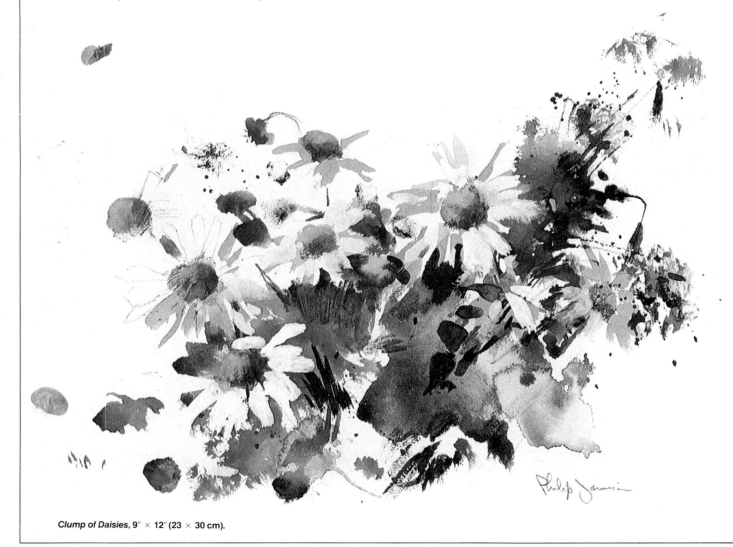

Clump of Daisies, 9″ × 12″ (23 × 30 cm).

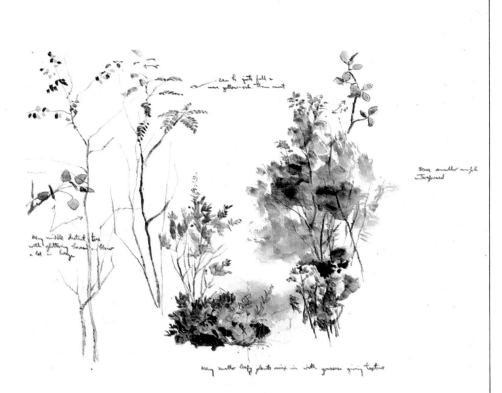

Flora of Ambrust Hill, 11″ × 14″ (28 × 36 cm). 11″ × 14″ (28 × 36 cm)

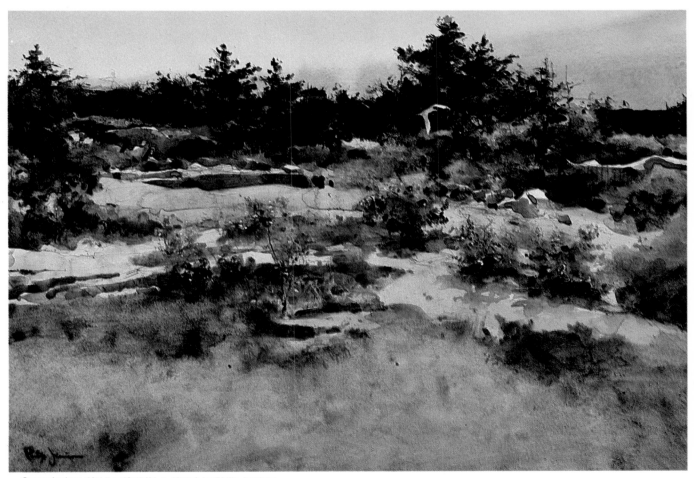

Quarry Ledges, 12¼″ × 19¼″ (31 × 49 cm), by Philip Jamison.

Painting Flowers after In-Depth Study

Occasionally Philip Jamison makes a quick compositional sketch prior to doing a finished painting. He looks at it completely as an abstraction in terms of color and shape. He used *Study for Bouquet on Ambrust Hill* as a preliminary sketch for a larger painting (not shown here) that is somewhat similar to *Flowers on Ambrust Hill No. 2*. The finished watercolor, although more detailed, has the same underlying pattern and colors.

***Study for Bouquet on Ambrust Hill**, 6½″ × 7½″ (17 × 19 cm).*

***Afterthought**, 9½″ × 12½″ (24 × 32 cm).*

Afterthought relates quite closely to *Study for Bouquet on Ambrust Hill*. The background of this sketch was also done as a compositional study for another painting. It was at a later date, back in the studio, that Jamison decided on a whim to interject a vase of daisies in the foreground. He still considers it a study.

***Flowers on Ambrust Hill No. 2**, 8⅜″ × 11½″ (21 × 29 cm), by Philip Jamison.*

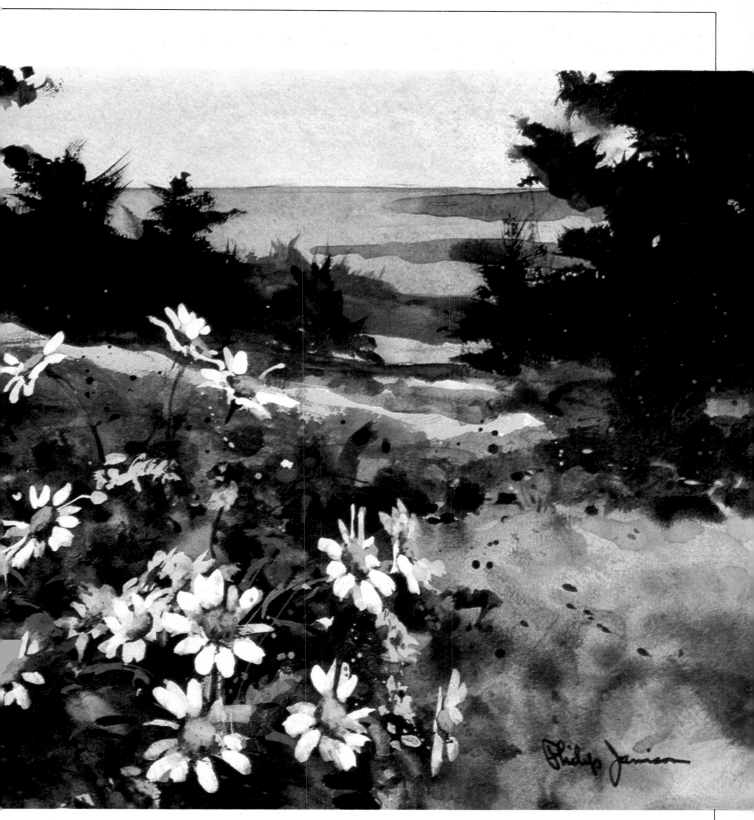

Flowers on Ambrust Hill No. 2 is one of the first paintings in which Jamison features a "bouquet" in the foreground of a landscape, a development that came about rather naturally as he painted more and more fields of daisies. Giving the group of flowers a bouquetlike promi-nence in the foreground not only empha-sizes the flowers but also helps Jamison develop the "picture" into a painting in his mind. It accentuates the mood of the scene, improves the composition, and quite possibly increases the illusion of depth.

Working in Series

Philip Jamison often works in series, doing a number of studies or watercolors of the same subject. The group of paintings shown on pages 126–129 evolved in this manner. Jamison did not start these paintings with the preconceived idea of making smaller sketches as studies for a larger painting. He did each one as an independent work, without planning that one would lead to another. As each is finished, he somehow became interested in doing another. He might decide that it would be interesting to try a different view of the same subject. Or he might want to interpret the subject in different lighting or weather conditions, discover an aspect of the subject he had not noticed before, or find another compositional arrangement.

This was the case when Jamison did these studies and paintings of Bridgeside Inn on Vinalhaven, Maine. It was changes in the weather—from fog to sun, which in turn changed the light patterns both within the room and outside—that initially triggered the progression. You'll notice that each painting varies not only in size, but also in the arrangement of the light patterns and in the furnishings of the porch.

One morning when Jamison ventured out into the enclosed porch of his mother's inn, the fog hung like a white blanket outside the long row of windows, almost completely obliterating his view of Indian Creek. Only a hint of the water, spruce trees, and fish houses showed through. This stark, eerie scene intrigued him so much that he got his sketchbook and made *Bridgeside Porch No. 1*, a drawing that turned out to be the first of a series of the porch. It was executed with a 6B pencil on ordinary smooth drawing paper.

Jamison painted *Bridgeside Porch No. 2* the next day. The fog had lifted and the atmosphere of the porch had changed completely. The contrast was astounding, and so he decided to do another sketch of it. This time, he chose to use watercolor in addition to pencil because the color in the scene was so much more pronounced without the fog. He used the same thin paper that he had used for the pencil sketch. He brushed in the watercolor quite rapidly and then, after allowing it to dry, refined and emphasized the drawing with a soft pencil.

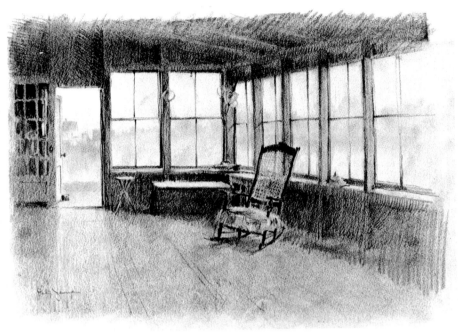

Bridgeside Porch No. 1, 11″ × 14″ (28 × 36 cm).

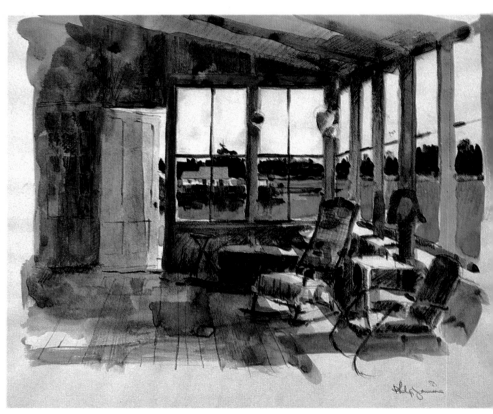

Bridgeside Porch No. 2, 11″ × 14″ (28 × 36 cm), by Philip Jamison.

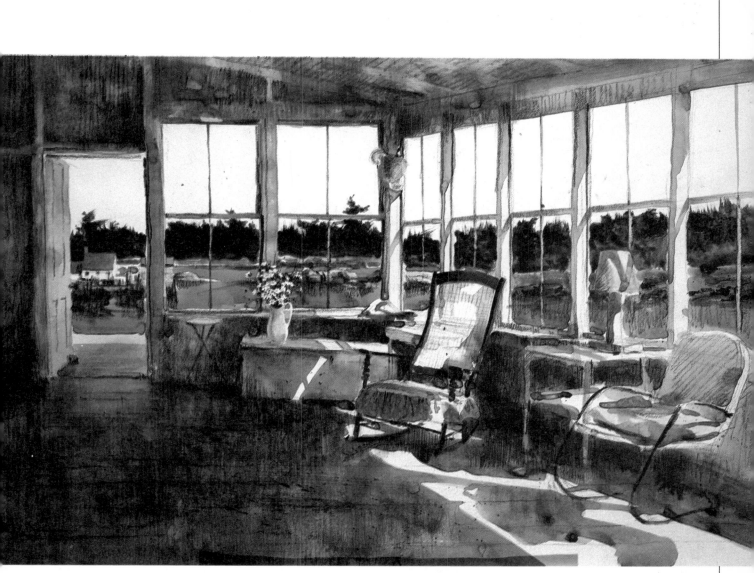

Bridgeside Porch No. 3, 10¾″ × 17⅛″ (27 × 43 cm), by Philip Jamison.

He was pleased with the results of his second sketch, especially the color and pattern, and so he was directly inspired to paint *Bridgeside Porch No. 3*, which became a larger, more sustained effort. He chose to shift his perspective ever so slightly and also to change the composition to a longer, more horizontal arrangement, because he thought that might produce a more dramatic painting.

Looking back on it, he's not so certain that he achieved this. He introduced a small vase of daisies simply to add a little vitality. The painting was executed on a thin 90-lb. watercolor paper, and although he did incorporate some pencil work, it is almost a pure watercolor.

Many Moods from One Subject

While Philip Jamison was painting the previous studies of the Bridgeside porch, he became aware of the constantly changing patterns that the sun made on the floor. There was a short time around mid-morning when this pattern intrigued him most, and that is when he chose to do this larger painting, *Bridgeside Porch No. 4*, using almost a full sheet of watercolor paper.

This time he adds a chair, features the vase of daisies even more prominently, and generally feels better equipped to work on a larger scale because he has become quite familiar with his subject by doing the previous drawing and watercolors.

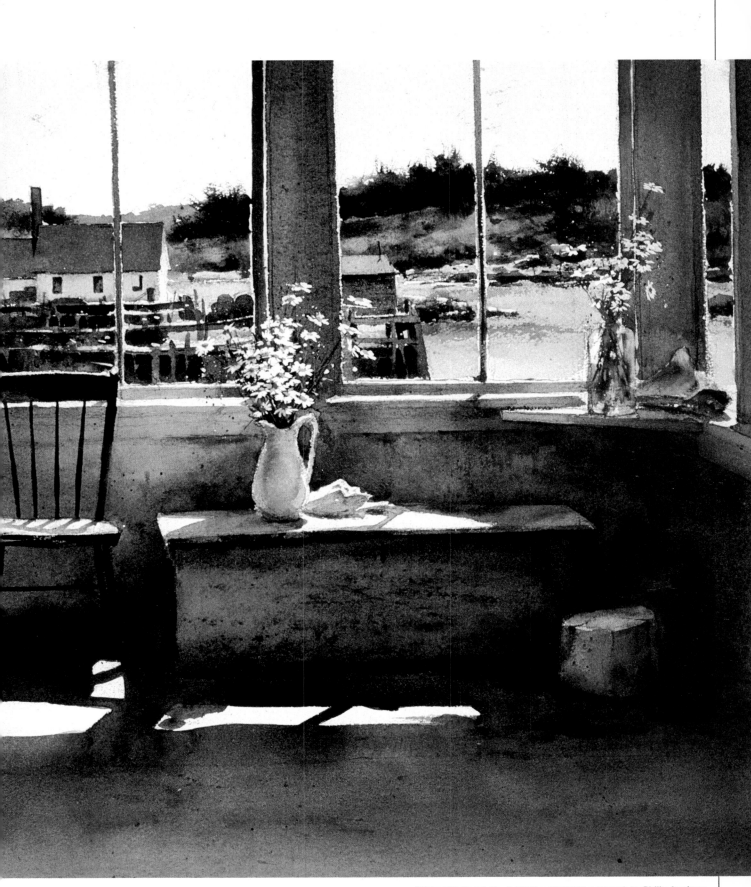

Bridgeside Porch No. 4, 18¾″ × 29½″ (48 × 75 cm), by Philip Jamison.

Interpreting Light

As has been said many times, you can interpret your subject any number of ways, depending on the aspect or quality of the scene you choose to emphasize. You can stress local color on a face because you don't want the features to be washed out in a strong light, or you can play up brilliant light on sparkling colors or focus on angles and shapes in a composition. Sometimes the attraction may not be the subject alone, but a combination of light, mood, and subject that triggers a painting. That's what inspired Charles Reid as he worked on the paintings shown here.

Even though he knew he wanted to paint the light here, he still had to make choices. The sketches show how the paintings might have looked had he emphasized the strong backlighting, stressing contrasts of light and shade (that is, values) rather than color. The effect of backlighting is dramatic, stark, and rather exciting. But other qualities can also be emphasized, and the finished painting describes his final interpretations.

Sketch 1. This is the view in terms of value, just about as he actually saw it. The strong backlight draws out local color and makes you aware of dark silhouettes against a light-struck table, floor, and landscape. This would make a good painting, perhaps one even better than the one he finally did—the sketch is definitely a stronger idea than the one he painted—but it would be a different painting, and what you paint depends on the feelings you want to convey. Reid points out that you can control a painting—to make a particular statement—through value changes.

Sketch 2. Reid prefers to emphasize local color rather than light and shade, and so this second sketch portrays the scene in a gentler way, through an interplay of subtle colors and values. Reid is painting the light here too, just not with a strong backlight. He is stressing another aspect of the scene, one more conducive to his painting style and perceptions. Again, both interpretations are equally valid. There is no one way to see or paint. But you must make a choice. And the approach you choose should be based on your own personality and what you want to say.

Here Reid decides to sketch the scene

1

2

in the afternoon, when he is able to see more color in the water and grass. He takes the chair away and balances the flowers by changing the color of the floor. He darkens the door frames slightly, but keeps the chairback and table objects high in key. There's a lot to be said, Reid believes, for sticking with a subject and trying several possibilities to make it work as a painting. Reid thinks that artists often look too much for good subjects to paint and don't try hard enough to make what's in front of them work through color and value changes.

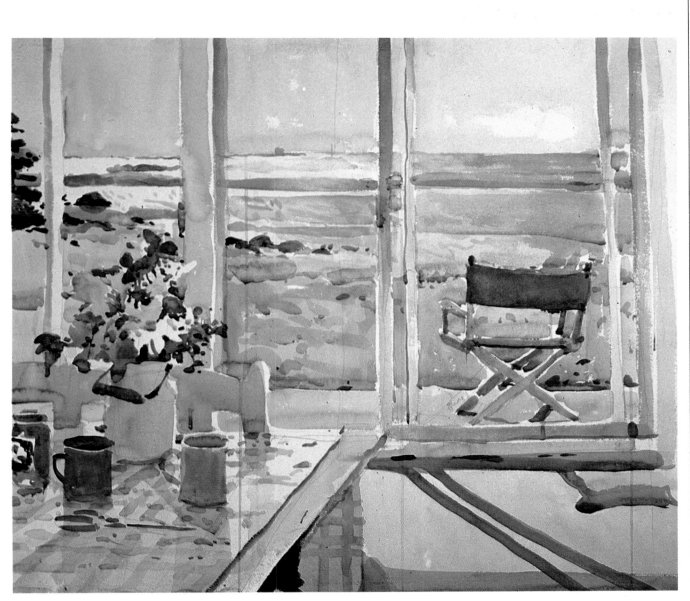

Half Moons, 22″ × 25″ (56 × 64 cm), by Charles Reid.

Half Moons. Reid painted *Half Moons* as the sun rose over the ocean. Clear, crisp mornings like this are rare in Nova Scotia, and so he tried to paint the light outside as well as the light that filled the room.

Painting light is difficult. Ironically, a painting must also contain darks in order to express light; otherwise it will look washed out. This painting is on the weak side and perhaps not as successful as Reid might have wished, but it did present an interesting challenge to him.

To express the feeling of light, he stresses the local color of each area in the room rather than the light-and-shade pattern that he actually saw. He also lightens the values in the shadows and in the rest of the room to keep the painting high in key. He also paints the door frame, flower container, cup, and chair-back much lighter than they were, while choosing to paint the flowers in terms of their local color rather than their value.

On the other hand, he records the values he saw in the landscape (and the chair leg) fairly accurately, keeping the color values about the same as they would appear in a neutral light. To give the painting substance, he adds a few dark accents—the table leg, the cracks and shadows under the doorway, and the dark spruce trees and rocks.

Composing with Color

Since colors can emphasize or subdue areas in a painting, you must choose (and place) your colors with care. Here are some ways that Charles Reid found to shape a composition through color.

Sarah in a Red Jumper. This painting of Sarah was done in one sitting. She wasn't pleased to be posing for Reid and decided to stare at her father with as little expression as possible. She wasn't about to take a "pose." Reid found it fun to go along with her and still manage to produce a painting.

Since the pose is stiff and straight-on, Reid deliberately places a red cloth behind her so that the color value tie-in between her red blouse and the cloth would ensure that the pose is underplayed and not too obvious. To further reduce the formality of the pose, Reid makes sure that the jumper isn't symmetrical. Notice that he continues it beyond her elbow on the left and lets just a bit of it show on the right.

Since Sarah was wearing a red bow, Reid thought he would emphasize it as a nice accent of color. So he lightens the wall and paints it a warm gray that ties in with the color and value of her hair. The result is that the top of her head gets lost against the background and the red bow stands out.

Sketch. What a different painting Reid's sketch would have made! Perhaps you may find it even better and more expressive than his painting. At any rate, it shows that you can completely change the idea and emphasis of a painting through the colors and values you choose.

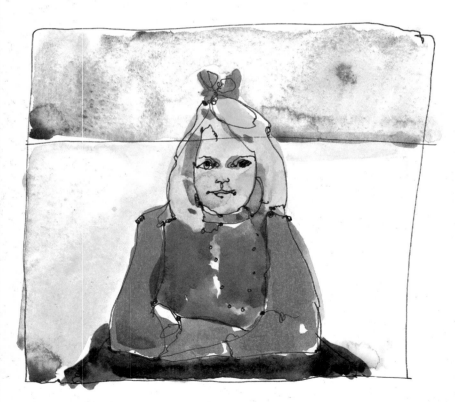

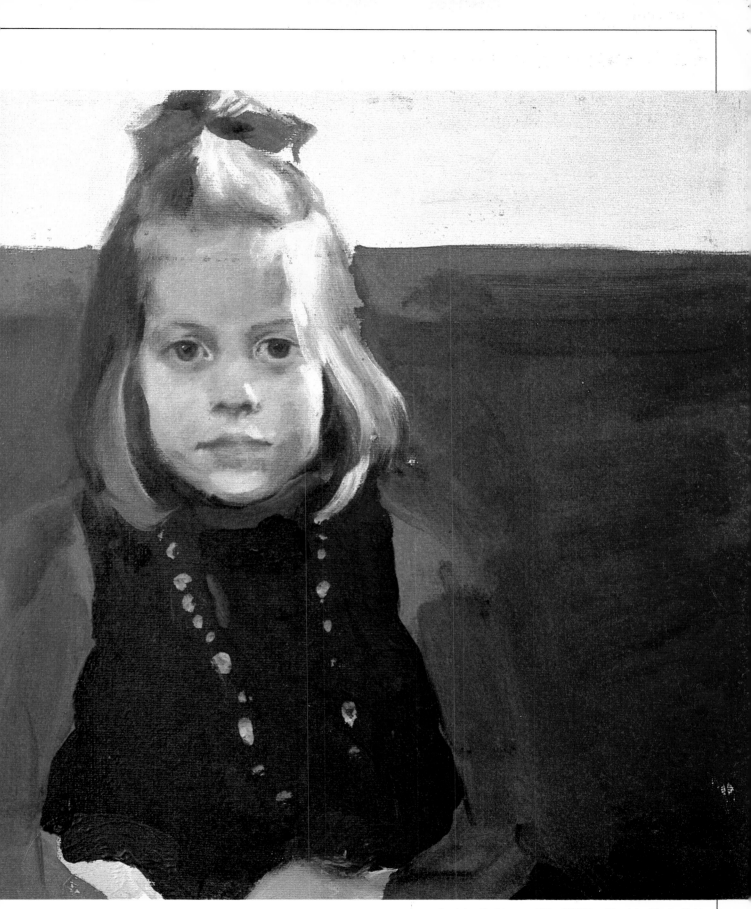

Sarah in a Red Jumper, 14″ × 18″ (36 × 46 cm), by Charles Reid.

CORRECTING FINISHED PAINTINGS

Sketching is an invaluable tool for gaining insight into the overall quality of a finished work. In this final section of the book, Charles Reid explores ways to improve and analyze your work through the use of correction sketches. The correction sketch, as the term implies, is an attempt to visually illustrate ways that your painting or drawing can be improved. For example, if your color values don't work in a certain area of your painting, a correction sketch can point out a different approach that may solve the problem. A correction sketch can also be useful as an interim step before the painting is considered completed. At this stage, the correction can guide you to the most successful solution for your painting.

Correcting Washed-Out Lights and Muddy Darks

The student paintings on these pages are not of the same subject, but each contains specific errors that often crop up. Compare each painting with the sketch Charles Reid made to show how the error could be corrected.

Washed-Out Lights. This painting was done in class. The assignment was to develop tie-ins between areas of similar value in and outside the figure. An excellent painter, this student was very successful in handling these tie-ins. The drawing and composition are fine too, and the color in the middle and darker areas is generally nice and rich, with good warm-color variations. But the problem is in the light areas. They are washed out and bland, appearing as "tones" rather than as color ideas.

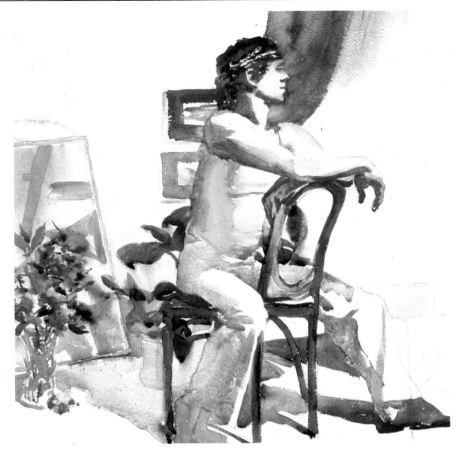

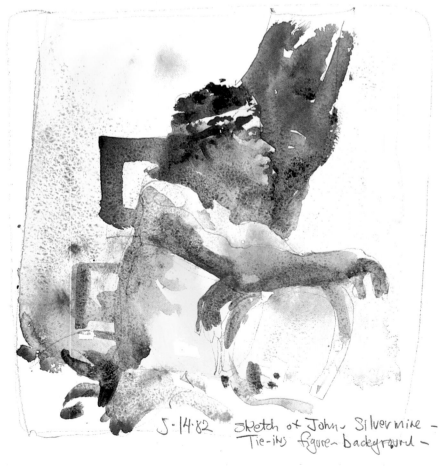

J.14.82 Sketch of John. Silvermine –
Tie-ins figure-background –

Correction Sketch. Reid strengthens the lights by exaggerating their color and by making some of the background areas a bit darker. Although this was an accident, it's better to get the color accurate even if the value does get a bit darker in the process. Reid uses cadmium red light, cadmium yellow, and yellow ochre for the fleshtones in the light and paints the shadows on the model near the picture frame with cerulean and cobalt blues. The background is painted alizarin crimson, cerulean blue, and yellow ochre for a light feeling, and Reid uses alizarin crimson, ultramarine blue, and raw sienna in the drapery.

Muddy Darks. The painter who did this is obviously very capable. Her handling of the watercolor is quite accomplished. But a bit of overworking is evident—the painting was worked on about a half hour too long. You can see the overwork in some of the "fuzzy" edges. More important, you can see it in the darks. They have no luminosity or life. This is because, in her concern with value, she ignored the color. She also mixed the darks with too many colors. If you want a really dark dark, you're better off using plain ivory black rather than trying to mix a black. However, Reid tries to get his students to allow light into their shadows by having them stress the color likeness of the shadow even more than its value. That is, Reid thinks it's better to use dark hues rather than black for your shadows.

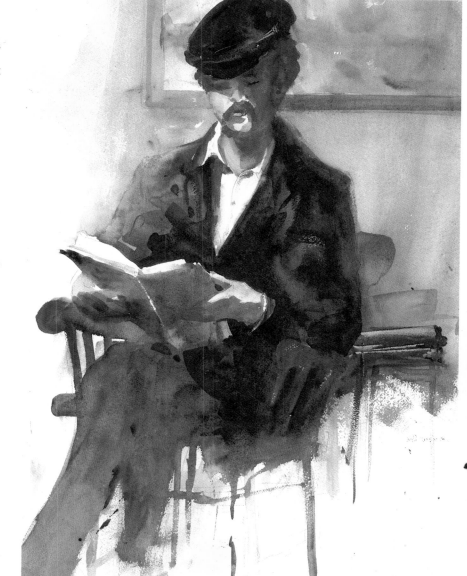

Correction Sketch. Reid tries to suggest the idea of dark darks without being too literal about expressing the values he saw. So instead of copying the exact value of the dark, he tries to paint the shadows through warm-cool contrasts. You might say that he "pushes" the color.

Since Reid likes to be able to identify the actual warm and cool colors that go into his shadows, he doesn't mix his watercolors on his palette as he would oil paint, but instead mixes them directly on the paper. Of course, that's only what he does for his darks. He tends to mix his lights more frequently on the palette rather than on the painting, just as he would oil paint.

Saving a Weak Painting with Darks

If you're working on a painting and it seems to lack punch—if your colors appear weak and washed out—the problem may be that your values are too light and your colors too weak. Charles Reid recommends that you correct such a painting by throwing in some strong, intense color and definite darks to strengthen it. But it may already be too late. Strong or dark color will probably look jarring and out of place on a weak painting, as well as unrelated to the rest of it. You must add your darks early in the painting stages, not as an afterthought. By then, it will probably be too late. In all likelihood, you will end up having to adjust all your colors by repainting everything.

Dark values are extremely important in balancing a painting. All you need is one or two carefully placed darks. Don't put them in at random, and never add them just because they're there. You must decide if each dark will help your painting and then choose the best spots for them. If a dark doesn't help the composition, don't add it or it will just become a distraction.

Sketch. Here Reid sketches his painting of Daisy but leaves out the darkest values to show you how it would have looked without them. He actually tries to make all his colors about the same value, but unconsciously he did make two changes to compensate for the lost darks, without even intending to do so. Can you see what they are?

Reid made the pinks behind Daisy more intense and a bit darker, and he made the yellow of the dress more intense too. So even though most of the values here are light and washed out, the intense tones give the painting some spunk.

Daisy at Silvermine. Reid did this painting as a demonstration to see if a painting almost completely light in value could be helped with a couple of much darker values. You can decide for yourself if it works. He's still not sure!

Daisy at Silvermine, 30″ × 24″ (76 × 61 cm), by Charles Reid.

Resolving a Divided Center of Interest

To Charles Reid, the importance of making connections or tie-ins between the subject and its surroundings cannot be stressed enough. Reid feels that a truly integrated painting depends on them. But tie-ins involve more than merely softening edges or repeating colors, shapes, or lines in various areas of a painting. They involve the essence of the composition itself. That is why you must plan your painting in a general sense in advance. If you don't, you will have problems similar to the ones Reid had in the two paintings on pages 140–143. Let's take a look at what went wrong and see how it could have been avoided.

Lauren. Lauren was a young woman "in passage"—her life was in a period of change. She had a very good face, an active personality, and such a fascinating personal history that as she talked, Reid had trouble keeping track of what he was doing with the painting. He got so interested in his subject that he forgot to work out a good picture idea. The problem was compounded by the fact that she was about to take off for Florida and so he felt that he had to finish her role in the painting quickly and leave the background for later.

There is really nothing wrong with doing this, as long as Reid remembered

to make major color and value notations of her complexion and costume on the painting. She was wearing a black blazer, blue shirt, and jeans—and his studio (except for the oriental rug) contains very warm browns. By the time he had finished Lauren's portrait and begun painting the background (his studio), however, she was gone and Reid found that he had no way to tie her colors into these surroundings.

He also discovered an even bigger problem. Except for Lauren's blazer, there were no strong contrasts in the painting, no big light-dark patterns. He hedged and made some half-hearted contrasts,

Lauren, 40″ × 40″ (102 × 102 cm), by Charles Reid.

but overall the values seemed "middling"—neither here nor there.

A painting can be successful in a high or low key, or it can have definite light-dark contrasts and be middle-range in both value and color. If you cover Lauren's figure with your hand, you'll see what that means. Each half of this painting works. But Reid couldn't have both within the same painting. He had to make a choice.

Reid thought of two possible solutions: He could cut off the left side of the painting and make it simply a portrait of Lauren without a strong background. Or he could look for and develop a major value and color tie-in between Lauren and the background. He decided on the latter course and sketched two ways to develop these tie-ins.

Sketch 1. Here Reid tries lightening the table and window area to create a major light area in the picture to balance the dark blazer. He also tries to put more color values (stronger and darker colors) in the lower section of the painting to balance the too-dominant figure.

Sketch 2. This time Reid tries to balance the figure by strengthening the upper part of the painting. He enriches the view through the window by adding some definite darks and by making the color of the grass more intense.

Which solution would you choose? How else might this problem be solved?

Establishing a Center of Interest

Charles Reid painted this oil in Sperry Andrews' studio. The property originally belonged to the American painter J. Alden Weir; the studio was actually built by Weir's son-in-law Mahonri Young (Brigham Young's grandson). Many great American painters of the late 19th and early 20th centuries—Hassam, Theodore Robinson, Ryder, Twachtman—had stayed in Weir's house. It intimidated Reid to paint with such important spirits lurking about!

Sperry and Reid have often shared a model, but since each of them has a different point of view, they're constantly deferring to the other's unspoken wishes. The result is that the question, "Well, what would you like to paint?," goes back and forth until the model gets fed up and considers leaving. Then they finally settle on a pose the model finds comfortable, no matter what it is. This is an exaggeration, but the fact is that Reid thinks it's hard to work with fellow artists you like and respect. Still, Reid says some of his happiest painting moments have been spent in Sperry's studio.

The main problem with this picture is the lack of connection between the model and the stove. They compete for attention because Reid was never able to decide which subject he was really painting. He thinks he should have let one or the other dominate. An obvious solution, Reid suggests, would have been to put the model in the foreground, yet he wouldn't have been happy with that, since he loved that wonderfully mottled, rich brown of the stove.

Potential Solutions (Sketches). Here are two pen-and-ink sketches showing what Reid would do if he had another chance at painting the subject. One way to arrange the composition would be to put the model behind the stove and slightly overlapped by it. With that solution, Reid would try to make her part of the stove. But his second solution—a back view with a very natural but awkward pose—might be good, too.

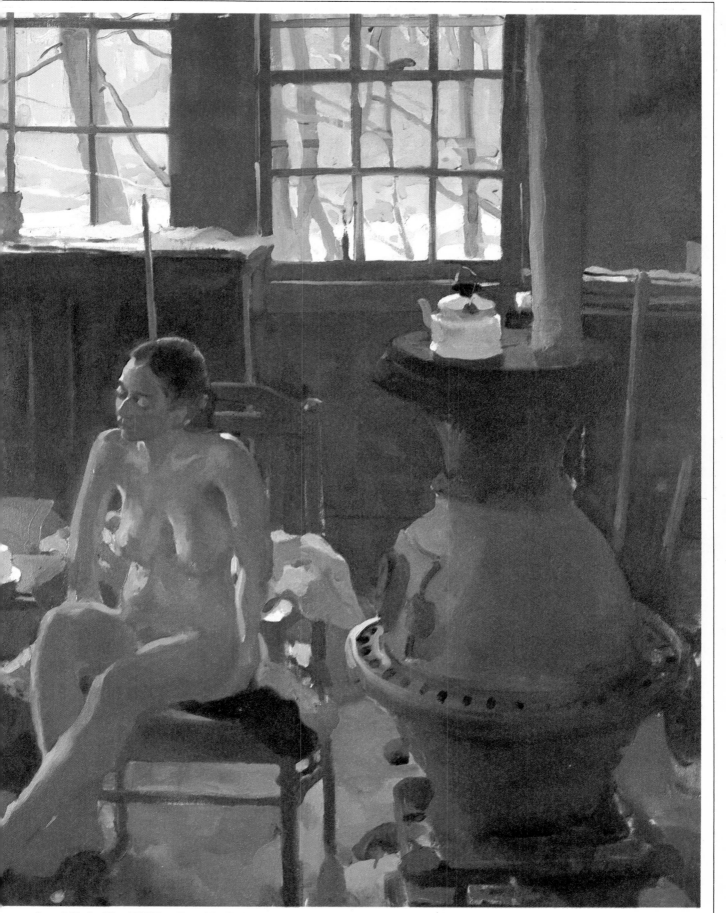

Sperry's Studio, 50″ × 50″ (127 × 127 cm), by Charles Reid.

Index

Animals, 26, 52–63
 at home, 52–53
 comparative studies, 57
 deer, 58–59
 elephants, 62–63
 form sketches, 58–60, 62–63
 movement of, 55, 59, 61, 63, 72–73
 museum, 56–57
 primates, 60–61
 zoo, 54–55

Charcoal technique, 22–23
 outdoors, 46–47
 rough sketches in, 88–89
Clouds, 44
Collage, 116–117
Color,
 choosing, 100–101, 108–111, 115, 116
 composing with, 132–133, 138–141
 correcting lights and darks, 136–139
 John Koser technique, 110–111
 landscape, 108–109
 light and, 130–131
 local, 130–131
 mixing, 137
 warm vs cool, 106–109, 137
Composing,
 by changing vantage points, 91, 120–121
 center of interest, 140–143
 landscapes, 110–111
 paintings from sketches, 100–113
 still lifes, 88–89
 the sketch, 73, 86, 92–93
 with color, 132–133, 140–141
 with geometric shapes, 90, 114–115
 with negative shapes, 86–87
 with value, 96–97
Contour drawing, 30–31
 with shading, 32–33
 with wash, 70–71
Contour sketching, 28–29, 68–69, 72–73

Darks, 138–139
 muddy, 136–137
Design,
 of finished painting, 114–115
 of sketchbook page, 38–39
Detail, 100–101, 117

Edges, 33, 82–83, 88–89

Figures,
 body language, 74–75
 dancing, 70–71
 forms and shapes of, 78–81
 light on, 33, 80–83, 102–103, 106–107
 movement, (in line) 68–69, (line and wash) 70–71, (watercolor) 64–67
Flowers, 122–125

Geometric shapes for drawing,
 animals, 58–59
 composition, 90, 114–115

landforms, 44–46
 proportions, 46
Gestural approach, 25
Gesture drawing, 25, 66–69, 72–75, 108
Golden section, 29, 104–105

Interpretation, 51, 73, 126–127
 of light, 130–131

Landscapes, 108–111, 122–123
Light and shadow, 34–35, 112–113, 130–131
 clouds, 44
 direction of light, 34–35, 44, 106–107
 figures, 33, 80–83, 94–95, 102–103
 landscapes, 108–109
 night light, 104–107
Light pattern in composition, 92–93, 95, 112–113
Line,
 crosshatching, 18
 contour, 30–31
 directed, 18, 33
 repeated, 19
 using various media, 16–17

Mannikin approach, 26
Materials, 10–14
 brushes, 13, 14, 34
 carrying cases, 11
 ink, 13
 markers, 13
 palette cups, 13
 paper, 10–11, 14, 34
 pencils, 12
 pens, 12–13
 sketchbooks, 10
 sketchboxes, 11
 watercolors, 14–15
Movement,
 animals, 55, 59, 61, 63
 figures, 64–71, 74–75
 gesture, 25–26, 66–75
 using repeated lines, 18–19

Negative shapes, 86–87, 92–93, 97

Outline sketching, 28–29, 68–69

Painting from sketches, 100–143
 city scene, 114–115
 figures in light, 102–107, 112–113, 136–137, 140–143
 flowers, 119–125
 interiors, 119–121, 126–131
 landscapes, 100–101, 108–111, 118, 125
 portraits, 132–133, 138–139
 seascapes, 116–117
Plants, 42–43, 86, 122–123
Point of view, 50–51, 91, 120–121
Positive and Negative Shapes, 84–85

Refining sketches, 47–49, 70–71, 86, 102–109, 118–119
Rhythm, 18–19, 24

Scribble approach, 24
Seascapes, 116–117
Sepia ink technique, 20–21
Series, 126–129
Shading, 32–35
 with line, 32–33
 with wash, 34–35
Shapes,
 accuracy of, 80–81
 of large forms, 78–79
 of shadows, 95
 positive vs negative, 84–87, 92–93
Silhouette drawing,
 figures, 64–65, 78–81
 still life, 88–89
 trees, 45
Sketchbooks, 10
 bindings, 10
 page design in, 38–39
Sketching,
 freehand, 72–73
 for painting, 92–93, 100–109
 purpose of, 51
 speed, 36–37
 to develop ideas, 118–119
Smudging, 33
Space, 100–101
Speed sketching, 36–37
Still lifes, 88–91
Studies of flowers, 122–125
Subject matter,
 choosing, 50–51, 100–102
 live, 52–53
 in a series, 126–130
 placement of, 73, 97, 120–121
 simplifying, 48–49
 studying, 122–125

Texture, 88, 95
Thumbnail sketches, 38–39, 116–117
Tonal mass approach, 26–27
Tone, 32–35
Trees, 42–43

Value,
 choosing, 132–133
 controlling, 95, 116, 130, 138–141
 local, 94, 130–131
 scheme, 96–97
 to find positive and negative shapes, 84–87
Value chart, 85
Value pattern, 96–97, 108–109, 114–117
Vantage point, see Point of view
Vignettes, 29, 86–87

Wash,
 figures in, 64–67, 70–71, 78–79
 painting with, 100–101, 110–111
 sepia, 20–21
 tonal, 34–35
Watercolor, 14–15
 brushes, 14, 34
 figures in, 64–67, 70–71
 mixing, 137
 painting with, 100–101, 110–111